WILLIAM HENRY JACKSON

An Intimate Portrait

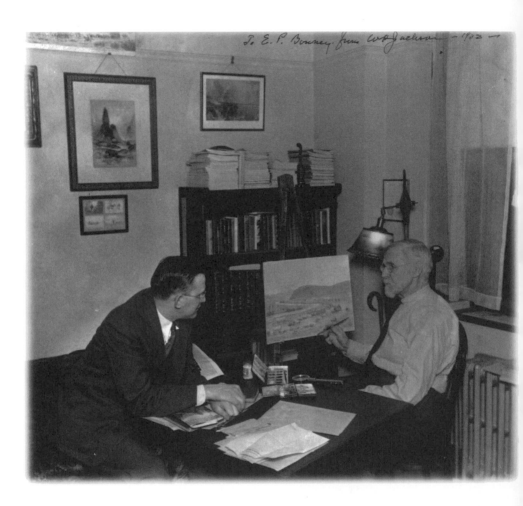

Elwood P. Bonney and William Henry Jackson

in Jackson's room at the Explorers Club, about 1932. S0025506

WILLIAM HENRY JACKSON
An Intimate Portrait

THE ELWOOD P. BONNEY JOURNAL

Edited and Annotated by
Lloyd W. Gundy

Colorado History
Number 4

ISSN 1091-7438

COLORADO HISTORICAL SOCIETY

Research and Publications Office
David Fridtjof Halaas and David N. Wetzel, *directors*

Publications Director
David N. Wetzel

Colorado History **Series Editor**
Steven G. Grinstead

Cover and photo section design
Mary H. Junda

Front cover: *Portrait of W. H. Jackson by J. N. Walters of the Orange (New Jersey) Camera Club.* S0025213

Back cover: *Mythology is at work in this 1930s cartoon. Jackson was hardly a "Yankee spy" in the Civil War; he first went west in 1866, not 1886; and the earliest known non-Indian to see Yellowstone was John Colter in 1807. The camera Jackson used to photograph the Mount of the Holy Cross was nothing like the one depicted, and the story of Jackson's exchanging a photograph for his life is apocryphal. Small wonder he dubbed another cartoon, drawn by the same artist and published in* Argosy, *as "bunk."* S0025212

All images are from the collections of the Colorado Historical Society unless otherwise noted.

The Colorado Historical Society publishes *Colorado History* to provide a flexible scholarly forum for well-written, documented manuscripts on the history of Colorado and the Rocky Mountain West. Its twofold structure is designed to accommodate article-length manuscripts in the traditional journal style and longer, book-length works which appear as monographs within the series. Monographs and special thematic issues are individually indexed; other volumes are indexed every five years. The Colorado Historical Society disclaims responsibility for statements of fact or opinion made by contributors.

Contents

Illustrations

Preface

The Colorado Historical Society is pleased to present this digest of the Elwood Bonney diaries—the first publication of material from the society's Elwood Bonney Collection. We hope that it will introduce our readers to the work of Bonney, an amateur historian whose loyalty and friendship to William Henry Jackson gave both men a good deal of satisfaction during the years that they knew one another. We also hope that it will shed meaningful light on Jackson's last years, when the aging photographer enjoyed the rewards, and the trials, of modest fame. Finally, we hope that this publication will spark further interest in the Bonney Collection, because that collection touches on so many themes—American life in the 1930s, the symbolism of our national parks, the Oregon Trail, the way Jackson's life became a legend even before it ended—and has such range and depth, that it will support many further publications in the years ahead.

As with so many things that go on in museums, or in the study of history generally, none of this would have been available to us today without the thoughtfulness, hard work, and timely support of many, many people. Elwood Bonney's children—Elaine Bonney Brenten, Barbara Bonney Fiala, and Diane Johnson—loved and appreciated the collection both for its historical value and because they knew firsthand what it meant to their father; without them, the collection might have been split into pieces or lost altogether. Jim Amos, a thoughtful Jackson enthusiast and National Geographic Society photographer, brought the Bonney Collection to our attention in 1988; his enthusiasm—amazement, really—left no doubt that the collection belonged under the Colorado Historical Society's roof. Martin J. Anderson, Bonney's protégé and a longtime Bonney family friend, pulled the collection out of storage, then sorted it, arranged it, inventoried it, and drove it to Denver in the trunk of his car; his respect for Bonney's work and his determination to preserve it have been an inspiration to all of us.

Funds to acquire the Bonney Collection came from many benefactors, whose kindness we note here. We are grateful to Mr. and Mrs.

Hugh R. Catherwood, the Colorado Historical Foundation, Stanley Cubrowski, J. Rathbone Falck, Ed Joyce, Robert G. Lewis, Anthony R. Mayer, the Joyce R. Strauss Fund, Mr. and Mrs. John D. Turner, and Mr. and Mrs. William F. Wilbur for their generous support; without them, there is no telling where the Bonney Collection would be today. A generous grant from the Volunteers of the Colorado Historical Society provided the means to process and catalog the collection once it was ours.

Lloyd Gundy, the editor of this volume, set out to process the Bonney Collection—to get it organized and ready for public use. But, as the collection worked its magic on him, he approached it with a growing (and contagious) sense of mission, adventure, and joy that we are happy to share in the following pages.

Eric Paddock
Curator of Photography

I am indebted to Stan Oliner, the society's former curator of books and manuscripts, who encouraged me to transcribe and edit the Bonney diary with a view toward publication. Professor Mark Foster kindly spared time to peruse parts of the initial draft and offered helpful suggestions on methodology. My thanks to the staff of the society's Office of Research and Publications, who created a professional work from my not-so-finely-tuned endeavor. I am most grateful to my wife, Wilma, who read the manuscript at various stages and provided much counsel along the way.

Lloyd W. Gundy
Editor and Annotator

To the Memory of Elwood P. Bonney

About the Editor

Lloyd W. Gundy, after retiring from a technical career, earned his master's degree in U.S. history from the University of Colorado–Denver. He has published articles on genealogy, utopian societies, and American history. He is currently a volunteer in the Books and Manuscripts Department at the Colorado Historical Society.

All lovely out here, but I am near the end of the trail for this year & will soon be turning back for the old Latham. Love to all,

Jackson

<small>August 28, 1938</small>

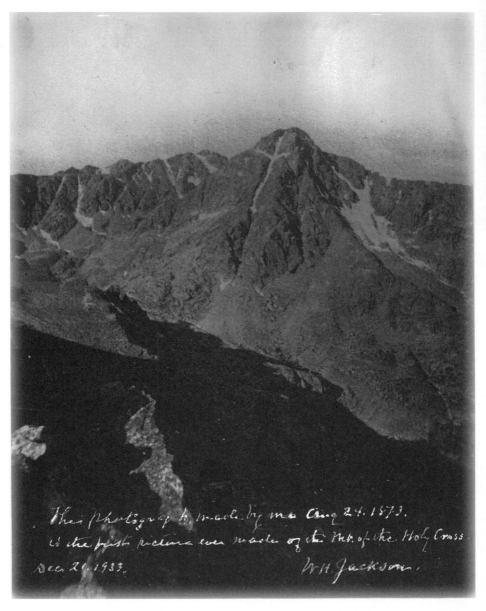

This photograph is made by me Aug 24, 1873. is the first picture ever made of the Mt. of the Holy Cross. Dec 26, 1933. W. H. Jackson.

Mount of the Holy Cross

On the back of this inscribed print Bonney has written, "This picture is an enlarged stereo glass plate negative—the first exposure of the mountain; the valley and waterfall are still in shadow—from which Jackson made an albumen print and gave it to Holmes, who with Gardner, climbed the Mount of the Holy Cross to the top on 8/24/73 [1873]. In the 1930s . . . Jackson said the 11 x 14 negative—which he called the 'crack' picture—had been destroyed . . . and Holmes sent him the albumen print for making another glass plate negative—and this latter negative was destroyed accidentally after a few prints (this is one of them) were made." See journal entry for April 22, 1936. S0025324

Introduction

Elwood Bonney, who befriended ninety-year-old William Henry Jackson in 1932, was an educated man interested in the classics. During his ten-year friendship with the West's pioneer photographer, it may have occurred to Bonney that his meticulous journal of Jackson's habits, conversations, and activities resembled James Boswell's *The Life of Samuel Johnson* (1791). Perhaps, in fact, Boswell was Bonney's model, for there are suggestive parallels here. Both reveal the day-to-day character of two great men, each admired or esteemed in his own way; both offer minute details of their subjects' lives, seen through the eye of the journal keeper; and both cast their subjects in the best light.

Like Boswell, Bonney wrote down every detail he thought pertinent—from the brand of shoes Jackson wore, to the meals the grand old man ordered, to the lilting expression he used when welcoming his guests. Side by side with these minor details, however, Bonney recorded the honors that came to Jackson in his later years, the adulation from others that made Jackson wince, and the reasons for his dissatisfaction with his largely ghost-written autobiography, *Time Exposure*. Nothing escaped this diarist's notice—for, in the end, this journal is Bonney's private tribute to a man he regarded highly, and who deeply appreciated their friendship in return.

Elwood Payne Bonney

Elwood Bonney was born at Pen Argyl, Pennsylvania, in 1898. An alumnus of Franklin and Marshall College in Lancaster, Pennsylvania, Bonney joined the Delaware, Lackawanna and Western Railroad (DL&W) in 1922. There he became assistant real estate agent with offices at company headquarters in Hoboken, New Jersey. Bonney married in 1934. The couple first lived in East Orange, New Jersey, later moving to Madison, New Jersey. Their first child, Elaine, was born in 1936, and two more girls, Diane and Barbara, followed.

Despite an age difference of two generations, an easy camaraderie had developed between Bonney and William Henry Jackson in the early

1930s. They met often for lunch or dinner, followed by relaxed conversation in Jackson's New York City hotel room. They sometimes attended a lecture at the Explorers Club or visited with mutual acquaintances. After Bonney's marriage, Jackson was occasionally a weekend houseguest in the Bonneys' New Jersey home. In November 1932, Bonney began recording these meetings, often in minute detail, in a diary that he would maintain for the next ten years until Jackson's death.

Bonney, after his retirement from the DL&W in 1960, devoted much time to researching and collecting information on Jackson's life. In 1975 he wrote to Weston J. Naef, a curator at the Metropolitan Museum of Art in New York: "I knew Mr. Jackson and since retirement my chief avocation has been viewing, collecting and studying everything by and about him"† Bonney died in 1986, leaving a rich legacy of assembled Jacksonia acquired by the Colorado Historical Society. The journal Bonney kept from 1932 to 1942 explains a period in Jackson's life largely unknown heretofore. That document, a significant part of the E. P. Bonney Collection of William Henry Jackson Material (collection 1643), is presented here in edited form with notations. Of it we shall speak more later.

William Henry Jackson

Jackson has been called "the greatest of all Western photographers,"†† the bulk of his most important work done from 1868 to 1898, years in which the art grew from a primitive state to technologies of mass production.

William first saw the light of day on April 4, 1843, in the small town of Keeseville, New York, near Lake Champlain. His talent in the graphic arts came naturally, as his father was a blacksmith and carriage-maker who dabbled with the new Daguerreotype photographic process while his mother enjoyed an innate ability for drawing and painting. Leaving school at about age fifteen, William, who could recall scarcely a child-

†Bonney to Naef, February 6, 1975, Collection 1643:357, Colorado Historical Society (hereinafter referred to as "CHS").

††William H. Goetzmann, *Exploration and Empire: The Explorer and the Scientist in the Winning of the American West* (New York: Alfred A. Knopf, 1966), 604.

hood day when he didn't paint or sketch, entered the job market. He began as a printer's assistant, moving on to jobs painting window screens, advertising posters, and stage backdrops, then to studio work retouching photographs with pen, pencil, and brush.

In 1862, with the Civil War raging, William and his brother Edward enlisted and went to war with the Twelfth Vermont Infantry. During his year-long army career, William marched, performed guard duty, and fought off an attack of "grippe." His main assignment, on direct orders from his colonel, was to "sketch and draw."‡ He did so—recording camp life, sketching military fortifications, and drawing maps. At the battle of Gettysburg his unit was stationed behind the lines to guard a baggage train. Thereafter, the Twelfth delivered 2,300 Confederate prisoners of war to a prison near Baltimore and returned north to Vermont, having completed the one-year term of enlistment.

At the Styles Gallery in Burlington, Vermont, Jackson resumed his career of hand tinting photographs and painting oil portraits, commanding twenty-five dollars a week at his final place of employment. Because of a suddenly broken engagement to Miss Caddie Eastman in April 1866, Jackson dropped his job, packed some belongings, and left town on the next train for New York. There he met a former army buddy, Rock, and his friend, Billy. The trio, foot-loose if not fancy-free, decided to seek their fortune in the gold and silver mines of Montana. Thus Jackson, the easterner, launched his career in the West. Seventy years later he would be lionized as that most American of all, a "True Pioneer."

At Nebraska City, Nebraska Territory, the three friends signed on to work as teamsters for a wagon train hauling freight from the Missouri River to the diggings in Montana. They were greenhorn "bull-whackers," driving their ox teams along the Oregon Trail to Fort Kearney, Chimney Rock, Fort Laramie, Independence Rock, and South Pass. At the Ham's Fork crossing, near old Fort Bridger, Jackson deserted the Montana train, soon hiring on with another outfit en route to Salt Lake City. After a few weeks of casual labor in the Salt Lake valley, he bought passage on

‡William H. Jackson, *Time Exposure: The Autobiography of William Henry Jackson* (New York: G. P. Putnam's Sons, 1940; reprint, Albuquerque: University of New Mexico Press, 1986), 58, 61.

a wagon train empty of freight returning to Los Angeles. Alternately riding, walking, sketching, and composing diary notes along the way, William reached that city on January 31, 1867.

Three months in California passed. Time spent sketching, painting, and "loafing around," in Jackson's words, although pleasurable enough, paid little; and weeks spent as a ranch hand cutting wood, building fences, and digging ditches convinced Jackson to search for a way back east. He signed on with Sam McGannigan, a drover with about 150 horses, mostly unbroken, headed for Omaha. From May 3 to late July, the outfit of eight men and one woman, who, in Jackson's opinion, was "barely intelligent enough to distinguish bright objects,"† drove the herd of mustangs from Los Angeles to Julesburg, Colorado, where the animals were loaded onto railroad cars for shipment to Omaha. Jackson's pay for the entire venture: twenty dollars. In Omaha, the next phase of his career would begin.

Jackson partnered with his brother, Edward, to enter the photographic business. Their Omaha studio did portraits, group photos, and outdoor pictures of shop fronts, farms, and buildings. Ed was the bookkeeper, their brother Fred an assistant, and with a friend as inside man, William worked in the field. He traveled about in a crude buggy fitted with a darkroom and loaded with the cumbersome equipment required for the wet-plate photography system of the time. He circulated among the surrounding Osage, Omaha, Pawnee, and Winnebago tribes. For an exchange of gifts or money, the Native Americans posed by the hour. The pictures were sold by the studio locally or on the eastern market.

In time, Jackson's interest turned to the railroads. On May 10, 1869, the transcontinental rails were joined at Promontory, Utah; that same day Jackson married Miss Mollie Greer of Ohio. After the ceremony in Omaha, the couple idled away six days on a riverboat to St. Louis, then Mollie returned to Ohio and William to Omaha.

In June, after wrangling two passes on the Union Pacific Railroad, Jackson and an assistant rode the rails and roamed the countryside, photographing the streets, denizens, and ramshackle buildings of trackside boomtowns from Cheyenne to Wasatch to Corinne, Utah. With an 8 x 10 "standard"

†Ibid., 159.

camera, another stereo camera with double-barreled lenses, and supporting equipment of pans, trays, chemicals, and a 30 x 15 x 15 box used as a darkroom, they photographed the railroad landscape, its bridges, rock cuts, and scenic views. In late September, Jackson hurried back to his business in Omaha, leaving his assistant in Utah to finish. The Jackson Bros. Company had gained a profitable number of unique western negatives for printing and sale.

That same year, while working along the U.P. line in Wyoming, Jackson had met Dr. Ferdinand Vandiveer Hayden, a government geologist and head of the United States Geographical and Geological Survey of the Territories. Hayden returned west in 1870. He called at Jackson's studio in Omaha, proposing that Jackson join his survey expedition across southern Wyoming as official, though unpaid, photographer. Jackson accepted the offer. With Mollie minding the studio in Omaha, he returned to the field with his usual cumbersome equipment of cameras, glass plates, chemicals, and portable darkroom. A military mule carried the 300-pound load. After an initial rendezvous near Cheyenne the twenty-man Hayden party worked across the Oregon Trail to Fort Bridger, south into the Uinta mountains, and back east along the Overland Trail.††

In 1871 Jackson became a salaried member of Hayden's staff—a paid photographer for the Department of the Interior. Thomas Moran, the painter, had also joined the expedition. Thus began a fifty-five-year friendship between photographer and artist.

The thirty-four-man survey party departed Ogden, Utah, in June, circled the Grand Tetons to the west, and entered the Yellowstone country from the north. Forty laborious days later, in addition to the geographical and geological information obtained, memorable Jackson photographs and Moran paintings of mountains, lakes, streams, and the strange geological formations of "Colter's Hell" emerged to be widely viewed by an enthusiastic America. They furnished the capstone for months of government lobbying by Hayden and others to make the Yellowstone region the nation's first national park. Congress, so per-

††The Overland Trail crossed southern Wyoming about fifty miles south of the Oregon Trail. Interstate Highway 80 roughly parallels it today between Laramie and Granger, Wyoming.

suaded, passed such legislation and President Ulysses S. Grant signed the bill on March 1, 1872.

Late in 1871 the Omaha studio had been sold, and Mollie joined William's retired parents in Nyack, New York, while he finished his demanding work in Washington. Sadly, Mollie died in childbirth in February of the following year.

The Hayden survey, now in several divisions, worked through the Grand Teton area and Yellowstone National Park in 1872. Jackson describes these few summer weeks as "one of my most fruitful periods."‡ Next year the team assembled in Denver. Jackson's party split off to photograph the central Colorado Rockies from Long's Peak on the north to the Sawatch Range on the south. From the mining town of Fairplay the entire expedition then set off to locate, survey, and photograph the storied Mount of the Holy Cross. Early in the morning of August 24 Jackson got his photos of the mountain as Hayden and others took survey data from its summit. The eight exposures he made would prove fine work.

Jackson's second marriage, in October 1873, to Emilie Painter of Maryland and Nebraska, made it an eventful year. Until 1879, the couple would make their home in Washington, D.C. There Jackson worked at the Department of the Interior during the off-season but took to the field every summer, except for 1876 when he was assigned to the Philadelphia Centennial Exposition to care for the Interior Department displays. These were models Jackson and others had constructed from pictures made and measurements taken during his previous two years spent on survey work in the Southwest, photographing and exploring ancient ruins, pueblos, and cliff dwellings.

Jackson returned in 1877 to the New Mexico–Arizona desert regions to study and photograph the Hopi and Navajo country. During the tour he exposed 400 negatives using his 8 x 10 camera and newly introduced dry film. He kept the film in a protected environment. Nevertheless, the film failed, and upon his return to the Washington laboratory none of the images could be successfully processed.

The expedition of 1878 would be Jackson's last for the United States government. The expedition "jumped off" from Cheyenne late in July

‡Jackson, *Time Exposure*, 209.

for the Wind River Range in Wyoming, then moved over into Jackson Hole† at the foot of the Grand Tetons and entered Yellowstone National Park for the last time. By 1879, Jackson later wrote, "I had established myself as one of the foremost landscape photographers in the country."†† But he was out of a job. Congress had reorganized the Geological Survey, and his work was no longer required.

The blossoming city of Denver offered promise for an enterprising photographer. Leaving his family in Washington for the time being, Jackson moved his equipment to Colorado. He arranged to open a studio at 413 Larimer Street in Denver, then took to the field again, this time to picture the silver boom in Leadville: its mines, miners, saloons, and brothels. In 1880, with a profitable business established, the Jackson family settled into a Denver home. Thereafter, Jackson turned his cameras to railroad work, often traveling in a private car furnished by the Denver & Rio Grande Railroad.

Jackson called this time his "Denver period." Certainly that place was his base of operations with his studio and family in residence. But he virtually worked the continent, making pictures for railroads and tourism interests from New York to Florida, Louisiana, California, Mexico, and Canada. He loved traveling, and his photographs were quite profitable. The family, now with three children, built a new home, entertained frequently, and enjoyed life. But soon the picture-maker would be away for not weeks, but months.

While on assignment for the Baltimore and Ohio Railroad, Jackson became acquainted with Major Joseph Gladding Pangborn, his girth as impressive as the name. The major, impresario for the B & O, offered Jackson a post with his proposed "Transportation Commission," which was to travel the world in a study of foreign railroad systems. After the close of the 1893 World's Columbian Exposition in Chicago, at which some Jackson pictures were on exhibit, Pangborn grew serious about his project. He rounded up financing from luminaries such as Marshall Field, Andrew Carnegie, George Westinghouse, and Cornelius Vanderbilt

†The place name "Jackson Hole" memorializes David Jackson, early mountain man and fur trader.

††Jackson, *Time Exposure*, 251.

(the younger). It was not enough to cover a photographer's salary. Nevertheless, Jackson joined up after arranging with *Harper's Weekly* to publish his forthcoming "World" pictures for not less than $100 per week.

The commission, replete with letters of introduction and encomiums from the press, departed the United States in autumn 1894. They toured Europe, Africa, Asia, Australia, and the Far East, crossing Siberia in the winter of 1895–6. After seventeen months of travel, entertainment by "poo-bahs," kings, and maharajahs, hundreds of photographs from exotic lands, and some 100,000 miles, Jackson returned to Denver.

The W. H. Jackson Photograph and Publishing Company, formerly Jackson & Rinehart, had fallen on hard times. Insufficient work was coming in, the photographic market was changing, the national economy still lagged from the Panic of 1893, and Colorado's mining industry suffered from repeal of the Sherman Silver Purchase Act. Jackson's career was about to enter the "Detroit period."

In 1898 the W. H. Jackson Company sold out to William Livingstone and his Detroit Publishing Company for $5,000 in cash and stocks worth $25,000. Moving to Detroit as a salaried director, Jackson took along for the company his magnificent collection of negatives and his reputation as a top-flight photographer. The company had recently acquired U.S. rights to the new Photochrom process for color reproduction of photos, and the negatives would provide a unique source for mass-merchandised picture post cards and large framed views. According to Jackson, the yearly production "was about seven million prints." Yet the inveterate traveling photographer continued in the field for several years. He photographed landscapes along both coasts and went to Canada, Cuba, and Nassau while also covering one of his favorite subjects, the railroads. Then he settled down in Detroit to work an eight-hour day as plant manager. He bought a Model T Ford, played golf, and enjoyed home life. Tragically, in the midst of prosperity, his wife Emilie passed away. The children had married and the grandchildren brought pleasure, but Jackson was alone.

In 1924 the company foundered and sank. With only $6,000 to show for his original $30,000, he "retired." He moved to Washington, D.C. But, remaining active, he spent time at the Library of Congress and the

Smithsonian Museum. He delved into records at the Department of the Interior for source material in his writing and painting. He had been elected a member of the prestigious Cosmos Club and liked the ambiance and the people associated with it. He began work on his first autobiography, *The Pioneer Photographer* (published in 1929), collaborating with Professor Howard R. Driggs of New York University.

Driggs had become president of the Oregon Trail Memorial Association (OTMA) upon the death of its founder, Ezra Meeker, and must have recognized that Jackson would be an invaluable addition to its staff. In January 1929, the association hired Jackson as a full-time employee for an initial period of three months at a salary of seventy-five dollars per month. His first assignment was to compile a map of the Oregon Trail and associated routes. Eighteen months later Jackson's name appeared in OTMA publicity as "Research Secretary" and his salary upped to $100 a month.‡ This stipend, with his monthly seventy-five-dollar military pension plus a few sales of paintings and the generosity of friends, provided his livelihood. Jackson moved to New York City, taking quarters at the Explorers Club before moving to the Army-Navy Club. Within a year Driggs was using Jackson's paintings to illustrate "the Winning of the West" in OTMA literature. By late 1930 the association could report: "W. H. Jackson, our Research Director, has constantly supplied historical facts and maps of the Western Migration. . . . In addition to the research Mr. Jackson has continued his work of making the pictorial record of the Oregon Trail. Twenty-four paintings are now completed."†

The Bonney Diary

About this time Jackson met Elwood P. Bonney. Bonney's ensuing account of their friendship provides a rare insight into the life and work of a celebrated American character. Numerous authors have rehearsed

‡Driggs to Jackson, January 18, 1929, Collection 1643:165, CHS. See also the Oregon Trail Memorial Association's (hereinafter referred to as "OTMA") budget for September to December 1930, OTMA file, Ray Lyman Wilbur Papers, Herbert Hoover Library.

†OTMA Semi-Annual Report, August to December 1930, OTMA file, Ray Lyman Wilbur Papers, Herbert Hoover Library.

Jackson's bull-whacking adventures, the photo expeditions of survey days, and the heroic effort expended in lugging heavy camera equipment about the country. Many treat the technical and artistic achievements of his photography. But the present chronicle has little of that.

The Bonney diary yields a heretofore unknown story in the last chapter of an old man's life (not a pejorative). It details his personal habits, his social life, the condition of his slowly declining health, his quick wit, his perceptive intelligence, and the *joie de vivre* that remained with him to the end of his life.

Bonney narrates particulars of their association that make the Jackson character delightful: They brace themselves on a rail station platform as an express roars through, thrilling at the noise and the wind in their faces. They munch peanuts from a vending machine as they ride the subway. Jackson tells Bonney of the time his photographic chemicals, carried in a valise, exploded a baggage car in the Albuquerque depot. Jackson enjoys good food with friends after a "snorter" or "dustcutter"; he eschews tobacco, keeps regular hours, and harbors a repertoire of stories he tells while "hopping around like a rabbit," in Bonney's words.

Other repeated themes that thread the diary together are Jackson's continuous sketching and painting, especially the paintings done for friends and his work for the National Park Service while on the Works Progress Administration payroll; the question of what disposition will be made of Jackson's work prior to and following his demise; the editing of his own autobiography and published articles; William Henry's unfortunate lack of confidence in his son, Clarence; and Jackson's belief in honesty and humility in the face of those who would make him the adventurous westerner of frontier mythology.

The diary may be seen as (unintended) social commentary on the lives of a successful 1930s bourgeoisie who seem unaffected by the (scarcely mentioned) raging economic depression and the growing specter of World War II. An example is the April 3, 1936, birthday party thrown for Jackson by his coterie of friends.

The diary was handwritten on plain 8½ x 11 loose-leaf sheets, scattered marginal notes being added at another time. Did Bonney anticipate that his diary would be read by others? Possibly. He organized

brief notes into readable narrative arrangements; it seems his practice throughout. The soliloquy in the entry for April 1, 1942, for example, had been inserted after March 28 as Bonney's explanation for his intimate friendship with Jackson. Not unaware of the diary's historical value, he may have considered future publication.

Some mechanical details of the present work: The text, originally a continuous narration, has been divided by yearly headings; passages with little bearing on Jackson's life eliminated; lengthy passages broken into paragraphs at logical breaks; minor errors of spelling corrected; and a consistent form for placement of dates observed. "Explorers Club" takes no apostrophe, whereas the "Adventurers' Club" does. Material not written by Bonney himself, such as Jackson's letters and the words of others, are set in italics. Abbreviations used in repeated citations are: AHC (American Heritage Center, University of Wyoming), CHS (Colorado Historical Society), and OTMA (Oregon Trail Memorial Association).

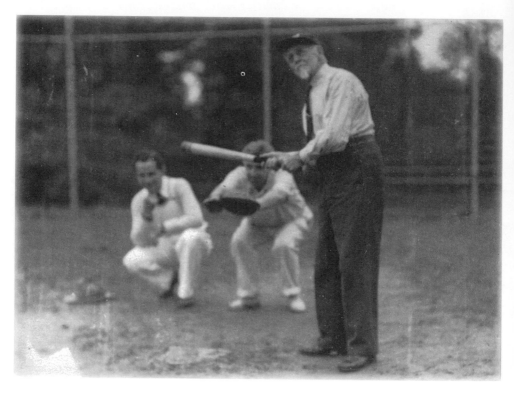

Jackson at bat

On an outing, Jackson is at bat, with
Lowell Thomas umpiring. S0025501

1932

While on the way up to the Explorers Club tonight to hear Capt. Carl Von Hoffman tell, at our first smoker in our new quarters (72nd St. address), about his 1924–25 trip across Africa, I stopped at the Army and Navy Club on 44th St, NY City, where Mr. Wm. H. Jackson is now living and enjoyed a pleasant two hours. Before going down in the dining room for dinner, Jackson asked me whether I would like a "little snorter," to which I reluctantly assented after endeavoring to persuade him to keep it for a more auspicious occasion. Jackson is 89 years of age at this time. (The quart of White Horse was a gift to him). And then when Jimmy Coit and Sandy MacNab appeared we enjoyed another.† I surely enjoyed the meal with Jackson, during which we discussed the West and his early adventures. Later we went to the club and after the lecture, Jackson, Ernest Ingersoll and I discussed Capt. John Moss and his alleged journey down the Colorado River in 1865.††

†James Olin Coit. Partner in Coit Brothers, Rayon and Cotton Brokers, 66 Leonard Street, New York City; known as "Jester of the Explorers Club" for his joviality. Born on a ranch in Idaho, Col. Alexander J. "Sandy" MacNab, Jr., worked as a cowhand and studied at the University of Idaho before enlisting in the army in 1898. He received a commission during the Philippines campaign. As a firearms instructor during World War I, he became known as the man who taught the American Expeditionary Forces how to shoot. After his 1935 resignation from the army he hunted big game in Africa. He died in 1955 at age seventy-seven.

††Ernest Ingersoll (1852–1946). Naturalist, journalist, explorer, author. Ingersoll attended Oberlin College and Harvard University and, as a correspondent for the *New York Tribune,* accompanied Jackson's 1874 photographic division of the Hayden survey into the Mesa Verde region of southwestern Colorado Territory. The two remained close friends. Ingersoll's many books include *Knocking Round the Rockies* (1882) and *Crest of the Continent* (1883).

John Moss was running a mining operation on the La Plata River in southwestern Colorado when Jackson's party met him in 1874. Since Moss was familiar with the territory and a friend of the Southern Utes, Jackson engaged him as a guide to explore the Mancos Canyon and its cliff dwellings and Anasazi ruins. Before leaving, Moss had some political business to settle in the new county where

Jackson said that when he first met Capt. Moss, he (Moss) was employed by the Parrot Co—a mining promotion concern and had several men down on the La Plata River in southwest Colorado preparing for placer mining. This was in 1874 and Jackson and Ingersoll spent a couple weeks with Moss going over the country looking for cliff dwellings‡ Jackson was again with Moss a short time in 1875. Both Jackson and Ingersoll agree that Capt. Moss was a reticent man. Jackson says Moss was about 40 years of age when he first met him and had to be "drawn out" to tell of his past adventures. Ingersoll said Moss was not given to boasting but told some yarns that were perhaps a little fantastic. Both Jackson and Ingersoll smiled at Moss' story of his alleged raft journey down the Colorado River in 1865. Jackson said that the only picture he recalled having of Moss—except for the one of Moss with a horse as printed in Jackson's book *The Pioneer Photographer,* page 229—was a full length studio portrait which he had loaned to Fewkes many years ago and which was never returned.† Jackson has made many inquiries at the Smithsonian Museum and to the Fewkes Estate, but the picture has never been returned to him. Ingersoll doesn't recall that he has ever mentioned Moss in any of his (Ingersoll's) books

(continued from previous page)
he was a candidate for an unspecified post. Jackson tells the story in *Time Exposure:* "since residency requirements were on the sketchy side for this first election, it was an easy matter for my photographic party, including the boys, to help vote him into office. After our ballots had been cast, Moss closed the polls, and we were off."

‡A fascinating account of the expedition and its discovery of the cliff dwellings and other Mancos Canyon ruins is found in Jackson, "Ancient Ruins in Southwestern Colorado," Hayden's *Eighth Annual Report to the Secretary of the Interior for the Year 1874.* Ingersoll filed a report with his newspaper which appeared November 3, 1874—the first published description of the ancient ruins. Mancos Canyon lies to the south of present Mesa Verde National Park in extreme southwestern Colorado.

†Jackson, with Howard R. Driggs, *The Pioneer Photographer: Rocky Mountain Adventures with a Camera* (1929) is Jackson's first autobiography. It covers the years only through 1878. His second, *Time Exposure* (1940), brackets almost a lifetime. The Fewkes mentioned is probably Jesse Walter Fewkes, who was connected with the Smithsonian Institution as an anthropologist and explorer and director of the Bureau of American Ethnology, 1918–28.

1933

February 13

A jolly fine day! Lunched with Dellenbaugh,†† chewed the fat on Colorado River and other western matters. Then met Jackson at the New York Historical Society, 170 Central Park West, New York City, to view the exhibit of western material Jimmy Coit joined us [for dinner]. On the way back from dinner we purchased two copies of the Feb. 11, 1933 issue of "Argosy" containing a short sketch of Jackson's life with very, very poor pictures. Jackson consented to autograph them "under protest" as will be noted. He, as well as Jimmy and I got a big laugh from them.

[In] the sketch of Jackson taken from a photo he was holding a walking stick and wore a slouch or felt hat. The original sketch showed the oxen being driven by reins. The artist removed them at Jackson's request but did not otherwise change the pictures as Jackson requested. Oxen were never driven as shown by the artist, but always the driver was on the ground at their side. No drawing boards were carried on the picket lines to sketch the enemies' [Confederate] lines. (The original sketch and statement said Jackson was a spy). Small, brownie type cameras and bulb exposure were not in existence in those days. The cameras were large and cumbersome—strapped to the back, especially when going was difficult, and not carried on a tripod under the arm as shown— and Jackson didn't look like a Mongolian, nor did he thumb his nose at the mountain. Modern type rifles were not in existence in those days, Indians didn't wear their feathers as shown, nor what is apparently an undershirt nor a sash about the waist. The Russian horses were not

††Frederick S. Dellenbaugh (1853–1935). Painter, historian, explorer, author. At age seventeen he accompanied John Wesley Powell's second Colorado River expedition as artist and topographer from 1871 to 1873. He painted the first pictures of the Grand Canyon area. Two of his many books deal with the expedition and the river: *Romance of the Colorado River* (1902) and *A Canyon Voyage* (1908). Dellenbaugh was a founding member of the Explorers Club.

blanketed, were not driven from a whiffle tree but a loose pole fastened to the sledge. The douga should be well up over the neck a short distance from the head. The driver rode in front with two passengers in the rear of the sledge. No wonder "autographed under protest" and the jolly good laughs.

While visiting Jackson at the Army and Navy Club (NY City) tonight, he showed me a picture—a photograph—of a gathering of members of the Natrona County Historical Society taken in Sept. 1927 at the dedication of "Jackson Canyon" between Casper and Red Butte, Wyoming.‡

While on a sidetrip during the 1st Expedition to the Yellowstone in 1870, Jackson found this canyon, and Hayden named it in honor of Jackson. The Historical Society made certain of the dedication by appropriate exercises in Jackson's presence in Sept. 1927.

April 5

At the Explorers Club this evening during his own 90th birthday anniversary dinner celebration (birthday was April 4) Mr. Jackson told of several of his early experiences and particularly about his adventures during the exploration of the Montezuma Canyon in Utah and said that the Indians were quite angry at all "whites" because the U.S. Gov't had taken away from them their best gold land without paying for it.† Hence, "whites" were not in safe country. Surveyors were at work at various times and the Indians hated them particularly. In fact, every "white" was to the Indians "Washington Americats, heap son-a-bitch."

At the Explorers Club this evening Mr. C. S. Jackson, son of Mr. William H. Jackson,†† while speaking of luck etc. of explorers, men-

‡Jackson Canyon debouches about three miles east of Bessemer Bend on the North Platte River, site of the river's last crossing by the westbound Oregon-California Trail. The expedition of 1870 took Hayden's group only as far as Fort Bridger and the Uinta Mountains, not to Yellowstone. Jackson, *Time Exposure,* 190–91.

†Jackson's adventure in which his survey party was forced by Paiutes into their camp, then released through negotiations, is recounted in Jackson, *Time Exposure,* 240–41. Montezuma Canyon lies in a north-south direction roughly twelve miles east of present Blanding, Utah.

††Son Clarence S. Jackson, fifty-seven, and family lived at 3712 Farragut Road, Brooklyn.

tioned that his father while on a recent trip into the mountains of the West found a revolver on a tree stump. This revolver had been placed there, investigation disclosed, 50 years previously. It was cleaned up in good condition and is now, I understand, in the Smithsonian Museum in Washington, D.C.‡

August 26

Spent Saturday afternoon and evening with Mr. Jackson. He recently returned from a 3 month visit "out West," looking healthier and happier than ever.† After a long chat we hiked from 28th St (Latham Hotel) to 42nd St library (NY City) and then Jackson even suggested (and we actually did) walk up three flights of stairs to the map room where Mr. Jackson examined the 1877 Hayden Survey atlas of Colorado to determine from the geological survey map the distance between the top of Notch Mountain and Holy Cross Mountain. This distance scaled

‡Most likely, the true revolver story appeared in *The Colorado Magazine* 7 (July 1930), 164: "An interesting relic of the Hayden survey of 1873 has come to the [Colorado] Historical Society. This briefly is its story:

"George B. Chittenden, upon joining the Geological Survey, was presented with a silver-plated Smith & Wesson revolver by former associates in the Coast Survey. This he carried with him to Colorado as a member of the Hayden expedition of 1873. While the party was skinning a grizzly bear on the headwaters of the Roaring Fork of the Colorado, this revolver, which had been borrowed by another man, was left on a log. The party moved camp that day and could not return for the sixshooter. Thus it lay, exposed to the mountain weather, for 39 years.

"In 1912, George A. and Henry K. Hutchings, brothers, . . . found the rusted revolver still lying on the log. The name 'George B. Chittenden' and '1873' were visible on the gun, but they knew nothing of Chittenden. In 1928, while accompanying the Colorado Mountain Club on one of its mountain climbs, W. H. Jackson, the pioneer photographer, learned of this revolver. Mr. Jackson had accompanied the Hayden party and knew Mr. Chittenden well. Arrangements were made for the return of the revolver to Mr. Chittenden and its subsequent placement in the State Museum at Denver."

Chittenden, through Jackson, had donated the revolver to the CHS.

†By 1933, Jackson had moved from the Army-Navy Club to the Latham Hotel at Four East Twenty-eighth Street, his residence for the next nine years. He customarily spent several months every summer traveling about the West visiting friends, attending conferences, and performing duties connected with the Oregon Trail Memorial Association (OTMA).

approximately 1¼ miles from top to top—or say approx 1 mile from the top of Notch Mt to the cross of snow on Holy Cross Mt. Mr. Jackson made his first and other photographs from the top of Notch Mt. and examined the maps to settle an argument he encountered out West this summer; some saying the distance was only ½ mile while others said it was 3 miles.†† Mr. Jackson said the Rocky Mountain Club of Colorado still use the old Hayden survey map as a guide for their trips. Later Mr. Jackson showed me the book (a large format) of the pictures he took of the 1893 World's Fair at Chicago‡

November 18

I spent Saturday afternoon—Nov 18, 1933—with Mr. W. H. Jackson before we attended the Adventurers' Club meeting in the evening. Jackson told me that his mother's mother's brother was the Samuel Wilson of Troy, N.Y.—the original "Uncle Sam." Jackson's grandmother on his mother's side was "Aunt Betsy" which name was later taken by Samuel Wilson's (Uncle Sam) wife. Jackson said that those who recalled Samuel Wilson said that he was not at all like the person the cartoonists pictured; that is, instead of being a tall and thin man, he was a short and pleasingly plump, jolly fellow†

On April 4, 1933, Mr. Jackson [celebrated] his 90th birthday anniversary. I have never seen him smoke or chew tobacco nor heard him swear—presumably he does not possess these virtues (!); but he doesn't refuse a "snorter" for good companionship, although he never touches

††The Mount of the Holy Cross, one of Colorado's 14,000-foot peaks, lies eighteen miles north-northwest of Leadville, in present Eagle County. Jackson was first to photograph the mountain with its unusual geological formation on August 24, 1873. The picture would prove to be, perhaps, his best-known work. In subsequent years the image underwent many reproductions and retouchings.

‡While visiting the 1893 World's Columbian Exposition in Chicago, Jackson substituted for the official photographer in making one hundred 11 x 14 views of the fair to be used in the authorities' final report. Back in Denver, where he lived at that time, he sold a duplicate set of the negatives to Harry Tammen, who promptly published the collection. Jackson pocketed some $2,000 for his ten-day effort. Jackson, *Time Exposure,* 263.

†Jackson explains how Samuel Wilson acquired the sobriquet "Uncle Sam" in *Time Exposure,* 4–5.

it when alone, so he says, and the contents in a few bottles in his room as it appears from week to week bears out this assertion. He stays up late, sometimes to 1 and 2 A.M. if the party is "alive" and generally never retires until midnight, but arises at 9 A.M. always, and feels OK. eats a late breakfast, takes no lunches, and eats a good meal for dinner at night.

A great, grand old timer.

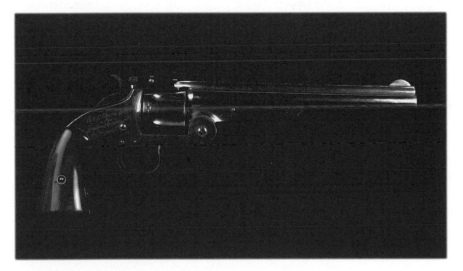

Chittenden's revolver

George Chittenden lost this revolver during the Hayden survey of 1873 and recovered it intact nearly forty years later. See journal entry for April 5, 1933.
H207 D88E

S0025507

1934

March 12

Mr. Wm. H. Jackson visited us over the week-end March 10 and 11, the perfect guest. To Orange Camera Club in afternoon 3/10/34. Several inches snow had fallen and I had to insist that Mr. Jackson wear a scarf; he refused to wear overshoes. I took him to Camera Club in afternoon in a taxicab. He complained about riding 5 blocks, he wanted to walk in the snow. He never did get the hike in the snow

[The next day] at dinner Jackson told with quite a twinkle in his eye and with much glee, apparently, that his daughter in Detroit liked to tell friends that her father never drank liquor.

March 21

Tonight I took Jimmy Walters over to NY City to visit Jackson at his room.†† We had a delightful time. After a little chat, Jackson suggested a "little snorter" which increased our appetite and we then left for Childs restaurant. After dinner we returned to Jackson's room and he showed Jimmy several pencil sketches he made during the Civil War, particularly some in 1862–3, and also his original sketch book taken across the plains in 1866.‡ Then he showed him his recent paintings and many photographs taken over a long period of years. We left for

††Jimmy Walters worked for Bell Telephone Laboratories, according to subsequent mention in the diary. In later years Bonney would state that Walters "was an old friend of mine. He was an enthusiastic photographer (avocation) and Jackson liked him very much. The friendship led to many happy hours at Jimmy's home in East Orange, at the Orange Camera Club and at my home in Madison." Notes attached to Jackson to Bonney, September 23, 1936, box 25, F. M. Fryxell Collection, AHC.

‡Jackson apparently carried multiple sketchbooks on his venture to California. In relating the trip from Nebraska to Salt Lake City, he mourned the loss of one 1866 sketchbook "containing many of my best sketches." He said nothing of its being found. On another occasion his diary disappeared, but it was picked up and returned. Jackson, *Pioneer Photographer*, 35.

home at 10:15. Jimmy was most enthusiastic about Jackson who presented to Jimmy a copy of the "Pioneer Photographer" inscribing it to "Jimmy Walters, High-Priest of Technical Photography—March 21, 1934." Before leaving Jackson suggested a "short snorter" which was also enjoyed by all, just enough to use up the left-over White Rock.

W. H. Jackson
Hotel Latham, 4 East 28th St.
New York, N.Y.
Sunday, May 6th, 1934

Dear Mrs. Bonney:
Ever since the ceremony at the "Little Church Around the Corner" that joined you irrevocably with my good pal "Bonney" I've been thinking, thinking, about what to send you as an appropriate [gift] of that happy occasion. I have looked and looked, here and there, at lots of things but arrived at no decisions. Now I am putting it up to you to select something yourself for you know best just what you would like to have, but are putting it off until "times are better" &c you know how it is and how often good intentions some times miss the mark.

Now, go to it, with [?] and of the little check herewith and with it my cordial blessings on your future happiness.
Sincerely,

W. H. Jackson

Mammoth Hot Sprs
July 30, 1934

Dear Bonney:
Herewith, on envelope, the first of the Yellowstone Stamps of the National Parks scenes the distribution of which is being supervised by P.M.G. Farley who is here for the occasion
Sincerely,

W. H. Jackson

September 7

Spent several very pleasant hours with Mr. Jackson tonight at his room—Hotel Latham, NY City. His son, Clarence S. was also present. Mr. Jackson had returned two days earlier (9/5) from several months visit through the West—Colorado, California, Utah, Wyoming, etc—he is feeling fine and looks it—said he gained 10 pounds (he certainly looked more chunky than when he left in the Spring). We spent our time looking at photographs he had taken during the trip; looking over newspaper clippings of his "doings" and events he attended or was honored at; lunched; chatted about his early travels in the Yellowstone and at Mesa Verde; and he also signed a statement to the effect that he made the first photograph of Old Faithful geyser in eruption in 1871, on my sheet of 50 of the Yellowstone Park commemorative stamps

He showed us two photos made by Haynes, one of Jackson and Postmaster Farley shaking hands; and one of Farley selling to Jackson and Senator O'Mahoney the first sheet of stamps. Jackson said only a part of the first sheet was placed in the Museum at Yellowstone; it was broken up and he got part and one of the stamps is on my first day cover which Jackson sent to me.†

Bonney's marginal note: Jackson was wrong—he did not photograph "Old Faithful" until 1872.

†The five-cent denomination stamp bore the reproduction of a painting based on a Jack E. Haynes photograph of Old Faithful erupting (Bonney-Haynes correspondence, September 9 and November 7, 1934, Collection 1643:292, CHS). For a discussion of the first photograph by Jackson of Old Faithful erupting, see E. P. Bonney to F. M. Fryxell, January 21, 1966, Box 25, F. M. Fryxell collection, AHC. During the commemorative ceremony in Yellowstone on July 30, 1934, Postmaster General Farley sold the initial sheet of Yellowstone stamps (the first in a series of national park stamps) to Senator Joseph O'Mahoney, who in turn presented Jackson with his batch, according to the *Casper Tribune Herald,* July 30, 1934. Jack E. Haynes (1884–1962) served as photographer for the occasion. He operated a photo studio and general store concession begun by his father, F. Jay Haynes (1853–1921), in Yellowstone National Park. Haynes the elder had been the official photographer for Yellowstone and for the Northern Pacific Railroad from 1885 to 1905. He launched the seasonal family business in Yellowstone with a base in Minneapolis–St. Paul. Their motto: "Publishers of the most complete line of pictures and books of any national park."

Sept. 25, '34.

Dear Bonney:
Merely to mention with this first issue of Mesa Verde stamps that sixty
years ago the 10th of September I made the first photographs ever taken
of the Mesa Verde cliff ruins, as shown by the "Two Story Cliff House"
of Mancos Canyon.
Sincerely,

W. H. Jackson††

October 26

This evening, as usual, I spent with Mr. Wm. H. Jackson. After dinner
we returned to his room for a long, pleasant chat. During the conversa-
tion Mr. Jackson remarked that he didn't know what to do with all his
books, pamphlets, letters, pictures, note-books, original sketches, paint-
ings, etc and I replied, "Keep them of course." He said "no, you don't
get what I mean. I mean when I go over the range." I tried to laugh him
out of that but it was evident that he at times thought of the disposal of
his various items either before or after his death. I remarked that his
son, Clarence, undoubtedly expected to have everything willed to him
to cherish in memory of his father. To this Mr. Jackson replied that
Clarence's interest was only a passing one, and would soon be forgotten.
(I made the above remark because a few weeks ago after dining with
Mr. Jackson and his son Clarence, who for several weeks lived in his
father's hotel room while his father was out west this summer, and for
several weeks after his return remained at the hotel and joined us at
dinner and our chats, remarked to me one evening while his father was
busy about some other matters, that he expected his father to leave ev-
erything to him and intended to set apart one room containing all his
father's items and designate it as "Wm. H. Jackson Room" in his resi-
dence when he was permanently settled in a home. During our conver-
sation it was quite apparent that Clarence was not at all fully aware of

††The envelope for September 25, postmarked "Mesa Verde National Park, Colo-
rado," carried the Mesa Verde four-cent stamp with a reproduction of Jackson's
photograph.

the many important historical matters his father was prominent in, and did not know of many things his father had done, places he had been, pictures he had taken, and articles he had written. However, Clarence did show much interest in these things, as well as surprise, and there is no doubt but that he appreciates his father's importance and was eager to learn more of his activities). I changed the subject, a sad one to me, and for the remainder of the evening we discussed other matters.

. . . He autographed several covers and blocks of stamps which I had with me While discussing the words to be put on my sheet of Mesa Verde stamps, Jackson "shied" at putting in any reference to his "discovery" of the Mesa Verde Cliff Ruins. He said the word "discovery" was pretty broad but he thought it alright to make reference to the discovery of the Cliff Palace fourteen years later (by Wetherill, of course) Jackson said "we just took a tip from some one else about the Cliff Ruins and went down there and photographed them." Jackson said there was a well worn trail through the Mancos Canyon and undoubtedly many natives, trappers, prospectors and miners had seen many of the ruins. Of course, Moss must have seen them before, or got word of them from reliable parties as he led Jackson and Ingersoll to them. However, it is probable that Jackson and Ingersoll did "discover" some of the ruins.

Later in looking through Jackson's book "Pioneer Photographer" we observed he used the word "discovery" etc and I kidded him about it. The first cliff ruin was seen [by Jackson's party] late in the evening of Sept 9, 1874 and first photographed the following morning

November 2

Again I enjoyed dinner with Mr. Jackson—and later, the usual chat. Mr. Jackson again remarked about the disposition of his many things after he "went over the range." I again suggested leaving them to Clarence but it was evident from Mr. Jackson's attitude and remarks, accompanied by certain movements of the hands that Clarence's interest was only a passing one, and would soon be forgotten I urged upon Mr. Jackson the importance of seeing that all his possessions were properly and safely disposed of and suggested that if not given to Clarence who expected them, then they should be given to the institutions which would

safely protect and cherish them, such as NY Public Library, Museum of [the] American Indian–Heye Foundation (both of which have several Dellenbaugh items and are mighty proud of them), Huntington Library in the Bronx, which now has some Jackson items acquired from some source, and is a branch of Heye Museum, or museums in the West or Southwest interested in such items as Mr. Jackson might have.‡

November 10

. . . I called on Mr. Jackson this afternoon for our usual weekly chat. I found his room a little upset. He had cleaned out several dresser drawers and piled the material—diaries, notebooks, scrapbooks, pictures, paintings, etc—on top of his dresser, to be later sorted and placed in a new steel filing cabinet, which arrived just as I was departing at 5 p.m. Mr. Jackson again remarked about not knowing what to do with his "junk." I bawled him out about referring to it as "junk" and suggested that many libraries and museums would be glad to have it, and while looking over sketches he made of cliff dwellings etc I suggested that some museum in the Southwest would be delighted to have it and he agreed

We had a nice drink of some apple wine which his friend Seymour had sent down from his camp.† Mr. Jackson told me over the phone a few days ago that he was holding up the opening of the bottle until I arrived. It was delicious. In fact, very much so!

‡The question of archive venues seems not to have been fully settled until years after Jackson's death. In addition to the large collection of Jackson's original glass-plate negatives and photographs, the CHS possesses five of his original, handwritten diaries as well as many letters and other Jacksonia. The society's recent acquisition of the Elwood P. Bonney collection significantly enhances its Jackson holdings. The New York Public Library owns many original Jackson diaries, notebooks, and sketchbooks. In addition to the Library of Congress's Jackson archives, original material may be found at the Denver Public Library's Western History Department, the museum at Scottsbluff National Monument, and across the country in both public and private hands.

†Edmund Seymour (1858–1949). Conservationist and businessman who established the New York firm of Edmund Seymour and Company in 1895. He was a founding member of OTMA, president of the American Bison Society, and charter member and treasurer of the Camp Fire Club of America, of which Sandy MacNab was president.

Mr. Jackson, who has been recently bothered by some bladder trouble and has not taken very much to drink lately, took about an inch in a small glass, and insisted I have a little bit more. After sampling it and finding it so excellent, Mr. Jackson smiled, winked and said he had to have more, and took a second and larger portion, which nicely whet our appetites for lunch. Before I departed later in the day he insisted upon taking another generous portion and I observed that we had probably consumed about one-half a pint.

November 17

Jackson is as hale, hearty and cheerful as ever. As we stood at the table eating our lunch at the Automat (he refuses to sit at regular tables, prefers standing) he examined some papers in his pocket book, among which was a check from Dr. Hebard for some paintings Jackson had sent to her.†† He said he had to think about getting a little money together because he couldn't keep up working all the time.

This is the third time within past few months that he has spoken to me about the "day of reckoning." Although I disbelieve it, he seems cheerful enough about it and says it can't be put off. He has finished several water colors within [the] past couple of months, and in line with several pictures he made for Dr. Hebard on Pony Express subjects, he has departed from his usual ox-team subjects in many cases and did two nice ones of a rider crossing a stream in a snowstorm at nightfall.

After thinking about the matter for 5 years he has now started an oil painting for Mr. Ellison of the Wagon Box fight.‡ It is about 24" x 30" or larger, containing much detail with well over a hundred Indians on horseback

††Grace Raymond Hebard (1861–1936). Professor, historian, author; headed the Department of Political Economy and Sociology at the University of Wyoming. Among her books are *The Pathbreakers from River to Ocean* (1911), *The Bozeman Trail*, with E. A. Brininstool (1922), *Washakie* (1930), and *Sacajawea* (1932). In 1934 she was working on a history of the Pony Express for which Jackson had prepared illustrative paintings.

‡Robert S. Ellison (1875–1947). Attorney and oil industry official in Casper, Wyoming, then Tulsa, Oklahoma. Ellison promoted the Old West and collected Western Americana. According to a contemporary, "Ellison footed the bill for

1935

January 25

I have been visiting Mr. Jackson regularly, especially on Saturday afternoons, but forgetting to make note of many interesting conversations. On the afternoon of Jan 12th we enjoyed an extended conversation and discussion about "Bronco" Charlie Miller, who claims to be the last of the Pony Express Riders. Miss Shaw, who wrote the book recently published, presented Mr. Jackson with a copy, and in the foreword refers to meeting Bronco Charlie and Mr. Jackson (she refers to him as "Daddy" Jackson) at the Deming home on Madison Ave at 30th St.† Jackson said he had never divulged to Miss Shaw his opinion of Bronco Charlie, particularly about the latter's claims of having been a Pony Express rider. Jackson considers Bronco Charlie's story preposterous insofar as reference to the Pony Express experiences are involved. During this past

(continued from previous page)
Jackson's seasonal treks westward, since the famous artist-photographer had only a veteran's pension. Their travels set a precedent for the Oregon Trail Memorial Association treks which became annual events beginning in 1930. Theirs was a historic friendship." (Jackson also was salaried in his position as research secretary for OTMA.) Merrill J. Mattes, *Fort Laramie Park History, 1834–1977*, prepared by Rocky Mountain Regional Office for Fort Laramie National Historic Site, Wyoming (Washington, D.C.: U.S. Department of the Interior, National Park Service, September 1980), 117.
 The Wagon Box Fight erupted on August 2, 1867, when several hundred Sioux warriors attacked a party of woodcutters guarded by a troop detachment out of Fort Phil Kearney, then Dakota Territory. The defenders, few in number but using breech-loading Springfield rifles, took position inside a corral of wagon boxes. Their superior firepower held off the Sioux until a rescue force could arrive from the fort.

†The book is *Broncho Charlie, a Saga of the Saddle: The Autobiography of Broncho Charlie Miller as Told to Gladys Shaw Erskine* (London: George G. Harrap & Co. Ltd., 1935). In the book's foreword, Shaw Erskine states that this 1932 meeting took place in her home. Present were Erskine; her father, "Colonel Richard C. Shaw, pioneer of Indian Territory days"; Edwin Deming, seventy-one, a painter friend of Jackson; Bronco Charlie, eighty-two; and Jackson, eighty-nine.

summer Jackson was over the Pony Express trail and attended several exercises held at places where monuments were erected. Jackson was an honored guest of the Utah Trails and Landmarks Association. Moreover, Jackson completed a month or so ago a series of water color paintings of old Pony Express stations and other scenes of those days to be used in a book written by Dr. Grace Raymond Hebard of Wyoming University on the subject of the Pony Express and which volume is now in course of publication by Clark of California. Hence, there is good authority for Mr. Jackson's opinions

I first met him [Bronco Charlie] June 30, 1932 at the Explorers Club when it was still at 110th St. NY City Mr. Jackson had asked me to come up to the club that night to meet a friend of his—and I met Charlie

Bronco Charlie, Jackson and I chatted for quite awhile in Jackson's room and later the three of us, accompanied by . . . [four others] went out to dinner at the St. Nicholas Restaurant on Broadway a short distance north of 110th St. Bronco was a picturesque figure with all his habiliments of the early days, including a Stetson with a band of snake rattles. Everyone looked at him, and I remember smaller boys approaching him and shaking hands on the streets

During the following summer (1933) Charlie again put in appearance in NY City, the Demings befriended him, he moved his few personal effects into their apartment and lived there for several months without paying any room rent or board money (Charlie was "busted"—altho' the Demings were nearly so, also) and even got his pocket money from Demings. Altho' there has been much book review and newspaper ballyhoo about the book and Charlie's proposed visit to London, so far as I could learn, he has not paid Demings any money on account and Mrs. Deming preferred to "forget" the whole matter.††

††Edwin W. Deming (1860–1942). Sketched, studied, and painted the Hopi, Apache, Yuma, Sioux, Crow, and other tribes. He and his family were adopted as members by the Blackfeet in 1914. The family lived in New York City, where Deming produced from his studio and home. Several of his works are on permanent display in museums across the United States, and his illustrations appear in some eighty-one books by such authors as Hamlin Garland, George Bird Grinnell, and Charles F. Lummis. Jeff C. Dykes, *American Book Collector* 14:3 (1963), as referenced in Maurice Frink, "Edwin W. Deming: 'That Man, He Paint,'" *American Scene* 12:3 (Tulsa: Thomas Gilcrease Institute of American History and Art, 1971).

At the Adventurers' Club meeting at the Hotel Martinique on Jan. 19th Charlie was a speaker—and did well, too! He wore high, laced boots, riding trousers and khaki shirt—and long hair (about 12 or 14 inches) tied with a bow close to back of his head Charlie's talk dealt with his Pony Express experience, told about the same as related in the book except that it was more brief, and his enlistment in the Canadian Forces, his trip overseas and the finding of his son who was brought in[to] a hospital as a casualty. Charlie had gotten a leave of absence and visited the American Forces and after being ordered out and ridiculed by the American boys, he, on the last day of his leave, found his son and was forgiven and loved by the boys who a moment before ridiculed him. It was a good story, effectively told, which brought tears to Charlie's eyes and held his audience spellbound and awed. After apologizing for weeping he sat down and the members gave him much applause, standing as they applauded. Before the dinner I was chatting with Charlie and introduced him to several of the boys— and as he wanted drink, I introduced him to Jimmy Doyle, who got him a "hooker" [a large drink], and introduced him to many more members and guests.

I visited Mr. Jackson a short time at noon hour on the 21st and he remarked about what a good speech Charlie made at the dinner. I have not yet seen Deming or heard his opinion.

January 26

This afternoon I visited Mr. Jackson and after lunching at the Automat— Mr. Jackson insisting upon standing at a table for that purpose, instead of sitting at the regular tables, as usual—we returned to his room. As we went out on our way to lunch the desk clerk at the hotel handed Mr. Jackson a letter which he looked at and wondered from whom it could be as it was in a woman's handwriting. I kidded him about being the boy who could get the girls and if he didn't look out they would get him. When we returned to his room he noticed Mrs. Haynes name and address on the back and remarked "I wonder what's on her mind," as he opened it. In the letter Mrs. Haynes thanked him for the 1934 Xmas card, remarking that it was unique and that she would put it in her gallery to keep. Jackson chuckled and remarked about her getting po-

etic. (Mrs. Haynes is the wife of Haynes, the well-known Yellowstone photographer)‡

We chatted awhile and then decided to visit the Demings. On our way we passed a book store and I remarked about the temptations before me continuously to buy books listed in catalogs sent to me—and learned that Jackson does the same as I, namely, to study the catalogs, grieve about inability to buy the books, toss the catalog in a waste basket, take it out again, fondle it, grieve some more, and again toss it back and endeavor to forget about the matter. I told him about my intention to purchase a six volume set of Charles Lamb's works published by the Three Sirens Press, leather back binding, good press work and binding for $4.85, saying that I preferred to invest in and read those types of books and writings than in most of the modern books. He agreed heartily, saying that he must train himself to read more of the classics and good substantial literature instead of the desultory reading he is doing. (Even at 92 he plans to cultivate his mind with good literature instead of wasting time on the ballyhoo and bunk which comprises most of newspaper and magazine writing today).

Upon arriving at the Demings he remarked about our having bored ourselves and having decided to visit the Demings and bore them. After a general all around laugh and visit we settled down to chatting and looking at several of Deming's old original paintings used for book illustrations. After we departed from the Demings I had only a few minutes left to catch the train but he suggested we stop at his room for a "wee bit"—straight—which we enjoyed and before I left for home he gave me 3 temple oranges for myself, Dora, and Mrs. Bache [Mrs. Bonney's mother].

I have mentioned these intimacies merely to record the fact that there is no sign of age mentally, either in Mr. Jackson's viewpoint or activities. He is just as alert and interested as any youngster, but he is getting a little careless about spots on his coats, vests and trousers. He washed a pair of trousers to his summer suit and did a swell job drying them so

‡Judging from the volume of Jack Haynes–W. H. Jackson correspondence, a warm friendship grew between the two. Mrs. Haynes also occasionally wrote newsy letters to Jackson about the family. Collection 1643:107–8, CHS.

carefully that they appeared as almost neatly pressed—and he used "Rinso" too!

February 9

This afternoon I enjoyed one of my usual Saturday afternoon visits with Mr. Jackson. I found him in good health and happy spirits. We chatted for a while about various matters, including Mrs. Dellenbaugh's recent death and it was evident that Mr. Jackson was deeply affected. After lunching, as usual, at the Automat, having "finished off" with chocolate ice-cream, we enjoyed a short stroll on 5th and on Madison Avenues, and then Mr. Jackson suggested that we walk down to Besslers on 23rd Street to learn whether certain slides he had ordered made from some photographs he had taken this [past] summer were ready for delivery, the pictures being some of those he took while going over sections of the Oregon Trail and Pony Express trails. On our way down 4th Avenue we stopped at a second-hand magazine store, and I finally "fell" for the Three Sirens Press' six volume set of Charles Lamb's works, which I purchased for $4.00—a brand new set—a splendid "buy!" Am I tickled!!

Mr. Jackson was in Washington, D.C. last week on business pertaining to Oregon Trail Memorial Association matters. While in the ante-room of Senator Borah's office a newspaper writer entered and during conversation Mr. Jackson made it known that he was the great grand nephew of Uncle Sam, the Sam Wilson of Troy, N.Y

March 30

Spent Saturday afternoon as usual with Mr. Jackson who was quite "chipper." When I arrived, he had just finished typing some letters and as he placed them in envelopes he hummed a song—and even whistled. I had never heard him do these things before!

After lunching at the automat we took the subway to the Bronx zoo to visit Jackson's old friend, M. L. Garrettson [sic], of the Heads and Horns Building.† In the subway we indulged in "penny-in-the-slot"

†Martin S. Garretson (1866–1955). Old West enthusiast and poseur who became secretary of the American Bison Society in 1917 and, in 1923, curator of the National Museum of Heads and Horns at the New York Zoological Park.

salted peanuts and before entering the zoo grounds we bought a bag of jumbo peanuts each and crunched those while walking along. We enjoyed a pleasant visit with Garrettson and later returned to the Hotel Latham for a rest and wash-up before dinner.

When we returned to his room he did not wish to lie down and rest, but busied himself with some matters, while I stretched my legs and would have welcomed a snooze. The walk at the zoo tired me, but apparently had little tiring effect on Jackson

April 3

This evening I attended a lecture and celebration held from 6 to 8 P.M. in the NY University educational auditorium at 35 East 4th St. NY City, arranged and presided [over] by Dr. Driggs, of the Oregon Trail [Memorial] Association,†† commemorating the Oregon Trail activities, and particularly the 75th anniversary of the starting of the Pony Express, and especially the 92nd birthday anniversary of Mr. Wm. H. Jackson, whose anniversary is tomorrow, April 4th.

Dr. Driggs opened the meeting by telling about the Pony Express days [remarking] that so far as accurate records show, including the researches of the Oregon Trail [Memorial] Assoc., and those interested in perpetuating the memory of the Pony Express riders, the last of the original riders on the main route between Sacramento Calif., and St. Joseph, Mo., died about a year ago in California

Following his talk, Dr. Driggs showed about 50 or more slides owned by the Assoc., many of which were made from Mr. Jackson's paintings, and colored by him. There were also several individual pictures of Mr.

††Howard R. Driggs (1873–1963). Lecturer, educator, author. A professor of English education at New York University, Driggs found time to write and coauthor more than thirty books. In 1928 upon the death of its founder, Ezra Meeker, Driggs became president of OTMA. When OTMA metamorphosed into the American Pioneer Trails Association in the early 1940s, Driggs continued as its president. He coauthored Jackson's first autobiography, *Pioneer Photographer,* in 1929. Jackson went on to provide many paintings and sketches to illustrate some of Driggs's books on western themes, notably *The Pony Express Goes Through* (1935); *Westward America* (1942); and *The Old West Speaks* (1956).

Jackson, some of early periods and some recent ones. During the talk, I heard Mr. Jackson say to Mr. Albright "Too much Jackson." . . .‡

Dr. Driggs then called upon Mr. Albright for a talk and he told of his first meeting with Jackson, when Mr. Ellison introduced them at the time Mr. Albright was Supt of the Yellowstone Nat'l Park. Mr. Albright then told of an incident which occurred in Jackson's 89th year. Mr. Jackson was in Mr. Albright's office in Washington, D.C. and remarked that he intended to visit the southwestern part of Utah that summer, as he had always wanted to go there but up to present time had not been able to arrange it. Mr. Albright reminded Mr. Jackson that the locality he intended to visit was the most inaccessible section of Utah and could only be reached by pack train, to which Mr. Jackson immediately replied, "I know it, I've already arranged for my pack train," showing that he was prepared and willing to rough it in his 89th year—as he also is even at this time. Mr. Albright also referred to his portfolio of Mr. Jackson's photographs, a "complete" set of the pictures made by Mr. Jackson in his first visit to the Yellowstone, which had been specially bound and used in getting Congress to make the Yellowstone a National Park. Mr. Albright had purchased the pictures when the Logan Estate was settled and assets sold in Washington 12 yrs ago†

‡Horace Marden Albright (1890–1987). Lawyer, conservationist, government official, business executive. In government service since 1913, Albright became superintendent of Yellowstone National Park in 1919. He was promoted to director of the National Park Service in 1929. Resigning that post in 1933, he joined U.S. Potash Company as vice president and general manager. He gained presidency of the company in 1946 and served until retirement in 1956. Jackson first met Albright in 1925 in Yellowstone National Park. The two became fast friends, with Jackson being a frequent guest at the family home in New Rochelle, New York, during the 1930s.

†Horace Albright, in unpublished memoirs possessed by his daughter, Marian Schenck, wrote that when the Logan album was purchased at auction, Logan's daughter verified that the volume had indeed been presented to the senator at the time of the vote on Yellowstone National Park. Albright states that he later donated the work to the University of California at Los Angeles. He proudly displayed a second album in his Yellowstone office.

Jacksonian mythology has it that such a portfolio, placed in the hands of congressmen, effected a favorable vote on the Yellowstone Park Bill in 1872. To cite a single influence (Jackson's photographs) for congressional approval of the Yellowstone Park Bill, however, is oversimplification. The efforts of Nathaniel P.

Dr. Driggs, in closing, passed a few remarks about [Bronco] Charlie
. . . but it was evident that he and the others in our group considered
Bronco Charlie not an original rider.

April 4

This evening "Jimmy" Coit and I "threw" our annual party for Messrs
Jackson and Deming. A few years ago we conceived the idea of holding
a celebration for them and the few parties we have given leave us with
many happy remembrances. This year we found nothing to interfere
with our giving the party on Mr. Jackson's 92nd birthday anniversary.
Hence, we held the party this evening in Coit's apartment at 62 Wash-
ington Square South, New York City.

I had hoped to meet Jimmy shortly after 5 P.M. to assist him with the
purchases and preparation of the food, but Mr. Jackson telephoned to me
during the afternoon and asked me to come to his room to assist in taking
some photographs of him and the flowers various parties had given to him.
I arrived at Mr. Jackson's room at about 5.15 P.M. and found him with three
large bouquets of roses, tulips etc given him by the people in the Hotel
Latham. A photographer from Shays (Cortland & Rector Sts—which firm
does considerable work for Jackson—and to which he entrusts many of his
valuable negatives, plates and prints for making additional pictures) arrived
shortly afterwards and two pictures were taken of Mr. Jackson at his desk
with the flowers in the background

We then visited Mr. Barber's apartment,†† where Jackson had left

(continued from previous page)
Langford, early Yellowstone explorer and first superintendent of the park, Congress-
man William Clagett of Montana, and F. V. Hayden himself must have figured large
in the bill's passage, as well as railroad and tourism interests. Ann Sutton and Myron
Sutton, *Guarding the Treasured Lands: The Story of the National Park Service* (Phila-
delphia: J. B. Lippincott Company, 1965), 20–23.

At least one author questions whether such a portfolio existed: Peter B. Hales,
William Henry Jackson and the Transformation of the American Landscape (Phila-
delphia: Temple University Press, 1988), 337.

††Guthrie Y. Barber (1875–1941). New York City businessman and collector of
western Americana. An avid history buff, Barber participated in the founding of
OTMA in 1926 and served on its board of directors in following years. After his
death, his collection of rare books, original manuscripts, and lithographs was
sold at auction over four sessions, the sale totaling $32,754, according to the
New York Times, October 25, 1941.

the basket of 92 roses presented to him the evening before by the Oregon Trail [Memorial] Assoc. Two pictures were taken there; one of Jackson alone, and [one] with Jackson and Barber—both pictures included the roses and the original of Jackson's painting "Crossing the Platte River," done in oil and owned by Mr. Barber.‡ I then hurried off to assist Jimmy with the cooking, the others to follow later.

I arrived a short time after 7 P.M. at Jimmy's apartment. Deming and Jimmy Hare were already present, and Coit was behind with the cooking, having been delayed at the office until 6 P.M. Coit had the baked potatoes in the oven and was making the Hollandaise sauce for the asparagus. I cleaned and stuffed the celery with pimento cheese, prepared the asparagus, set the table, helped prepare the cocktails, soup and peas. The rest of the boys then arrived and the party was complete with:

Mr. Wm. H. Jackson

Capt. Edwin W. Deming

"Jimmy" Hare

G. Y. Barber

James Olin Coit (Corporal Coit)

E. P. Bonney

. . . [After dinner], smoking of cigars, cigarettes and pipes—and then the telling of stories, yarns and jokes brought many a pleasant recollection to the minds of the "old timers" and many a hearty belly laugh was emitted. At 11.15 P.M. we departed, everyone saying that he had had a most enjoyable time—and there was no doubt about it, either!

‡Over time Jackson painted several variations on the theme of crossing the Platte River. Small changes differentiate them. One reproduction, entitled *Upper California Crossing*, appears in Clarence S. Jackson, *Pageant of the Pioneers* (1958), 56; another, labeled *California Crossing*, fronts page 87 in Howard R. Driggs, *Westward America* (1942); *Fording the South Platte* was printed in Jackson, *Pioneer Photographer*, 26.

Travelers after 1858 on the Oregon-California Trail south of the Platte River forded the south branch at Upper California Crossing, near present Julesburg, Colorado, if they had not previously crossed over to reach the North Platte. Jackson first sketched the scene on July 24, 1866. Merrill J. Mattes, "The South Platte Trail," *Overland Journal* 10:3 (Fall 1992), 3; Jackson, *Time Exposure*, 118.

Mr. Jackson was suffering from a slight cold which seemed to be nothing more than a hoarseness, which he made little of, but it is the first time I have known him to have a cold. It did not seem to detract from his pleasures of the evening. Everyone had more than plenty to eat—and there was more food and beer left in the kitchen—and still there was enough cash left over to pay a maid for washing the dishes the following day

May 4

Visited Mr. Jackson as usual today. . . . He still has some oranges on hand and we each ate one before going out to the Automat for lunch. Jackson ate only a piece of apple pie and drank a cup of coffee, and when I endeavored to persuade him to eat dessert with me he refused and with a twinkle in his eye and a hearty laugh he replied that he was saving the space for the New England boiled dinner Mrs. Barber was cooking for him this evening. We returned to his room and chatted awhile, settling the important questions in the world—and then we visited the Demings. Deming was busy painting small sketches and had about a dozen spread out on the sofa before him. He insisted that we accept one

May 11

Phoned to Jackson from the office and a half hour later when I knocked on his room door he greeted me with the usual "Come—come." Although his voice is generally low pitched he peculiarly raises it to almost a high pitch when saying those words quite short and snappily like and then tapers them off with a few more "comes" and "well, I'm glad to see you" or "How are you" and an outstretched hand, and always a happy, pleasant smile.† As I walked towards his desk to greet him, I did not notice a new acquisition hanging on the wall to the left. After a moment's chat, he called my attention to it. It was a framed enlargement of a photograph made in the laboratory of the National Park Service in Washington, D.C. where Jackson had visited a few weeks ago

†Jackson's voice is high-pitched and the pattern staccato in the 1940 78 rpm recording of an oral interview conducted under the auspices of the Department of the Interior. His knowledge and wit in the conversation overshadow the suave interlocutor. Collection 341, 4:2, CHS.

renewing old acquaintances in that Dept., and in others where he is well known. It is about 18" by 30" or larger, and is a beauty. It is tinted with oil colors and presents a mighty fine appearance. Jackson said that when he opened the package he was so surprised he almost fell over—he was greatly pleased, said so and [it] showed, and at once wrote a letter of thanks for it. With it they also sent two other enlargements made by Mr. Hunt, the Nat'l Parks photographer; . . . Jackson said he thanked Hunt for both but told him he couldn't quite place the one picture but assumed it was in Zion Canyon. While we were talking Jackson suddenly saw the light! And did he laugh. He recollected then that it was a picture of the Jackson stairway in Chaco Canyon, but as it had been taken from a low point, looking up, and quite overexposed, the stairway barely showed. Then Jackson got out the Hayden Reports and showed me the sketch he had made from the opposite canyon wall, which was looking down on the stairway and presented an entirely different appearance.†† Jackson was sure Hunt would get a great laugh out of his letter because Jackson had not recognized the subject although Hunt had told Jackson he would send the picture, and Jackson said he would hurry off another letter to Hunt about it.

Although a few friends have remarked to me that his appearances indicate a gradual failing of body, I have not observed it, perhaps because I see him so frequently [At lunch] I was not able to persuade him to eat dessert with me as he was saving the space to enjoy dinner with Mr. & Mrs. H. C. Bretney of Jacksonville, Fla. who were visiting in the City.‡

††Present Chaco Culture National Historic Park is located some forty-five miles south-southeast of Farmington, New Mexico. Jackson first explored and sketched the area May 7 through 15, 1877. His drawing of the stairway appears as plate 63 in *Report on the Ancient Ruins Examined in 1875–1877 by William H. Jackson* (Washington, D.C.: Government Printing Office, 1878). A photograph of "Jackson Stairs" illustrates text in Michele Strutin and George H. H. Huey, *Chaco: A Cultural Legacy* (Tucson: Southwest Parks and Monuments Association, 1994), 14.

‡H. C. Bretney is the son of Captain Henry Clay Bretney, who played a role in the so-called Platte River Bridge fight, July 25–27, 1865, when many hundreds of Cheyenne, Sioux, and Arapaho attacked 119 officers and men at Platte Bridge Station (present Casper, Wyoming) plus an inbound supply train of 25 men. Defenders persevered with losses of 22 men in the train and 6 from the post. Indian

After enjoying our snack, we walked down 5th Ave. to 23rd Street, then back thru the park, enjoying the pigeons, tulips in bloom, the hot sun, and life in general. We stopped at the Woolworth 5 & 10 to get some envelopes I wanted and at the same time each of us purchased a dime's worth (3 oz) of salted, mixed nuts to nibble on. Then we went to the new book store on 5th Ave just below 28th St and browsed among the old books for about an hour It was then about 4 P.M. so then we went back to Jackson's room and at his suggestion ate an orange. They were the remnants of a case sent to him by some unknown friend, which he has kept in his room and although the skins have become thoroughly dried out and like leather, the juice is plentiful and sweet. After discussing plans to visit the Orange Camera Club to do some work for Jackson, who feels that the commercial houses are not giving him the quality of print he wants, and some chatting about the progress of Dr. Hebard's book on the Pony Express, now in the Clark Co's. hands, and Dr. Driggs' book on the Pony Express, both of which Jackson is illustrating,† I hurried home to East Orange, leaving Jackson happy and apparently healthful, looking forward to his annual trip out west this summer, he expecting to leave early to fit in with Dr. Driggs' plans, who will accompany him part time.

May 16

Jimmy Walters and I visited Jackson this evening, enjoying dinner and a long chat with him afterwards. I found that Jackson can still "pack a punch" when, a short time before going out to dinner, Jackson suggested a "little snorter" from the bottle of Black & MacDonald Scotch and as

(continued from previous page)
casualties were estimated at 60 or more. Remi Nadeau, *Fort Laramie and the Sioux* (Englewood Cliffs: Prentice-Hall, 1967; Bison Book edition, 1982), 187–97. Jackson and the freight outfit he worked for crossed Platte Bridge a year later on August 18, 1866. Jackson's painting of the 1865 battle appears on page 37 of *Pageant of the Pioneers: The Veritable Art of William H. Jackson* (Minden, Neb.: Harold Warp Pioneer Village, 1958) and is reprinted in this volume.

†Driggs's book, *The Pony Express Goes Through,* "illustrated in color and black-and-white by William H. Jackson," reached publication in 1935. Dr. Hebard's book was in the hands of publishers at the time of her last illness. It apparently never went to print. Arthur H. Clark to Jackson, December 19, 1934, Collection 1643:31, CHS.

I passed some facetious remark when near him, he gave me a nice, snappy punch on the chest and hot-footed it to the bathroom cabinet where he keeps the bottle. After dinner we walked up to the Demings for a chat and to arrange for the showing to some interested friends of the movies I took of Jackson, Deming, Hare, Ingersoll and some others. During our conversation Mrs. Deming mentioned Bob Bartlett's talk over the radio today at the Advertising Club Luncheon.†† She said he swore considerably and that the announcer later apologized, saying it had been an uncensored speech. I remarked to Deming that I had been pleased that the Explorers Club had last year honored Matt Henson at one of the lectures,‡ but Deming seemed to feel otherwise for he said he would never entertain a "nigger." . . . Later we returned to Jackson's room to continue our chat. Jackson had a copy of April 1935 Explorers Club Journal which had just been issued. In it was a belated notice (and an apology for it) regarding the life membership given to Jackson on April 5, 1933. And it perpetuated the horrible statements contained in the NY Sun article on April 6, 1933 to the effect that Jackson cut the cake with a dagger he carried when exploring the Grand Canyon before the Civil War! . . .

During the discussion about the errors in the Explorers Journal about Jackson, he remarked about the uncertainty and unreliability of statements made by many old timers which have found their way into newspapers, magazine articles and books and which are grossly inaccurate. He wished to show us a statement by an author about this very thing but upon looking for it, recalled that it was in the recently published book about the Tabors which he had read and returned to one of the clerks at the hotel who had been a clerk in a Denver hotel during the days of the

††Robert A. Bartlett (1875–1946). Captain of Robert E. Peary's ship, *Roosevelt*, during the latter's second and third attempts to reach the North Pole in 1906 and 1909. *National Geographic* 37:4 (April 1920), 319–22; *New York Times Magazine*, April 1, 1934, 4–5.

‡Matthew A. Henson (1866–1955). African American assistant to Peary during many of Peary's late nineteenth- and early twentieth-century expeditions. Henson was especially noted for accompanying Peary during his attempt on the North Pole in 1909. Henson, at age eighty-eight, visited with President Eisenhower at the White House on April 6, 1954, an occasion marking the forty-fifth anniversary of Peary's exploit. *New York Times*, April 7, 1954.

Tabors.† Jackson considers the book a very good one and accurate as to historical facts. Jackson is a stickler for veracity and what he says and writes he can back up by referring to his diaries extending from Civil War days to date or the Hayden Survey Reports. He has most of his original diaries in his possession—or in a few cases copies thereof where the originals have been deposited with some organization or library etc— and he frequently refers to them to be certain his statements are correct.††

May 18

Visited Jackson as usual this afternoon and in the evening we went to the Adventurers' Club meeting. When visiting Jackson on the 16th he said he had twenty pen sketches to make for chapter headings in Dr. Driggs' new book about the Pony Express . . . which will be published in August and also contain eight pictures in color by Jackson and small sketches for tail pieces to each chapter. In view of all the work to be done—in addition to writing an article about the Pony Express new medal for the Scotts Coin Collector magazine and another article for another paper—before June 15th when Dr. Driggs wants Mr. Jackson to accompany him on the western trip, I suggested to Jackson that probably he wouldn't be expecting me on Saturday as he would be too busy but he quickly retorted "Why not, if I work hard all week, I guess I can take off on Saturday afternoons." And so I visited him today After our usual luncheon we visited Jackson's optician the Randel Optical Co. on 40th St. and Mr. Randel again examined Jackson's eyes which have been troubling him considerably lately. He now wears separate glasses for distance, and for ordinary or general conditions, and attaches another pair to these latter ones for reading and painting. I heard Mr. Randel congratulate Jackson on the unusually fine condition of his eyes for his age, saying that one was still 50% clear and the other was about 60% clear, whatever that means. Jackson remarked that his eyes were his chief means of livelihood and he wanted to take very good care of them.

†The book referred to may be Lewis Cass Gandy, *The Tabors: A Footnote of Western History* (New York: The Press of the Pioneers, 1934).

††See the first note on page 25.

We returned to Jackson's room, on the way gazing in clothiers' windows as Jackson wants a new suit. He purchased a cheap (50¢) pantagraph by which he hopes to reduce several subjects in his various paintings to assist in making the head and tail pieces for the chapters in Dr. Driggs' book, and when we were back in his room we spent an hour and a half playing with it in an effort to calibrate it—we found we weren't so "hot" in calibrating it entirely

May 23

Jackson had in his possession the draft of a chapter—being Chap VI "Photographing the Frontier"—of a proposed book by Robert Taft, Prof. of Chemistry of the University of Kansas, Lawrence, Kansas, which Mr. Taft requested Jackson to read over, correct, modify, exclude or add what he thought necessary or proper. It is to be a book about the development of photography, and particularly photographing the West. Chapter VI contains much about Jackson and we took turns reading the manuscript and commenting about it, making minor changes whenever necessary.‡ Although Mr. Taft had taken from Jackson's book the "Pioneer Photographer" reference to the dedication of Jackson Canyon near Casper, Wyo. Jackson said it was a minor matter, too small for mention, and he was going to suggest to Taft that the reference be omitted. Taft also mentions Hine who took some photographs in Yellowstone the same year Jackson did, but lost all but possibly a dozen or less in the great Chicago fire the following year [*sic*]—those that were printed and saved probably being lost in the U.S. Govt files, perhaps in Washington, D.C. Taft refers to Jackson as having taken the first photographs of Yellowstone and Jackson wants the reference changed to give due credit to Hine.† These two items alone clearly show Jackson's retiring and conservative

‡Robert Taft, in *Photography and the American Scene* (New York: The Macmillan Company, 1938), deals with Jackson's early achievements in chapters 15 and 16, 291–311.

†T. J. Hine. Chicago photographer attached to the 1871 government-sponsored Barlow-Heap party in Yellowstone. Hine had only printed sixteen negatives after returning home before the Great Chicago Fire wiped out the balance, according to Robert Taft. The fire erupted October 8, 1871, in contrast to Bonney's chronology.

nature and his fairness in matters of great importance. Jackson also expressed the desire to rewrite his autobiography, saying that his "Pioneer Photographer" was rather elementary.

May 31

Visited Jackson this evening after arranging by telephone for the visit. When I arrived at his room he was busy typing a letter He had only a few paragraphs to finish the letter and I sat down to read the Herald Tribune. He got up, went to his dresser and got a bag of mints and offered me some—those small, round, hard mints about an inch in diameter and one-quarter inch thick, such as I used to buy when I was a youngster. After typing another paragraph he turned to me saying, "If you want to mix up a cocktail, you know where the ingredients are." I graciously (?) declined and laughingly remarked that I would wait for him. When he finished the letter he suggested a "snorter" before going out to dinner and he measured out two "Scotches" which we took with a little water and a "mud in your eye," Jackson remarking: "whatever that means"—and then smacked his lips, smiled and commented on how good it was. He suggested that we eat at the Automat at 31st & B'way as the variety and supply was greater so we hiked to that place

After dinner Jackson and I walked around to the Demings Going east on 30th St. he read several Jewish names on the windows of business places and remarked that it appeared that all or most business seemed to be controlled by the foreign people. We enjoyed a long chat with Deming, looking at several pictures he is now working on or retouching

June 5

Tonight was a big night! I showed movies at Demings We planned to make it a private evening for intimate friends of Jackson and Deming and following are some who were able to attend: Mr. and Mrs. Ernest Ingersoll; Robert Bruce; Joe Boland; Jimmy Hare; Mr. Forbes; Mr. & Mrs. Robinson; a Mrs. Brown; Mrs. Bache and Dr Van Danez; Jimmy Coit; Dr. and Mrs. Wallace; several other individuals whose names I've forgotten and those mentioned hereinafter.

Dora met me at the office and accompanied by Miss Liddy and A. C. Doran we went over to Jackson's room, meeting Mrs. Doran in the hotel

lobby.†† Jackson was feeling quite chipper. At my suggestion the telephone operator phoned up to Jackson that I was there with a bevy of good looking girls and he replied to send them right up. After a chat and viewing of many of his pictures, diaries and photos, we went out to dinner . . . and then went to Demings. Going up Madison Ave. from the restaurant towards Demings, I suggested that Jackson take care of Miss Liddy and Dora, and he quite surprisingly to them set a fast pace and soon outdistanced us, but we caught up just as they had gotten into the elevator. We were the first arrivals, hence had an opportunity for all to get acquainted with the Deming family The parties then began to arrive in quick succession, there was great hilarity and handshaking and back-slapping. The pictures went on at 9:20 P.M. and lasted an hour. I gave a verbal explanation as the show progressed. There was clapping as good shots of Jackson and Deming and others were shown and favorable comments with various scenes, interspersed with laughter where due.

. . . Jackson, Ingersoll, Hare, Deming and others were quite chipper—in all, it was a grand evening! . . .‡

June 9

Mr. Jackson visited us at East Orange over the week-end As it was raining and chilly, we enjoyed the warmth and companionship of the fireplace while Mrs. B. and Dora prepared a delightful meal of corned-beef and cabbage—Jackson's favorite. We ate heartily and returned to the fireplace for a chat of half an hour before Jimmy Walters called at 7:30 p.m. to take Jackson and me to the Orange Camera Club to hear a lecture on transmission of pictures by wire (telephotography) by Dr. Reynolds of the Bell Tel. Laboratories. After that we joined in the eats with the boys at about 10 P.M.—Jackson taking a bowl of corn

††Dora is Mrs. Bonney. Miss Liddy and A. C. Doran are fellow employees with Bonney at the Delaware, Lackawanna and Western Railroad.

‡Bonney singles out these four perhaps because of their celebrity status and age: Jackson, ninety-two; Hare, eighty-eight; Ingersoll, eighty-four; Deming, seventy-four. Deming's family often entertained cosmopolitan groups. Sunday night suppers, with a simple, adequate meal and lots of good fellowship, were special. Frink, "Edwin W. Deming," 1971.

chowder, coffee, crackers and a dish of cubed, fresh pineapple. I didn't take to the chowder. Then Jackson, Dr. Reynolds, and I went over to Jimmy Walters to see some new Kodachrome color movies. Jackson and Jimmy each took a good "snorter" of Seagrams . . . and I don't know how Jackson managed to mix it with the other stuff. We retired about midnight.

Jackson was up early Sunday morning, feeling fine after a good night's rest—but I was tired. It was still raining in scattered showers and again we sought the warmth of the fireplace. At noon it cleared but no sun appeared, so we donned light over coats and enjoyed an hour's stroll (Jackson called it "stroll"—not a walk). Later we did justice to roast duck and topped it off with strawberry shortcake. Then to our chairs for another chat and to browse among my books. Jackson left for NY at 5:49 P.M. saying he enjoyed the nice, quiet week-end as he did enough running around anyways

June 15

Arrived at Jackson's room at about 12:45 P.M. . . . After a half hour chat during which I told him of the pleasure I got out of properly arranging and indexing my [personal] material (clippings etc. etc.)—which conversation resulted from his saying that he would have to leave for the West leaving a lot of work undone, particularly properly indexing a lot of his material, which he immediately proved by being unable to locate an old map he said he had and from which he hoped to see whether the name "Grand Canyon" was on it as he was certain it was a map made previous to Powell's trip down the Colorado River, and then said he didn't know what good it would do anyway to properly arrange all his material as no one would want to look at it afterwards, and I promptly corrected him in that respect, reminding him that he had much interesting and valuable information in his files—we left for the Automat and our usual "stand-up snack," as he calls it

[Later] we took a good sunning on the top of the Fifth Ave. bus, going up the Ave. and Riverside Drive to 158th Street. This trip lasted two hours and with our hats in our hands, we got a good cooling off in the breezes and I particularly got a good sun-burn, but Jackson said his skin was so hardened by such exposure that he doubted whether the

effects would show up on him. After returning to his room, he immediately started on his sketching work, as he still has a few pen and ink sketches to finish for Dr. Drigg's book on the Pony Express to be published in August. He told me that he would get $400.00 for the several sketches he made for chapter headings and tail pieces and the use of some of his water color pictures which are to be reproduced in color in the book. He worked almost an hour on sketching while I read the N.Y. Herald Tribune, the NY Sun and even snatched about a half hour's sleep in the chair. Then he stretched out on his bed for about a ten or fifteen minute rest before we washed up for dinner. We ate at the 30th St and B'way Automat and he then accompanied me up Broadway to the 32nd St. Hudson Tube entrance. I jokingly remarked that he was going to make certain that I went home instead of galavanting around with some woman and he laughingly replied that I couldn't look to him for an alibi. We parted at about 6:45 P.M. after shaking hands and I wishing him the best of luck and happiness on his Western trip on which he will start early next week.

June 22

Jackson's plans to have been "somewhere in the West" by this date went awry because Dr. Driggs, who is now out there somewhere, has not yet given any definite instructions to Jackson as to where and when he should depart and arrange to meet in the West After lunch we visited Woolworth's 5¢ & 10¢ Store to make a few purchases and then returned to his room to discuss a letter he had just received from Arno B. Cammerer, Director of the National Parks. With the aid of Public Works funds the Park Dept. is preparing numerous exhibitions, to be eventually placed in the National Museum in Washington, D.C., of the West. Dr. Cammerer is very desirous of obtaining the services of Mr. Jackson, particularly in an advisory capacity and has requested him to fill out an application. The salary offered is only $1800.00 a year because the allotment will not permit higher salaries, but the offer seems to be a splendid one and I encouraged Jackson to apply. Of course Dr. Cammerer will handle the matter personally and there is little doubt but that the whole plan would be approved Dr. Cammerer suggested that this summer Jackson visit the laboratories at Berkeley, Calif., where some of

the work is being done. Other work is being done at Morristown, N.J., particularly the Hayden Survey work, and Jackson has been offered the opportunity of remaining in NY City if he does not wish to move to Morristown, N.J. or Berkeley, Calif.† We enjoyed a great laugh about filling out the application showing age, past employment, experience etc. Surely the application is one to be framed! Where is there another comparable case—an old timer, and a grand one, too!, still living who so vividly recalls the early days and has accurate diaries and photos to help in the work

St. Joseph, Missouri
August 20

Dear Bonney:
I have been so rushed for the last two weeks that I have had little time for writing.

Just arrived here this afternoon from our ten day ride along with the Boy Scout Pony Express riders with messages from the Gov. of California and other like officials along the route to the President.†† The ride

†Arno B. Cammerer (1883–1941). Director of the National Park Service, 1933–40. Like Jackson, he was a member of the Masonic Order and the Cosmos Club, Washington, D.C., and probably knew Jackson for some time. His letter invited Jackson's participation in the Park Service's museum program, stating that Jackson's "advice and supervision" of other artists, as well as "the actual painting of pictures," would be most welcome. A Public Works application was enclosed and the letter postscripted "of course I still have to get the approval of the Secretary [Department of the Interior] to the plan of appointing you." Cammerer to Jackson, June 19, 1935, Collection 1643:27, CHS.

††Under the aegis of OTMA and celebrating the seventy-fifth anniversary of the Pony Express's birth and the silver anniversary of the Boy Scouts of America, a group of Boy Scouts riding in relays carried the mail from Sacramento over the old route to St. Joseph. Messages for President Roosevelt from personages along the way were then forwarded, as described by Jackson. The association had a medal struck to commemorate the Pony Express Diamond Jubilee; on one side in relief is the figure of a Pony Express rider, and the flip side shows the changing of horses at an Express station, both following paintings by Jackson. The medal sold for twenty-five cents, "thus making it available to every boy who revels in Western lore." Undated newspaper clipping, "Coin Collector," Collection 1643:290, CHS.

ends here so far as the riders are concerned but the messengers go on by plane—a tri-motor Army plane. Starting in the morning at 8, and I am one of the little party going with it, arrives Washington same afternoon— the presentation to the President being made Thursday afternoon. This brings me back sooner than expected to New York

So long, had so many "snorters" at a big dinner party just over that my head is a little bit on the bum.

So long.

Jackson

September 6

Visited Jackson tonight. It was my first visit since June 22

When I arrived at his hotel (Latham on 28th St) I found him in room #902—four floors higher up to get better north light for painting purposes. Dr. Driggs was with him, having set up his screen and projector to show some movies of the carrying of the Pony Express message After a chat, Dr. Driggs inscribed a copy of his book "The Pony Express Goes Through" to me. The volume was recently published (Aug. 8th) and illustrated by Jackson, who likewise added a little inscription. For the past three or more weeks I had been carrying around a review of the book clipped from the NY Sun, . . . [Jackson] was so pleased with the remarks in the review about his pictures enhancing the book that I gave him the clipping

He is now a working man! The W.P.A. project to prepare exhibits of early survey expeditions for museums is now under way and Jackson has been taken on to prepare four large oil paintings, each about 2½ or 3 feet by 5 feet, depicting the Hayden, Wheeler, King and Powell surveys in the field.‡ He has slightly arranged the furniture in his room which is the same size, shape, and layout as his former room, has his telephone on his desk at the foot of his bed, much more convenient for him than

‡These four great surveys of the American West, led by Ferdinand V. Hayden, Lt. George M. Wheeler, Clarence King, and John Wesley Powell, operated from 1867 through 1879, all four being in the field 1869 to 1878. Jackson was the photographer for Hayden, Timothy O'Sullivan for King and Wheeler, and E. O. Beaman, then John K. "Jack" Hillers, traveled with John Wesley Powell. Goetzmann, *Exploration and Empire*, 430–577.

heretofore, leaving an entire corner free for a large easel which gets a fair amount of north light for his work. His first picture will be the Hayden party, using the Tetons as a background. The directors of the work wished Jackson to show the party in the Yellowstone at the Old Faithful Geyser, but Jackson has persuaded them that such a setting did not portray the actual facts and did not permit him to make a good picture as no background would set it off. The directors admitted the merits of his arguments and have given him cart blanc [sic] to proceed as he thought proper. He says he cannot show the various parties at work, surveying, geologizing etc. where there is no proper setting for such work, even though the directors have the National Park idea in their heads and wish to get Old Faithful in the picture. Perhaps he will later attempt such a picture, but the four leading pictures he wishes to make quite characteristic of the work and places where it was done.

He said he had been reading the bulletin of the Southwest Museum (I believe it was) for some casual reading and when I remarked that it might be somewhat scholarly, he picked up the item and read at random an article about the Inquisition during the early Spanish settlement in New Mexico. After reading a few paragraphs about witchery, etc. he came to an item about charms and potions to win back the love of the lost ones and we enjoyed a real laugh about that potion made from herbs into an ointment to be rubbed on the body, best results being obtained if applied during sexual intercourse—we agreed that such application might at first appear to be complicated, but after all a technique could be evolved that was quite simple and pleasing.

I am worried about one thing, though. He told me that at three different times he had almost been hit by autos while crossing the streets in the City, and I lectured him well about waiting for traffic lights in his favor before venturing upon the street

September 13

Instead of the usual visit to Jackson tonight it was a little party. When I arrived Jimmy Walters was already there enjoying a chat, looking at paintings and photos. Major Russell came in a short time later. Jackson was in the usual good spirits. He had about half finished the first painting in oil for the Park Dept. It depicted Hayden and his party in

Yellowstone gazing at "Old Faithful" in eruption. Although Jackson feared that he could not make such a picture and had intended using the Tetons as a background he has produced a pretty nice composition

He apparently is making good time on the work, and at the rate he is going will have the four done quite early—unless delayed in looking up data about some of the other parties, especially King. Of course, the Hayden Survey is most familiar to him and the easiest to depict, hence, he "broke in" on that subject. After the four of us enjoyed a dinner at Childs at Jimmy's expense we walked up to Tex O'Rourke's office and gave a preliminary showing of the 1935 Adventurers' Club Al Fresco Movies, there being quite a crowd of boys present—and two women. Tex, being in the wholesale liquor business, had plenty of it around and although there were at least 6 quarts and pints on the desk in front of me [neither] I nor Jackson indulged.† Home at 11 P.M.

September 25

. . . I went over to 28th St. and stopped to see Mr. Jackson. I found him "chipper" as usual and expecting a call from a Mr. Nusbaum of the Mesa Verde Nat'l Park.†† We chatted about ten minutes about various matters and particularly his new oil paintings, when Mr. Nusbaum called and I departed.

Having finished my business by 1:30 P.M. I walked around to see Jackson again, and found him putting in the first touches of color to the picture of Powell and his 1872 party at their camp about six miles below the entrance of the Little Colorado River into the Colorado River

†Tex O'Rourke (1887–1963). Former Texas Ranger, soldier of fortune, prize-fighter, radio personality; past president of the Adventurers' Club of New York City. A raconteur, he claimed that Jackson in reality was William H. Bonney (Billy the Kid), as they resembled each other in height, weight, and appearance. The Kid, O'Rourke's story went, survived Pat Garrett's bullets and enjoyed longevity as William H. Jackson. *The Adventurer,* April and May 1941.

††Jesse Nusbaum (1887–1975). Explorer of the American Southwest and super-intendent of Mesa Verde National Park. His designs and supervision are reflected in the architecture of many National Park Service buildings within the park. Thomas J. Noel, *Buildings of Colorado* (New York: Oxford University Press, 1997), 600–602; see also *Colorado Heritage* (Spring 2000), 19–32.

Jackson had carefully gone through Dellenbaugh's "Romance of the Colorado River" and "Canyon Voyage" for correct information about Powell and his party, camp site pictures etc. and in doing so he observed that two pictures in "Canyon Voyage" were improperly captioned. The pictures are those opposite pages 24 and 30 and were taken by Jackson in 1874 and 1870 respectively and not by Beaman.‡ I accordingly noted my two copies of the "Canyon Voyage."

September 27

. . . [Jackson] was as "chipper" as ever and pleased with the amplifier he had installed on his telephone. He has had difficulty hearing the bell and a few days ago while visiting him it rang twice but he did not hear it and I called his attention to it. The phone desk girl spoke to him about the cost of installation and he said "yes" to everything she said, but he admitted to me afterwards that he didn't know what she was talking about. The girl presumed such was the case and later spoke to me saying she doubted whether he understood and asked me to tell him what the cost of the item and installation would be. Jackson told me that many times as he is near the window painting, he fails to hear the bell, or thinking he hears it he answers only to learn that [nobody phoned]— hence, it is well that he has the louder bell and an amplifier installed.

We visited only a few minutes, agreeing to meet later for dinner that evening We went to Childs and upon my refusal to permit him to "set me up" to the dinner, he won his point and treated me to a glass of sauterne. We walked several blocks after dinner, enjoying the air and exercise and then returned to his room.

Most of our conversation dealt with Powell and his river trip and a discussion of the picture Jackson was painting. He already had a good deal of color in the canyon walls and in the sky but the foreground, figures, boats & rapids were merely sketched in. He is using as a model

‡*A Canyon Voyage* indicates that the photographs of Red Canyon on the Green River in extreme northeastern Utah were taken by E. O. Beaman in 1871. Beaman, until resigning, was photographer for John Wesley Powell's second expedition. Jackson, with the Hayden expedition in 1870, had photographed in the Uinta Mountains for some two or three weeks. In 1874, however, Jackson was working in the Mesa Verde area and southeastern Utah, some 250 miles south of Red Canyon, and must not have taken the photograph that year.

the photograph made by Hillers in 1872 and reproduced in the "Canyon Voyage" opposite page 224.† I found only two criticisms to make, both of which Jackson considered quite in line with the facts. Due to the fact that his picture will not be the same proportion as Hillers—Jackson's will be 30 inches wide and 60 inches long††—he erred in the perspective insofar as a distance cliff is shown over the canyon wall to the left of the river, making it appear that the south plateau rim was close to the river— much closer than it actually is—and showing fair sized trees on it. This does not appear to be the facts according to the photograph nor the maps, and by making a sketch from the photograph and marking it off in squares, Jackson agreed that the distant cliff should be lowered and put closer to the river near the center of the picture and otherwise made to appear more distant that he has it. We will check over my geological survey maps on our next visit and determine whether it is the rim of the south plateau or a lower point shown in the photograph.

The other criticism was to the effect that the most distant cliff, just over the river in the center of the picture, was not a peak or temple as Jackson has shown it, but more of the nature of a flat topped plateau dropping off in a not too steep cliff. We will also endeavor to determine from the maps just what the actual facts are. Jackson is somewhat uncertain about the colors he should apply to the canyon walls but assumes a reddish brown is proper as Powell had not at this point yet run into anything but streaks of granite. He expects that Birdseye, who has

†E. O. Beaman quit the Powell expedition in February 1872, with John K. Hillers replacing him as photographer. Hiller's picture, upon which Jackson's painting is based, was apparently made in August of that year.

††Note that the pictures are thirty inches wide and sixty inches long, for thereupon hangs a tale. Jackson, in *Time Exposure,* 334, simply states "four 30 x 60 canvases," but the four paintings loom large in Jacksonian mythology as being thirty feet by sixty feet. Authors, both popular and scholarly, disregarding the improbability of such dimensions, continue to repeat it. For example: Ann Hafen, review of Jackson, *Time Exposure,* in *The Colorado Magazine* 18:2 (March 1941), 80; Helen Markley Miller, *Lens on the West* (New York: Doubleday & Company, Inc., 1966), 179; Beaumont Newhall and Diana E. Edkins, *William H. Jackson* (Fort Worth: Amon Carter Museum of Western Art and New York: Morgan and Morgan, 1974), 149; *Photography in the Fine Arts Quarterly,* January 1993 (Denver: Camera Obscura Gallery), 4.

made the trip, will criticize the picture and I suggested (as much as it hurt me to make the suggestion) that he first consult Clyde Eddy, who has made two trips through this canyon, the last trip being in 1934, about the color and other characteristics as to tree and bush growth....‡

October 12

. . . As pre-arranged, I called at Jackson's room for him yesterday and escorted him out to East Orange to remain with me over night

After arriving at E. O. we went for a short walk and he waited while I purchased a brown lightweight overcoat and brown suit at Altmans, where we chatted with Dora a few minutes and looked over the store. While looking over furniture in the basement I asked him whether he saw anything he wanted and he replied that he did but smilingly agreed that he would not know where to put it if he did buy it. Then we took a long walk thru the Orange Park and returned home. I was tired and after reading the newspaper for a short time, dozed off for a short nap, but Jackson's vitality kept him active and interested in magazines.

Before going to dinner I showed 400 feet of movies. Mrs. B., Dora, Jackson and I ate at the Hearthstone. Mrs. B who is on a limited diet was amused and surprised at Jackson's order which consisted of fruit salad, roast veal with filling, french fried potatoes, fried eggplant, cream cheese salad with oil and green peppers, a soft bun and a sugar coated one, a chocolate nut sundae and coffee. When looking at the menu for choosing a dessert I remarked to Jackson that I knew what he was going to have, but he was ahead of me, having looked at "desserts" early in the meal and decided on the sundae which was my guess for him, and my choice also. Jackson told Mrs. B. that he did not recall that he had ever been ill due to eating various mixtures of food, and never suffers from indigestion. He said he could "eat a welch rabbit [sic] and drink a glass of beer and go to bed happy."

In the evening we went to the Orange Camera Club and heard a

‡Col. Claude H. Birdseye (1878–1941). Topographer and explorer, at this time chief of the Division of Engraving and Printing, U.S. Geological Survey. The many Grand Canyon exploits of Clyde Eddy, member of the Explorers Club and the Royal Geographical Society, are recounted in the *New York Times,* August 19, 1934.

lecture by Fassbender on Lenses and Cameras for photography. After the lecture, Jackson joined with the boys in eating soup, cake, etc. etc. but I refrained except for a few grapes. We returned home at 11:15 P.M. and found that the girls had already retired, both being tired from house cleaning work. Jackson was surprised, and upon looking at his watch said "Why, it's only 15 minutes past eleven." I gave him some "Time" magazines and he said this morning that he read until 12:30 A.M. and then enjoyed a good night's sleep.

This morning he waited for the family to arise, and at 8:30 I sent him to the bathroom for his shave and shower. After a breakfast of soft boiled egg, cup and half of coffee and bread and marmalade, we enjoyed a chat about various matters, including how to make good coffee. He said the best he had was when they put it in an iron pot at camp and boiled it up well. After going thru my Colorado River matter for anything that might help the picture, he left for home at 12:49 as he had several letters to write today.

October 31

. . . The 27th was a dull, rainy, disagreeable day and when returning from the Acme office at 3 P.M. I decided to stop off for a short visit. The young lady at the desk's phone board called [Jackson] on the phone saying that there was a gentleman coming up to see him, but she did not mention the name. After stepping off the elevator at the 9th floor and turning a corner in the corridor, I was surprised to see Jackson standing there, outside his room door, waiting to greet the "gentleman." His expression indicated his pleasure at seeing me, and after a pleasant hand-shake and a little banter about the fact that I surprised him, we enjoyed a chat for about 20 minutes. Jackson said he was mighty glad to see me as he had been feeling lonesome and expressed the wish that I could remain with him for the balance of the afternoon and have dinner with him and a chat afterwards. He was well along on the picture of the King survey showing the party in camp. He said that he recently enjoyed a visit from an official of the National Park Dept; the first visit from any official since he had been taken on as an employee. This party remarked about the pictures Jackson had already completed, but Jackson in his usual conservative manner did not indicate whether the individual waxed

enthusiastic over the finished work. However, he did tell Jackson to take his time and not hurry the work, all of which is contrary to Jackson's belief of an honest day's work and he is frank to admit it, having several times remarked about the delay, lack of interest and squandering of funds by individuals in Govt employ. This party also remarked that they had been working a long time to put Jackson on the pay roll and indicated that the Park Dept. were pleased to have Jackson with them

November 2

In reply to my phone inquiry, Jackson replied that he expected "to be around" all afternoon and would await my call for lunch. Accordingly I arrived at his room about 12:30 as he was just finishing up some re-touching to the Powell–Grand Canyon picture. He said the Nat'l Park Dept. man who visited him recently suggested warming up the tone of the picture and Jackson was adding a little more color here and there, particularly to the walls and the plateau points in the distance, which that individual suggested be brightened up with more blues and purples— as the Park Dept. usually overdo all their paintings etc of the Canyon. Sometime ago Jackson told me that when he inquired at the Dept about purchasing supplies it was suggested to him that he requisition them. This took entirely too long to satisfy Jackson, hence he purchased most all his colors locally as he could get exactly what he wanted and when he wanted it. However they said they would pay for the materials and asked Jackson to request the dealers to send the bills to the Gov't which would eventually voucher them and the dealer could then refund the amount to Jackson, as he had already paid the bills. Jackson ridiculed such red tape. However, he did requisition some material and it eventually arrived a couple weeks later. He requested a small bottle of linseed oil—a few ounces only—but received a full quart which caused Jackson to laugh and remark that it was enough for three lifetimes. After chatting for about fifteen minutes we went to the Automat for our usual "stand up snack" then browsed in a near by book shop for about one-half hour.

Upon returning to his room we made some photos which Jackson desired—using his Kodak. He suggested the settings and exposures, and I did the snapping. It was my first experience with flash powder. We

used his flash pan—an old one which he has had about 20 years—set off by a trigger as the apparatus is held in the hand. Victor Flash Powder was used—and not an excess of smoke resulted. I took two of him, one at the King Survey picture and one at the Canyon picture. Then two more of the Canyon and Yellowstone picture full size; and then two of the room from each end. After that was done he showed me some prints—reductions—he had made from an 8 x 10 of him, taken by Bachrach in Washington, D.C. early this Spring at the time some newspaper man proposed to write up an article about him and mention his "Uncle Sam" lineage, but which article we never saw or heard about. It is a striking picture of Jackson and as he considers it one of the best and desired to make some for distribution among friends, he had a smaller negative made from it, but thought the result too dark and contrasty—altho I think it fine—and tonight he proposes to endeavor to print some more to his liking. He gave one to me inscribing it, "To Bonney, in memory of many happy hours spent together—and the ones to come."

I suggested that he ought to endeavor to get his diaries in print—and he agrees, and would like to find an interested party to do it. He said that Wilson of the Press of the Pioneers had spoken to him a few weeks ago about having his life written up, and had mentioned the individual to do it. Jackson wasn't certain whether the individual was Stanley Vestal, at any rate that name came into his mind.† He said the man was some well known writer from Denver. Hence, Jackson is waiting a little longer to hear again from Wilson, hoping something more might develop. A few weeks ago when Jackson mentioned this to me he expressed the thought that he felt the life story should be delayed until after his death, but I argued otherwise, saying that many things of importance would thus be lost; but that if a good writer did it now—a real historian could by questioning him obtain much of interest and importance—and I urged Jackson to go through with such a plan if at all possible

This started us on an interesting perusal of his old journals, the originals and copies—of his trip across the plains in 1866 and back in 1867.

†Stanley Vestal, a.k.a. Walter Campbell (1887–1957). Journalism professor at the University of Oklahoma for thirty years. Vestal penned many books and articles on the history of the West.

His original journal of '66 is in a small sheepskin book and the pencil writing is becoming smudged and faint. However, as soon as he returned in August '67 he rewrote the journal—also the '67 trip back, the original of which is in a larger journal, the pencil writing being better preserved and very slightly smudged, with many sketches of hills, some individuals, guns etc. of the times—in a large book about 8 x 12. This is in ink and was written about a month after his return in '67. He used his original diaries as a basis, but has in some places made extensive changes and additions—which are most easily found upon checking the two journals, as I found when he read one and I the other—based upon his memory of many incidents which were still quite vivid in his mind but which because of lack of time or for some other reason he failed to make note of at the time of happening. In fact, he said he didn't quite understand how he had managed to get so much written in his original journals when he looked back and realized how busy he was and with so little time for writing in his journals and sketching because of either rising very early or retiring very late depending on when camp was broken or eventually made at night—and all this in addition to his duties as a cook at times. He also has a typewritten copy of the journals, made up in later years with many typographical and other changes, but with pencil interlineations to make it conform to the wording of the original journals. He agreed that it would be best to publish the original journals in their exact wording, and then add footnotes to cover all changes and additions.††

After reading various parts of the 1866–67 journals, he got out his typewritten and illustrated—with his photos made at the time—copy of his trip, across Siberia (and Manchuria) in the winter of 1895. He read many pages to me and we enjoyed several laughs, particularly during that part which describes a meal of about 14 courses, which Jackson listed in detail, and of about 10 more courses which Jackson lost accurate note of because of the wines and hilarity. He contemplates making

††Jackson's original diaries for 1866 and 1867, 1873, and 1874 finally came to publication in LeRoy Hafen and Ann Hafen, *The Diaries of William Henry Jackson* (Glendale, Calif.: Arthur H. Clark Company, 1959). Jackson had proposed such a work to Hafen in 1938. Jackson to Hafen, September 12, 1938, Collection 1643:32, CHS.

some slides and working up a short lecture for some Sunday night at the Demings. He sure does plan for the future! . . .

Earlier in the afternoon, when we were discussing his paintings, he said he was somewhat handicapped because he could not get the small details accurate enough to suit him. When he is working with water colors, he has one hand free to manipulate a large reading glass and thus get in small details correctly, but when painting with oil colors, both hands are fully occupied with brushes, palette, stick, etc, and nothing but some sort of flexible extension arm would be practicable.

He then got out, from among many others, a painting he had made years ago of a gateway at the City of Suva (?) in Algiers, depicting natives on foot and upon camels. He remarked that he could not get details such as in that picture, in his work today; and it is of course apparent that the accuracy of his present work is not so good as formerly—but still mighty fine for his age! . . .

And so I left him—he planning for work years ahead, and I in doubt whether I can arrange to visit him next week!

November 20

Last evening Jackson and I finally got together again, and of course, my recent cold was a topic for discussion. Jackson has never been ill in bed a day in his life, and very rarely physically indisposed at any time, altho for a short time last Spring he was troubled by a mean little throat cold He then said that recently, that is, during the past few years, that he was going to the doctor for physical examinations every three or four months, but that at each time it was the same story: nothing irregular with the heart or other vital organs—and the usual bill for $10.00 at each visit.

We then devoted our time to a criticism of some of Mr. Jackson's oils, chiefly the Powell–Grand Canyon picture, and the King Survey Party. Jackson is astonished at the various effects the change of light has on the Canyon picture, saying that at some times of the day the effects are radically different from those at other times and at night under artificial light. We concluded that the two boats shown in the picture are too small, and later he will enlarge them especially in length. The King survey picture is almost completed. He has even taken so much care to

see that there are only 38 stars in the field of the flag and he endeavored to show them clearly. However, he did make one bad slip—and that was with his rest stick. Two large spots in the sky, each about 10 inches square, and a couple of smaller ones were badly marred while the paint was wet, having numerous deep marks in the dried paint. Of course, he can repair the damage easily, in fact, he says he likes to go over the entire picture again to thicken the paint. He attributes the trouble to the fact that he cannot see details very well without getting close or using his reading glass, hence, continual moving about with the hands more than usually full with glass, stick, pallette etc. resulted in the marring

We went out to dinner a few minutes before 7 P.M. I ate fried oysters which raised hell with me during the night, but I presume Jackson fared well on his roast veal, it being the only thing on a pretty complete Childs menu which appealed to him—and he topped it off with an orange marshmallow sundae! During the meal he remarked about Rufus Choates recent plaint in the newspapers about retailers asking such high prices for wine when it should be so low, and remarked that he could enjoy a big glass of wine with his dinner anytime.

We returned to his room and when going over some papers he came across a recent Sunday gravure section showing several Arab horses, which sheet he was saving to give to Deming. This started Jackson on reminiscing and he lamented the fact that he did not have a camera with him when returning from California with horses in the Spring of 1867 as he at that time witnessed a very interesting fight between two large black stallions. He said he rarely has seen anything in print about such fights and doesn't recall seeing any picture depicting such action, and then he told me the story. He said as they were leaving Los Angeles, that is they were somewhere outside and I believe the date was April 14th, 1867, they passed the herd of wild horses out of which the leader, a large black stallion, came over and circled the pack Jackson was driving, apparently looking for some females he could cut out and run in with his own wild herd. The leader of the pack Jackson was driving was also a large black stallion which showed fight and the two approached one another. After a little pawing of earth and snorting, they reared on hind legs, each throwing his front legs over the shoulders of the other encircling the necks and biting the manes. He said that at times each seemed to have

the advantage and when referring to his diary he found that they finally had to corral the horses and rope the wild stallion and chase him off. His diary does not contain any details of the fight, but he says he clearly recollects them and that they are substantially as related above.

We then got to discussing the Southwest, and as I had just finished Lummis' "Some Strange Corners of Our Country" and was now reading "The Land of Poco Tiempo" I asked him to again show me the Lummis items which he had shown to me a year or so ago. He got out an interesting letter from Lummis to him written in 1925 after Jackson's visit with Lummis and several photos taken at El Alisal and presented to Jackson in July 1927, also a few autographed cards‡

November 30

Arrived at Jackson's room at 12:30 He was busy painting but stopped long enough to greet me and say that the latch string was always out for me. He was just very roughly painting in the large group of figures which will be the main feature of his Wheeler Survey oil painting.

We chatted about a great many things, in fact, so many that it was not until almost 2 P.M. that we headed for the Automat and the "stand up" snack. I told Jackson of a picture, made by the Detroit Photographic Co. which I saw in a yard office at the Lackawanna Steel Co. plant at Buffalo on Nov. 22nd. His memory certainly is vivid for he at once told me how long the picture was and the general composition. He said he had been working in Denver when he was instructed to go to the Bar H (?) Ranch in the Panhandle of Texas, owned by some woman, where there was to be a big round up especially for picture taking purposes. He said the picture really is three separate shots—one as the cattle were coming in, another as they were close to the camera, and the third after they had driven them over to drink from the creek on the left. He said that in taking one picture, it was necessary that he place the camera high over the gate on the swing-bar, he standing on the fence and leaning way over to operate the camera. The cowboy warned him

‡Charles F. Lummis (1859–1928). Editor, author, explorer, ethnologist; friend and correspondent of Jackson.

that if his black cloth waved in the wind it would frighten the cattle and they would stampede back on them (the cowboys)—hence, if such a thing happened they said they would shoot Jackson right off his perch. Jackson had a great laugh telling me about it. He said he carefully gathered his cloth tightly in his hands and altho he feared the clicking of the shutter might frighten the cattle, he said all went off quietly, even tho there were a few cattle directly under the camera.

He said that at Fryxell's† request he had made a water color copy of his Holmes Mt. of the Holy Cross and found it a harder job than he had anticipated. The first sketch he discarded, and had [deposited it] in the corner refuse file, but I urged him to keep it and try working it over which he will do sometime. He said Holmes' picture was painted on a tinted paper, which tint showed through at some spots and made it difficult to copy. Holmes' picture—given to Jackson as a wedding present—is very fine and follows Jackson's photo closely so far as the Mt. itself is concerned, but the foreground was improvised by Holmes.††

Again we discussed the Powell Survey picture. Jackson's not satisfied with his work as respects the character and color of the canyon walls. He might discard the entire background and work in something else. The Survey people at Washington sent up four photos showing canyon views from Grand View and Desert View (Navajo Point).

. . .We chatted some more about the canyon walls' color and character, looked over some current periodicals and then I read several more letters from Lummis, which Jackson had recently found in his files.

And so home to bed at 9:30.

†Fritiof M. Fryxell (1900–1987). Author, editor, professor of geology at Augustana College in Rock Island, Illinois; geologist for the National Park Service, 1929–39. He worked for the U.S. Geological Survey between 1946 and 1966. Fryxell sometimes appeared with Jackson on the speakers' platform during ceremonial occasions, such as the Grand Teton National Park dedication in 1929, when other speakers included Jackson's friends Horace M. Albright and Grace Raymond Hebard. D. W. Greenburg, "The Grand Teton Park Dedication a Historic Epic," *Annals of Wyoming* 6:3 (January 1930), 270–3.

††William H. Holmes (1847–1933). Anthropologist, archaeologist, geologist, painter. Curator of the Smithsonian's National Gallery of Art at age eighty, Holmes had been a friend of Jackson since their days with the Hayden expedition in 1873. As Jackson was photographing the Mount of the Holy Cross, Holmes accompa-

1936

I have been lax, lazy—and busy. Have visited Jackson several times
since Nov. 30, 1935. He visited me early in December, and with Dora
we went to Nutley to see some amateur movies of the western parks.
They weren't so bad—but not so good either, but Jackson "warmed up"
to the occasion and enjoyed those of Yellowstone Park and surprised me
by becoming quite talkative about Yellowstone and his experiences there.
I was pleased, of course, for I think Jackson is entirely too reticent about
his experiences

A short visit the day before Christmas resulted in a stroll and a long
chat afterwards while devouring some oranges his friend Bretney had
sent up to him. Jackson loaded me with fruit and nuts before I came
home, so the girls had something, too.

On Jan. 4th he wished me to accompany him to a photographic ex-
hibit at Radio City, but we found that it had closed, hence we crossed
the street and enjoyed the paintings in the Grand Central Art Galleries,
after which we strolled down the Avenue taking in the sights in windows
and otherwise. Jackson again commented that he wished he could find
a club in New York into which he could stroll when he had time and find
all the leading current magazines on the table. He still bewails the fact
that his reading is desultory and that he must get out more substantial
stuff

On Jan. 11, I again enjoyed a visit. After our usual "stand up" snack
at the Automat we took a stroll. Jackson asked me whether I noticed
the type of people at the tables in the Automat and then explained that

(continued from previous page)
nied Hayden on the mountain itself. Later, he painted the mountain based on
Jackson's photographs. A gift of the picture would be timely for Jackson's second
marriage, on October 8, 1873. Now Jackson copied Holmes and sent the water-
color to F. M. Fryxell. When Fryxell asked him to price it, he suggested ten
dollars. Jackson to Fryxell, November 28, 1935, box 29, F. M. Fryxell Collec-
tion, AHC.

his reason for not sitting at the tables was because he did not like the type of people. It is true that many are Jews or other undesirable types, but then there were some other folks that looked OK to me.‡ Anyhow, now I know why we always stand. As it was late when we went to lunch, we decided there was not sufficient time to go to the American Museum of Natural History, so we paid a visit to Demings. After a chat there for three-quarters of an hour, we returned to his room to eat some apples the Demings had given to us. We had no sooner entered than Jackson said a little snorter ought to settle our lunch and although I protested some, wanting my apple first, he said the apple would set on top the Scotch. He got out the Black & White (MacDonald's—from Barber) and we "killed" one toasting "The first today."

I often, too often, wish I could full and properly record much of our conversation to show his wit, and his keen interest in past historical matters, as well as in present, and current affairs. He gets the same kick out of Ding's (J. N. Darling) cartoons in the Herald Tribune as I do, and also saves lots of them, as I do; he enjoys a good joke, or a good story; he is disgusted with the rotteness of politics and ridicules the Townsend Plan to give the old folks $200.00 monthly,† he ridicules the New Deal policies (although I remind him to be careful as he is drawing WPA money for painting pictures for the National Museums). An official was down from the Morristown headquarters a few days ago—the first visit he has had from anyone to inspect the work he is doing—and looked over the four pictures Jackson has about completed. Jackson's reply to my inquiry indicated that his work was not warmly praised, but so far as I could determine, satisfactory. Of course, he was given no instructions, or suggestions, except to depict the four survey parties—Hayden,

‡Jackson appears to be anti-Semitic in this passage, or Bonney's perception makes it so. Compare diary entry for May 31, 1935.

†Dr. Francis E. Townsend in 1933 had proposed a $200-per-month pension plan, with few conditions, for all citizens over the age of sixty, to help fight the Depression while aiding the elderly. By 1936, about half the American population favored the plan. President Roosevelt, however, preempted the public appeal of Townsend by pushing for the Social Security Act and signing it into law in August 1935. Robert S. McElvaine, *The Great Depression* (New York: Times Books, 1984), 241–57.

Powell, King and Wheeler—and he did it as he thought best, sticking to historical accuracies (except the anachronisms of 1871 . . . and showing Langford who was not with the 1871 party) by following photographs or from actual knowledge of the ground, particularly in the Yellowstone picture. He has retouched that one, brightening up the hills in the background and reducing the strong blues he had in the sky. He says he thinks it the best of the four. He asked for more work, and was assigned to prepare three small water colors to accompany other paintings being done by other artists. One of these is to depict a miner panning gold by a stream and being confronted by a couple ruffians with guns intent upon jumping his claim. Jackson is going to criticize this suggestion because he says that when a man had already staked out a claim, he didn't work with a pan, but immediately built a sluice to recover gold in volume instead of panning out a shovel full at a time, which would be very slow and laborious labor to work out a claim. He says panning was only done when prospecting and ruffians couldn't jump a claim if the man had none, and was only prospecting. This seems to be logical, but apparently the generally accepted view, as depicted by artists, or most of them, is that most all gold was panned. Most pictures I recall seeing were panning operations, not sluicing, probably because the former is more romantic.

Another picture is to be an Indian Treaty scene—and another a wagon train going west. He has started this last mentioned one and his sketch (in water color), about one-third completed, is a beauty. It depicts in the foreground a four ox team, with man on horseback, one on foot driving, with wife and child on foot, and a mother on the wagon

He recently sold some pictures, paintings and photographs to a German, Rudolph E. Proshopp, who is writing a book on the beet sugar industry and to illustrate it will use some of them and has asked Mr. Jackson to make a special one showing the Mormons coming down Echo Canyon with some cumbersome machinery on their wagons††

When we went [to] Deming's apartment he immediately started show-

††Very likely the German was Emanuel Ritter von Proskowetz, a figure in the European sugar industry. See Truman G. Palmer, *Translations from European Sugar Journals,* issues of 1911–12 and 1913 (Washington, D.C.: United States Beet Sugar Industry, 1914).

ing us some old paintings he has resurrected, paintings very dirty and terribly banged up at the corners, which he made years ago, one or two of ponies he rode or rode by well known Indians, some scenes of western country etc. etc. Deming says they are "invaluable" but the way they lay around, the way they are handled, and their condition hardly indicates an "invaluable" condition. Of course, we admired them but such admiration was brief because it had been the "teenth" time we have seen them and heard about them. The same goes for several old photographs he exhibited at the same time. As we were leaving, Deming showed us several large water colors he made for the usual New Years Eve party—and they were not "so hot." . . . On New Years Eve Deming always throws a big party (or at least the family joins in some way, altho who pays the bills I don't know). I haven't gone the past few years but Jackson said almost everyone was dressed in evening clothes—and yet he hasn't $4.00 for the Explorers Club dinner, and none of his friends who put on the dog apparently give the matter a thought or give the old man a lift in the way of a free ticket. Such is life. He struggles on, always hoping, confident that he can get good money for his paintings, only a few of these left being worth anything, and these he can't sell because his price is too high: a few, very few, may be worth $500.00, some at $100 to $200, and perhaps one at $800–$1000.00. His water colors at $35.00 are worse and worse, but they are confident, and Mrs. Deming bolsters him up.‡

. . . Just before I left Jackson, he showed to me a little translation (similar to a "pony" of Cicero's "Old Age and Friendship") which he has been reading, indicating that he is getting away from some of his "desultory" reading.

‡Bonney's observations on Deming's work sadly contrast with an earlier article in the *Christian Science Monitor*, March 20, 1931: "As a painter and sculptor Mr. Deming's work is unusual in that it contains none of the conventional earmarks of having been done by a white man, so true, experts say, are his paintings and sculptures to the Indian viewpoint. Frederic Remington, noted painter of the West, once remarked, 'Deming, you paint the Indian from under his blanket; I paint him through a rifle sight.' Mr. Deming did a group of paintings of Indian life that are eventually to be in the National Gallery at Washington. They are now in the Museum of Natural History in New York." The recipient of multiple professional honors, Deming had displayed his work in well-known institutions around the country. *Who's Who in America* (1936–37), 712.

January 18

I was busy at the office until 3 P.M., but then went up to enjoy the usual Saturday afternoon chat with Jackson before going to the Adventurers' Club Dinner.

. . . I gave him two issues of the National Geographic to complete his file, also a clipping taken from the English Speaking Union Journal about an old Englishman who married three times after passing the age of 100 years. This latter matter tickled Jackson, we had a good laugh, agreeing that there was still hope for Jackson, and he put the clipping away for his files. I also loaned to him my bound first volume of the Pony Express Courier.†

As Laboy had asked me over the telephone a few days ago what Jackson was asking for his water colors, I raised the question with Jackson and he suggested giving to him one of his so-called rejects. We finally picked out one—a scene of a wagon train going down in the valley near Chimney Rock, similar to mine but not quite so finished in details and not quite so large, but held a few feet from the eye there was something rather striking in the composition and colors Jackson inscribed it: "To Merle Laboy, My Pal of Happy Days at the Explorers Club—Wm. H. Jackson 1–18–36."†† . . .

Jackson told me that he had visited on the 17th the Morristown, N.J. headquarters of the Park Service, and enjoyed the treatment the fellows gave him, showing him around the work rooms, also the Jockey Hollow Park. Jackson said there were many men around the work rooms, but none seemed to be doing much, and there were few signs of much activity otherwise, either in painting or models. He said that from what he

†*The Pony Express Courier,* a periodical out of Placerville, California, appeared from June 1934 to April 1944. It featured book reviews, pioneer diaries, mining stories, and, of course, all the history it could dig up of the Russell, Majors, and Waddell enterprise. Jackson, as an illustrator of the Pony Express, would be much interested in the contents.

††Merl Lavoy (1886–1953), as the correct spelling seems to be; labeled the "modern Marco Polo" for his world travels. "A former Pathe News cameraman, he went to France to film World War I and later roved the continent. His South Sea islands documentary films attracted wide attention." *New York Times,* December 9, 1953.

saw he would not be afraid to put his work up against any of it. He observed one painting of Boulder Dam being done by an artist who apparently knew very little about it because he had shown the rocks as being colored yellow with dashes of pink! (Perhaps the whole thing is to be done over with a dark color later to get the real tones of the Black Canyon—at least I hope so!) Jackson said there was a model of the Dam near by, ready for painting, and this Jackson said depicted the walls, by the plaster used in modeling them, at about the color they really are.

Jackson's observations of the work done, or being done, or the lack of it, and labors towards producing any, seems to reveal the reasons for earlier instructions to him from the Park Service people not to hurry, not to rush, but to take his time. He has already completed four large oil paintings about 30" x 60", and two of the small water colors they asked him one week ago to prepare. Meanwhile, he has carried on his usual correspondence, made pictures for others as a sort of diversion, and hasn't missed a party or any other affair.

January 26

Instead of our usual Saturday afternoon visit in NY City, this week-end get together was in East Orange—and Jackson was the guest of Jimmy Walters, who on Saturday evening gave a lecture on color photography at the Orange Camera Club. As a result of Jackson's letter of Jan. 23rd, I telephoned to him not to hurry, but to plan to be at the Club at about 8 P.M. giving him specific instructions about stations etc We were a little worried when he failed to show up on time, and more so, when he had not yet arrived after 9 P.M. However at 9:30 he put in appearance, as chipper and gay as ever, if not a bit more so. He had gotten off at Orange, and knew he was lost because he couldn't find the large concrete pillars supporting the tracks at the East Orange & Brick Church stations. He said he did a lot of walking around, and eventually found a taxi-cab—and convinced the driver that he must go west, and not east—from that depot! Finally a policeman directed them—and Jackson arrived with his usual smile saying that as he had gotten as far as Orange, he decided to "see it through" and find the Camera Club (at Main & Clinton Sts.). He returned home with Jimmy about 11:30 P.M.—and today I learned that they sat up and chatted until 1 A.M.

Jackson has the faculty of making himself contented and comfortably at home, whether in a strange bed or not, and as a result of this, did the unusual (for him) thing of oversleeping. They called him at 9 A.M.! When he visited me a year or so ago, he was up at 7 A.M. and he had his cold shower before anyone else had arisen! After he and Jimmy took a ride around the country, they called at 82 Harrison and chatted for an hour or more, then to camera club to get our equipment, back to Jimmy's to get Jackson's bag and we put him on the train at 3:49.

Jackson appeared to be in great shape. The women commented about his youthful appearance, snappy dress and chipper disposition. We chatted and "kidded" him about the blonde he was hurrying home to see, also about being employed by the "New Dealers" painting pictures, and he joined in with many hearty laughs

February 1

. . . [Today] I found him taking life easy enjoying the NY Herald-Tribune. We chatted for a few moments about the King Survey oil painting which Jackson has been touching up, and in some respects changed, before we went for lunch. Jackson has changed the grouping of King, Emerson and others and now shows four men at the table in front of the headquarters tent. By following an old photograph of the men, showing three in a group at a table (a studio portrait) he has now just King behind the table, standing beside another party Jackson has touched up the foreground and background, also the sky. He commented about the fact that he seemed unable to get the ethereal appearance in the distant mountains and lays the fault to his eyes which he realizes are failing him slowly. He also showed to me the finished water color of the Indian Treaty, and the Covered Wagon going west—this last one being a perfect beauty! He has also finished the black & white of three ruffians jumping a claim of two miners at a sluice box.

After lunch . . . we went to the Woolworth 10¢ Store as he wanted to get some shoestrings. We found later that he had misjudged the length, getting 24 inches instead of 27 inch—and altho he wears low cut shoes, his ankles are very large and the shoes do not close sufficiently to reach the edges of the tongue. He made the 24 inch ones do the job by skipping some of the lacing holes.

While in the store Jackson said there was something else he wanted to see and asked me to follow him. He led me to the glassware counter and picked up two small glasses, each being clear, uncolored glass about 2½ inches tall and about 2 to 2½ inches across at the greatest diameter, the glasses being almost ball-shape with heavy round bottoms so that when topped over, they immediately right themselves. They appeal to him because they are much like a small, amber colored Russian glass he has. He originally had two, each with a Russian inscription around the top edge, which he acquired in Russia when he made the world tour. The one has disappeared, probably lost or stolen, the other he still has but is bound together with transparent tape, having knocked it on the floor sometime ago and badly breaking it. These white and new ones help him to recollect the real Russian one and presumably the good times he had when he acquired them. Later in the afternoon before we went to Gimbles, he suggested a "snorter" of Scotch to christen them and so we clinked glasses and enjoyed a short, snappy swallow with the "first one today."

I did not get over to visit Deming as our conversation proved too interesting to break off. I have been encouraging Jackson to write an article or two for the Pony Express Courier and I believe he eventually will, using particularly that part of his diaries relating to his experiences from Salt Lake City to Los Angeles in 1866–67 and his return with horses in 1867. He said Mr. Wilson of the Pioneer Press had mentioned to him a couple of times about publishing his story, but not much progress has been made to date so far as Jackson knows.

Meanwhile, Dr. Driggs, who has just about completed his manuscript about the annexation of Texas which will be published by Stokes and which Driggs wants Jackson to illustrate but Jackson says it is out of his line and urges Driggs to give the work to Deming,‡ proposes writing up Jackson's story and publishing it Of course Jackson has all of his original diaries and copies of some of them. His original western diaries commence on April 14, 1866 at Burlington, Vermont, when he decided to leave the state after his girl had "thrown him over," and continue

‡The book became Howard R. Driggs and Sarah S. King, *Rise of the Lone Star* (New York: Frederick A. Stokes Company, 1936), "illustrated in color and black-and-white by Edwin W. Deming."

through to August 7, 1867 when he arrived back at Omaha by rail with the horses from Cheyenne, the western terminus of the railroad at the time.† Having plenty of time on his hands after his return, he decided to rewrite the diaries which are in small various sized volumes, and commenced the re-writing on September 28, 1867 in a journal size volume, the diaries covering 271 pages, each about 8 x 14 inches. When re-writing these diaries, Jackson did some editing and cut out a little irrelevant material or condensed it and in other cases enlarged upon his original diaries by inserting some recollections still fresh in his mind after so short a time after his return, all of these additions being matters which because of rush and work he had failed to put in the original diaries. It should be remembered—and Jackson has commented to me several times about it—that he was busy from before sun rise until long after sunset, and he was compelled to do most of his sketching by stopping along the road, making a sketch, and then running to catch up with his team. Jackson often said to me that he can't figure out now just how he found so much time to sketch and write as he did. From time to time he is making notes and getting his material in better shape, hoping that some day he can get everything in ship-shape. He is always planning ahead and from all he says looks ahead to the future more as a man of 50 years than as a man of 93—his next anniversary being the 93rd in April 1936.

After discussing his diaries for a while, we got to discussing scrap books and he got out a few of his containing very early clippings of his first days in Denver, articles by him, about him, or about events in which he was interested

As I wished to buy a new felt hat and Jackson wished to buy a cordial to take over to Brooklyn tomorrow, where he will have dinner with his son to celebrate the latter's birthday anniversary, we walked up to Gimbles. Jackson purchased a cute, little bottle of apricot cordial and I bought a Stetson featherweight. As we got off the elevator, Jackson stopped me and slyly remarked about looking at the books while we were there, he knowing my interest, and weakness! We browsed for

†The horses, trail-driven from California, were loaded into rail cars at Julesburg, Colorado Territory, the railroad having not yet reached Cheyenne. Jackson's group arrived by rail in Omaha on August 2, according to his diary for that date.

about half an hour, Jackson purchasing a copy of Plutarch's Lives and altho I was sorely tempted I finally dragged myself out without acquiring a book, leaving Jackson at the Hudson Tube entrance, agreeing to meet him some night next week when convenient

February 5

In accordance with arrangements made yesterday, Mr. John White, the "Lonesome Cowboy" over the radio for the past several years and a close friend of Miss Liddy of the office, and I called on Jackson at about 6 P.M.†† Mr. White, having heard much about Jackson from Miss Liddy, was desirous of meeting Jackson, so the talk immediately turned to Jackson's experiences in the early days and the paintings he is now working on [Later] Jackson got out his original 1866 diaries and the "Omaha edition" of it and read many passages to us. From there on until after 11 P.M. when we departed for home, we were continually on our feet. I endeavored a couple of times to get Jackson to sit down and once I heard White remark in a low voice that he would like to sit down— but there was nothing doing in that way and Jackson and we were on our feet more than two hours as he read and hopped around like a rabbit digging out old photos, diaries, etc. etc.

One passage Jackson read told of his efforts one night during 1866 on the plains to play on his flageolet the tune "The Year of Jubilo" (perhaps, now better known as "Kingdom Comin"), by Henry Clay Work, an old Civil War tune. Jackson turned to the back flyleaf of his original 1866 diary, showing us the notes.‡ I suggested to White that he hum the tune, but he said he would sing the song. He did. While White sang several verses, Jackson stood silently by, his gaze towards the floor, but his smile was something to look at. I don't believe I ever saw him look

††John I. White (1902–1992). Entertainer by avocation, who performed cowboy and western songs on "Death Valley Days," a weekly radio show, for some six years beginning in 1930.

‡The 1862 words and music for "Kingdom Coming" appear in Henry Clay Work, *Songs* (New York: Da Capo Press, 1974). Jackson's 1866 diary rendition of several bars from the song, though not exact, closely resembles the original score. Box 3, Collection 341, CHS.

any happier. He grinned from ear to ear—a wonderful smile, and occasionally he would shake his head slightly or murmur a word of approval, or make a movement indicating he was keeping time with the singing. When White finished, Jackson said there was nothing finer to bring back the recollections of the old days, and that he had not heard the tune since 1866!

Jackson then read more out of his diaries and told us a lot not in them but which he recollected as he read them. One interesting time was on Sat. June 23, 1866 when he and his pal were broke in Omaha. They wanted a place to sleep, so sought the Railroad Station and curled up on the benches. The station agent awoke them just after the midnight train had left, so in disgust they said they would wait for the next one. At 3:30 in the morning the agent again wakened them to catch a train at that time but somehow they managed to "miss" that train also. Next morning they gave a "bar-keep" a spare shirt in exchange for coffee and rolls.

Jackson also told us in detail about yoking up the oxen saying it was quite a trick, especially for the beginners, and at the start usually took all the morning before the train was ready to move, but that they all improved greatly later and were off at sunrise. He said some days they drove from early morning until late in the evening, one time until 2 in the morning, but that generally they coralled before sunset and also had a hour or two of rest during mid-day. He told us quite vividly of being awakened before sunrise by the resounding and loud crack of the horse's whip at the canvas side of the wagon and his yell that "the bulls are coming" and they quickly got into their clothes as the fractious animals came snorting into the corral in none too good humor; and how he took a yoke in one hand, a bow in the other, and the pins in his mouth, and after finding one animal and securely yoking him—the bow being held by a pin in only one side of the bow above the yoke—he then dragged the animal around until he found the mate. These were then chained to the wagon and he then had to hunt up his lead oxen and the others, finally getting them all in proper order and chained to the wagon. He said it was quite a trick to get the teams all lined up without undue tangling of them with others and the wagons. Jackson also showed White his Civil War diaries—and the several small sketches he made at

that time and sent home to family & friends from whom he later collected them—some of the first postcards—even tho they were "home made."

Before leaving, I suggested to White that he sing a few more verses of "The Year of Jubilo." It so pleased Jackson that he clapped his hands in joy. Oh, but it was good to see him so happy! He then suggested another short "snorter" which we toasted as the "second one today" and hurried away to catch our trains.

Jackson gave White a photograph showing him painting the "King Survey in Carson Valley in 1869"—autographing the back of the photograph

February 8

. . . Jackson and I got on the subject of painting. He is now doing a water color to present to a Mormon Elder at Salt Lake City who helped in the Pony Express Celebration last summer. It will show an ox-freight team passing Chimney Rock. Jackson had completed one showing a train in corral [formation] at the Rock but had gotten the tone too harsh and so he started another in more subdued tones.† He is also working on an oil painting about 15" x 20", showing a freight train passing Scotts Bluff. He is making it for himself, saying he always wanted one depicting the scene in subdued tones when the sun was so low there was little color except on the top of the Bluff and the sky in the east.††

After a short chat we went to the Automat for lunch, Jackson taking a cup of coffee and a piece of lemon meringue pie, with a heavy meringue top. He asked what we should do this afternoon and then sug-

†Chimney Rock (now a national historic site), a lone promontory of some 325 feet, stands just south of the North Platte River in western Nebraska. Many wagon-train emigrants along the Oregon-California Trail commented in their diaries about the unusual landmark. Over time, Jackson made at least six paintings illustrating pioneer activity in the area. Merrill J. Mattes, *The Great Platte River Road* (Lincoln: University of Nebraska Press, 1969), 378–420.

††Jackson rendered no fewer than four paintings, with slightly variant details, of a wagon train threading Mitchell Pass at the foot of Scotts Bluff along the route of the Oregon-California Trail. He himself got his ox-team and dual wagons through the pass in a difficult crossing in 1866.

gested that we go up to the Bronx Zoo and see the "Sinful Maverick," ‡ and perhaps we could persuade him to come down to the Adventurers' Club Meeting next Saturday night. Although it is warm enough in the sun, it is still pretty cold in the shade, and having this in mind I commented about the weather. Jackson thought it would be agreeable enough, but the walk over to the Seventh Ave. Subway was a chilly one, and after we got on the platform he apparently had a change of mind for he suggested that as it was two o'clock, perhaps we had better make the trip some other time and start earlier. I agreed, but as we were already on the train I suggested we go to Macy's to look over books—as Jackson had told me that he had seen C. M. Russell's "Good Medicine" there in a nice format for a few dollars, saying that Barber had gotten several to present to friends. None of the clerks knew anything about the book and all I asked directed me to the counter handling medical books!† The book section was crowded and seeing very little could be accomplished, we left in disgust and went to Gimbles. There the crowd was less, but inquiry resulted in being told that the book was out of print. We then strolled into Willoughby's Photo Store and browsed a bit until Jackson suggested that we stroll around to Barber's Apt. and get the information. Barber was preparing to leave, but chatted awhile showing us a copy of the book and telling us it could be obtained at any Doubleday Doran book store for $3.79 While visiting Barber, Jackson remarked about the pleasant visit of White and the song. Barber said he had a record of the song and would play it on the Victrola when Jackson came again.

We then called at the Demings, and were greeted by Mrs. and the Capt. We chatted about the picture Deming is painting for Driggs' new

‡"Sinful Maverick" is a nickname proudly adopted by Martin S. Garretson. The moniker, written large, adorns his letterheads. Old West enthusiasts of the day and members of OTMA addressed each other by such in-group appellations. Jackson, for example, became "Mustang Jack"; LeRoy Hafen, Colorado state historian, was "Pikes Peak Roy"; and his wife, Ann, "Denver Annie"; other ladies included "Skyline Kate" and "Navajo Nell"; Walter Meacham, OTMA promoter in the Northwest, signed "Oregon Walt." Collection 1643:94, CHS; Walter E. Meacham Papers, passim, Special Collections, University of Oregon Library.

†Charles M. Russell's *Good Medicine* (Garden City, New York: Doubleday, 1930) is a collection of the artist's light-hearted letters and illustrations.

book about Texas and then Capt. told us about Buffalo Bill, and how he once asked Deming to take a "cousin" back to NY from some place in Connecticut. The "cousin" and another flashy friend later called at the Deming home and invited Deming to a tea, "if Mrs. Deming would permit." She said she consented, but the Capt. evidently got cold feet and the day he was to go to the tea he hid so that no one could find him—and Mrs. Deming still has her husband

February 15
Visited Jackson—and as usual we chatted about so many things I've forgotten most of them. The picture [mentioned earlier]—an oil painting of an ox team at Scotts Bluff at twilight—he has presented to the National Park Museum people, inasmuch as he made it on their time (so he says) while waiting for assignments of additional works. It's a dandy—and I presume they are glad to have it—I know I wouldn't hesitate a bit about accepting it.

We later walked over to the Doubleday-Doran Bookshop in the Penna. R.R. Station and he purchased a copy of Well's [H. G. Wells's] "Outline of History"—and I got a copy of Russell's "Good Medicine." Then we returned to his room and admired our purchases, both agreeing that Russell's book is a dandy. After resting a bit, he suggested a "snorter" and then we left for the Adventurers' meeting. During a friendly drink some reference was made to "Uncle Sam" and I told a few of the boys about Jackson's ancestors. Jackson said he had never seen the promised newspaper article about "Uncle Sam" and himself—and presumably nothing has yet been published

February 27
Dora and Mrs. Bache went to Town Hall to listen to symposium about New Deal—Mrs. F. D. Roosevelt presiding. It was a night off for me, but I couldn't get Jackson on the phone and he wasn't at his hotel when I called at 6 P.M. I went around to the bookstore on 5th Ave. just south of 28th St. and admired several volumes I wanted, but left without making a purchase, going up to Childs near 30th St. hoping I might find Jackson there. I was disappointed, but sat down to eat—and while waiting for a waitress I heard a familiar voice and there stood Jackson. A

waitress to whom I spoke remembered that Jackson and I were "pals" and when he sat at another table she told him I was there. He had been up to the Explorers Club for a short visit and was just returning. After the meal I coaxed him into the bookstore again—and he having my weakness, went along without argument. I found several volumes I wanted and he agreed to let me keep them in his room for the time being, so that I could take home one or two volumes as convenient Jackson said he would have lots of fun looking them over—and we tucked the box-full under his bed.

He is now making for the Museum, 2 water colors of Civil War scenes showing Grant at or around Vicksburg. This is a new subject for him—and he is not quite so enthusiastic about them. He said he thought he preferred working in water colors, but now is of opinion that he much prefers oils, as they readily permit of going back and working over. He said he thought the Scotts Bluff oil which he gave to the Museum people was one of his best and he was quite pleased with the results He proposes to make a small one for a gift to some friends recently married. He showed me about 40 or 50 prints of water colors sent to him by C. P. Russell, Chief of Museum Division of the Park Service, on Feb. 25, which Russell thought might be of interest. The paintings were made by a Baltimore artist named Miller and were of the fur trade in Missouri and made in 1837. Russell said he had a copy of Miller's field notes.†† Jackson doesn't think the pictures good at all! He said they were too

††Alfred Jacob Miller (1810–74). Miller was operating a portrait studio in New Orleans when Sir William Drummond Stewart hired him as artist for the 1837 trip Drummond was to make along the future Oregon Trail to the American Fur Company rendezvous on the Green River. Thereby, Miller became the only contemporary to paint the mountain man/fur trapper and to leave us the only contemporary paintings of old Fort Laramie (then Fort William). In romantic images, Miller also captured the vanishing life of Blackfeet, Sioux, Crow, and Pawnee. His work lingered in obscurity until Mae Reed Porter discovered some one hundred watercolors in the Peale Museum, Baltimore, which prompted an increased interest on the part of scholars and the public. Now, Miller is ranked as one of three great painters of the American West in the 1830s, along with George Catlin and Karl Bodmer. Bernard DeVoto, *Across the Wide Missouri* (Boston: Houghton Mifflin Company, 1975), ix–xii; William H. Goetzmann and William N. Goetzmann, *The West of the Imagination* (New York: W. W. Norton & Company, 1986), 58–68.

idealistic and are the style of those illustrating Cooper's tales. There were several duplicates and it appeared that most of them were first sketches and others studies sketched later, as some showed much more detail We chatted more—he suggested a drink, smacked his lips afterwards, saying "Enough to cheer, but not to inebriate," and so home to bed.

February 29

Arrived at Jackson's room a little after 1 P.M. and found him cheerily responsive to my knock, and upon opening the door saw him comfortably seated with his nose in Plutarch's "Lives." After a short chat about an 8" x 12" oil he had partially dashed off in the morning following the larger Scott's Bluff oil, we discussed [what to do] We finally decided to go to the laboratories of the Gem Ear Phone Company to test out their hearing aids, as Jackson's hearing is getting worse and he doesn't enjoy lectures etc. We went up to 34th St. and tried out the equipment; it worked well—that is the sound, not the bone construction method with Jackson, but he didn't have $50.00 with him and agreed to call back the following week. We strolled back down 5th. Ave, purchased some salted nuts and then visited Demings After about 3/4 hour chat, Jackson and I returned to his room and he packed his bag to come to East Orange for the week end. We hurried so much I presume that was the reason why Jackson did not suggest a "snorter."

Jackson ate dinner with Dora, Mable and me and later Dora, Jackson and I went over to the Orange Camera Club for Ladies Night. Jackson was full of pep! He enjoyed himself immensely chatting with men and women, and they all admire him, an honorary member, who does not look his age, nor act it for that matter. Except during the lecture, when I sat beside him, he was on his feet all evening! No, except when he ate several sandwiches and drank a cup of coffee. He had ceased eating, but when one young lady came around with some good looking sandwiches, he commenced again! Some time after 11 P.M. we went to Jimmy Walter's home and he set up his apparatus for enlarging 16mm movie film he recently constructed, and also demonstrated the new Eastman Polarizing Screen. Meanwhile we were enjoying a good long Rye highball. Got home sometime after 1 A.M. . . .

March 7

Arrived at Jackson's room at about 1 P.M. and entered in answer to his cheery "Come-Come." He yawned, stretched and inquired whether the City-wide service men's strike had yet tied up the Latham Hotel elevator service. I told him it hadn't although the elevator operator said the union was after them, but so far they had refused to go out on strike. Then Jackson—and I—went off on a tirade condemning the strikers, their audacity, their depredations—everything. Jackson was quite "het up" about the matter saying he didn't understand why they thought they "could do as they damn please" and why the City permitted them "to do as they damn please." As well as I can recollect it was the first time I've heard Jackson so "hot" about a subject that he used the word "damn."

Then Jackson showed to me the copy of Miller's Field Notes (see 2/27/36) sent to him by Russell of the Park Museum staff, the copy having been made from the originals in the Baltimore Museum. Jackson said he was disappointed about the notes because they were not connected in a continuous series or in diary form, but apparently thrown together, a small portion fitting each picture Jackson says Miller refers to the Kansas River as being a clear stream, and reflecting the hills thereabout etc. whereas it has always been known to be a dirty river and, moreover, quite flat country in the locality described by Miller, hence the reference to reflections seems in error. Jackson says Miller also refers to cottonwood trees around Chimney Rock Jackson says no cottonwoods grow anywhere near Chimney Rock, in fact, there are none high up on such plateau country. Miller's sketch certainly isn't like anything of Chimney Rock Jackson has sketched in the original note books he carried across the plains in 1866, and 25 years previously (Miller's was an 1837 visit) the conditions in such dry plateau country must have been about the same as Jackson saw it Miller's picture of "Devils Gate" shows nothing that is true of the "gate" or the surrounding country, either today or according to Jackson's sketches in 1866. I asked Jackson whether he was going to write to Russell setting out all his objections and criticisms and Jackson replied that he wasn't because he presumed Russell and his men believe they have made a "find" in uncovering the pictures and notes and Jackson says he doesn't want to spoil the illusion

Jackson is now making sketches for the Park people showing types of dress worn in early days. He thought he might get some help from the Museum of New York City exhibits at 104 and Park Ave. so we went up there but found little to help Jackson in his work, although much interesting stuff about early NY City

March 14

. . . Jackson has told me about [urinary problems] and today he said his regular doctor had sent him to a specialist who said the trouble might be cleared up without an operation. The specialist gave him 100 pills which Jackson said had already helped him a great deal and perhaps their use might clear up his trouble.

[Today] I did not phone, but went directly to his room finding him in at about 1 P.M., busy making some notes on new assignment of work given him by the Park Service for about 6 or 8 more pictures. After an exchange of inquiries about the other's health and happiness, I as usual, looked around to see what work he had done recently. I found that he had sent to the Park Service the several small water colors and few sketches he recently completed, but he still has the 4 large oils and the oil of Scott's Bluff. This latter oil he is not yet satisfied with, particularly the sky, which appears to be (from the coloring) a western instead of an eastern sky, being red and orange at the horizon and blue above. He thinks this color kills that in the foreground and he proposes to darken it near the horizon and lighten it much more higher in the picture. He is getting much more fun out of the oil work than out of the water color work, for with the former he can work over an item again and again until he gets exactly what he wants.

Then we looked over several sketches he made in pencil, at the Park Service's request, to show the various types of dress worn by the early peoples, which sketches are to be used by an artist in modelling miniatures for sets. The sheets are about 8 x 12 inches and contain 3 faint outlines of the shape of the human body, a side view, a front view and a rear view. The outline is only sketchy, being printed in yellow color, not a deep shade, and only visible with ease to me (and with difficulty to Jackson) only when held at a certain angle. When he received these several weeks ago Jackson had not noticed the outlines and wondered

why they wanted the material done on that certain paper. I called his attention to the outlines but it was with some difficulty that he could follow them. We finally resorted to some colored glass filters he had, about 3 x 3 inches, and found that a violet one was ideal and showed the outlines in a clear cut manner in red color. The Park Service people later told him he need not necessarily follow the outlines, and so, in several cases he had departed from them. However, in two sketches showing the dress of women of the early days he followed the outlines, but failed to put in sufficient shadowing and lines to cover 50% of the yellow lines—and thus produced a most unlooked for result. In the front view [male features are shown] . . . and that is not so definite or true as to leave no doubt, but it comes darned close to it! Although Jackson's eyes are still excellent for his age, and he told me that now since he has been working on the sketches he can more clearly see the outlines without the aid of the violet filter and his working without it, he admits he has slipped, for to any one with fair eyesight [male figures] show up plainly under the women's clothes! It gives one the impression that [one] has x-ray eyes and can see through the women's clothes, and see a man's body under them! I called it to Jackson's attention and we had a good laugh about it. Then I gave him the violet filter and we took another look— and we both laughed so much I had to wipe the tears from my eyes! I suggested to Jackson that he deliver the pictures without retouching but he says he must put in more shading and get his erasure working. Most of these sketches are quite authentic in their depicting of clothes worn during the early days, for in several instances he has carefully followed old photographs, some of himself and personal friends.

We then went to the Automat for our usual snack, Jackson indulging in apple pie and milk, I taking coffee, my favorite cream cheese and orange marmalade, a raisin bread and fruit salad. The weather being mild with some sun shining through the haze over the city, we decided to go to the Bronx Zoo and visit "The Sinful Maverick" (Garrettson). Garrettson's office door was slightly ajar and although I wanted Jackson to peep in and startle him with a bark, Garrettson must have sensed our presence and immediately turned, exclaimed a greeting of welcome and came to meet us. We visited for about 1½ hours, most all the time being taken with a review of Garrettson's manuscript for a book about

the American Bison [Illustrations include] scenes of early skinning, skulls and bones on the prairies, some copies of Jackson's paintings and Garrettson's drawing, and sets of horns, heads etc. etc. One is a print of Jackson's 1878 photo of a bison skin containing Indian hieroglyphics and picturegraphs‡

Garrettson showed to us—and laughed and joked and ridiculed a letter he recently received from a man named Parker . . . [who] said he was informed that the early oxen were faithful, docile, kind creatures and that the inhuman treatment of them by ox team drivers was almost a crime. Garrettson ridiculed this and said he wrote to Parker giving him some different information. Jackson and he had a great laugh about it, and Jackson said he wrote in his diary only a few days after he started his ox team trip that he didn't believe that he swore before, that the oxen so exasperated him he swore a good deal at them, and he told of experiences when they had to double team at steep, hard going places and how difficult it was to handle the oxen. Jackson spoke particularly of one time when the oxen of one of his companion drivers got away and wandered among the sagebrush at night during one of those tough, double-teaming jobs—and how the driver used to stone them, then beat them with the whip, and finally take them by the horn with one hand, the nostril with the other hand and then bite their ears! Jackson said it didn't appear to affect the oxen at all! Both Jackson and Garrettson ridiculed the actions of some recent writers (none were named), such as this Parker, who write about matters although they had no experience and in many cases very little authentic knowledge or information on the subject they endeavored to handle.

March 19

On the way back to the office from the Acme Co's office this noon, I stopped at the Latham Hotel [Jackson] said he had been working continuously since 9 A.M. at his water color work and thought that a breath of the balmy spring air would do him good—and he agreed to

‡*The American Bison* (New York: New York Zoological Society, 1938) carries three Jackson illustrations. The one on page 45 attributed to Jackson is actually by another artist.

look at me from across the top of one of the "standee" tables at the Automat. He must have felt good, for in addition to the usual milk and pie, he decided to have a dessert, and pickled prunes. After deciding to meet again at 5:30 for the Adventurers' meeting, I left for the office.

Arrived at Jackson's room again at 5:30 P.M. . . . Somehow we got on the subject of painting and when he first took it up. He said that in the late fifties he left his family in Virginia (about 1858 when he was 15 yrs of age) and came to Troy to live with an uncle. He attended school there but did not go entirely through the grade schools but as he recollected it he entered the 8th grade but did not complete that grade.† He said he did not recall why he left school. At Troy he worked for a photographer re-touching photographs—enlargements which he said did not in those days come out very clearly—with a fine pen and India ink. He looked through his photos for a representative picture and found one of himself at the age of 21 years, which he had recently signed and dated as representing himself in 1865. Certainly he did very fine pen work. He said he recalls making a little studio on the second floor of a barn on the rear of his uncle's property—the type of barn common in earlier days with an outside stairway—and it was in this studio that he painted portraits in oil, copying photographs of members of his family. He said he did some other painting work, particularly mentioning the painting of scenic effects on window screens, a quite common thing in those days

Before we left his room to go to the Adventurers' meeting he told me that he had just received word that a Mr. Livingstone had died.†† He was the owner of all the negatives Jackson made while with the Detroit Photographic Co. and Jackson said he had been corresponding with him to get the loan of several of the negatives made on the Siberian winter

†According to Jackson in *Time Exposure,* the family lived in Philadelphia in 1853 when he went to live with Uncle George Allen in Troy, New York. Within a year, the rest of his family followed and Jackson moved back with them. It would have been about 1858 when he quit school.

††Robert B. Livingstone. Manager of the Detroit Publishing Company, Livingstone possessed thousands of Jackson's negatives and prints at the time of his death on May 17, 1936. Although bankruptcy of the Detroit Publishing Company in 1924 forced Jackson's retirement, Livingstone, former executive of the company, was doing business under that name in the 1930s. Collection 1643:137–40, CHS.

trip, which he wanted to make some slides to use for lecture work! There is no indication of him letting up on his activities, he continues to plan for work in the future.

Jackson said that earlier in the day he had a call from a saleslady of the ear phone people where we visited a few weeks ago, but told her he thought the contraption a little too inconvenient and cumbersome to wear all the time, and as he really did not need it except on special occasions, he decided not to purchase it

March 26

This evening Mr. F. B. Scott, his daughter, a friend Miss Morrell, Dora and I met at Jackson's room; Mr. Scott's daughter and friend wishing to meet Jackson and talk and view some of his early photographs as both these young ladies are studying photography at the Clarence White School of Photography. Jackson had arranged several of his old prints in convenient groups for easy viewing, and showed us a nice collection of photographs. The young ladies asked many questions and exclaimed over the excellent results obtained in the days when filters were not available, yet Jackson got some fine cloud effects without detriment to the balance of the subject matter.

Some time after 7 P.M. we went out to dinner, and, although I had told Scott that Jackson and I usually ate at Childs and that is where Scott (the dinner was on him) should take us—and that we would walk— his daughter suggested to her dad that they kidnap us—and they did. We landed at the "Great Bear" on Second Ave. between 12th & 13th Sts.—a Russian Restaurant with a reputation. We had a delightful table place across the small dance floor from the orchestra—a typical Russian outfit. I stuck to plain foods, although the others made a slight departure, and when I told the head gazebbo who Jackson was and where he had been, he fell all over himself to see that we got real stuff so far as they could give it and so far as we wished. I turned down the drinks offered—the others did not—and Jackson was given a special additional one of vodka. The music was delightful—entertainment not so bad either—the flaming dagger dancer being especially interesting and spectacular. We were there about 2½ hours and Jackson seemed to be enjoying the music and the atmosphere, although he could not hear all of our conversation at the table because of his deafness.

We later returned to the room for a further visit with him When Jackson was asked about his age and reference was made to it being 93 on April 4, 1936, he said it should be turned around and made 39—to which I said it should be 16 and never kissed—with three good looking ladies around. This started Jackson on reminiscing and he remarked that in 1870 when he joined the Hayden Survey the party stopped at a ranch and he met the owner's daughter; next year he met her again; and the third year she became the second Mrs. Jackson‡—all told with the usual little twinkle in his eye, and he then produced a picture of her standing beside her pony. This picture he has recently carried around with him and I have seen it before. We viewed many of his photographs of water colors, etc. and also looked over the large oil paintings etc. etc. before we left for home, having had a grand evening.

Jackson said it had been a great day for him as he had many callers— more than usual and busy most all day with them. Altho it was 11 P.M. when we left he was chipper as ever

March 30

[Tonight] . . . I found him reading the "Pony Express Courier." He is quite pleased with the Courier—at the time he was also looking thru it for some pictures showing early mining methods to use in his work— and commented about its contents; also about the many fine books advertised in it and recently published about early Western history Jackson said he would like to buy and read a lot of the recent new books and reprints now being published, but he does not have the room for the volumes—his interest is still very, very much alive in all things about him, and particularly the good things! . . .

We went to Childs at 7 P.M.—and the waitress seemed to be quite familiar with his tastes, knowing that he usually, perhaps always takes fruit cup to start, followed by vegetable soup, then a good substantial entree and a finish with coffee and fruit salad sundae. On the way out

‡Either Bonney must not have heard this love story correctly or Jackson was spinning a tall one. The second Mrs. Jackson was Emilie Painter, daughter of Dr. Edward Painter of Baltimore. Jackson first met her about 1871 while photographing on the Omaha Indian Reservation in Nebraska, where Dr. Painter was then serving as agent. The two married at the home of Emilie's brother in Cincinnati on October 8, 1873. Jackson, *Time Exposure*, 210–11 and 219–21.

we weighed ourselves, I was just a bit under 155 pounds and Jackson decided he would investigate the matter and found he tipped the scale at 143½ pounds. It was a balmy evening, and in reply to my suggestion that we take a little walk, he asked if I felt like walking up to 42nd St. (we were then at 30th St.) and when I assented he said he wanted to see the new Wrigley Chewing Gum electrically lighted sign about which much was published in the newspapers and we hiked up to 44th St. at the Astor on Broadway and gave it the once over

Our chat then continued [in his room] and he showed me the album of dry mounted photographs of several of his pictures which Dr. Driggs wishes for the Oregon Trail Assoc. records. Jackson also got out the large oil painting of Yellowstone & Old Faithful, saying that he only recently realized that he had omitted Moran from the scene so he painted out one rider and put Moran on the horse's back, using his photograph of Moran on a horse's back (the same photo shown on the Colorado Mt. Club magazine for September 1935 Trail & Timberline)—The three most prominent figures on horseback in the picture now are, from left to right, Hayden, Langford and Moran.

Jackson also showed to me a newspaper clipping from the Denver Post, March 23 [sic], showing several of Jackson's early photographs and containing an article about the Denver Library's acquisition of them through the Carnegie fund. Jackson said Wyer of the Library had communicated with him about them, having acquired them from the recently deceased individual who owned them, or from the Detroit Publishing Co., and Jackson said he recommended that the library acquire the album of prints rather than the negatives He is quite pleased about the matter—and it surely does him good to see such interest in his work being taken by the Library (about which he has heretofore spoken to me.)†

I am a little apprehensive about one thing and that is his eyesight; not

†*The Denver Post,* March 22, 1936, stated, "More than 2,000 original prints, comprising [Jackson's] entire Colorado collection, have just been acquired by the Denver Public Library for the western collection of pictures thru a special grant of the Carnegie funds." In fact, after months of negotiations the Denver Public Library had purchased eight albums of 1,711 prints (known as the "old Colorado Albums") in October 1935 from Robert B. Livingstone of the Detroit Publishing Company. Livingstone to Jackson, October 22, 1935, Collection 1643:138, CHS.

so much about his work because that does not seem to be affected particularly as all small details are done under a magnifying reading glass, but when handling items he is apt to overlook them. He said he recently picked out an old photograph to send to Fryxell because he was desirous of obtaining it, and put it on his dresser with other papers, and now everything is gone—presumably thrown out as waste!

Bonney's marginal note: 4/4/36—he found it today

April 3

Jackson's 93rd Birthday Anniversary Party at Coits

I telephoned to Coit to tell him that the menu mentioned in his letter of April 1st was OK—and that I would be at his apartment at 5:30 P.M. Found that a lady friend occupying an adjoining apartment had given Jimmy quite a big hand—the table was set, several vases of flowers and candles were distributed about the room, the air was full of great expectations of the good times to be had when the boys arrived. Most of the groceries had already been purchased and, after getting a few items lined up, we left for the butcher's shop and acquired a beautiful 4 lb sirloin steak (that weight after almost all the bone and fat had been cut out) about 2 inches thick—ideal for a charcoal broiling. Then we acquired a quart of wine and a quart of 5 Star G&W whiskey and two cigars for Capt. Deming and hurried home. I peeled the potatoes and diced the Spanish onion while Jimmy busied himself with other duties, and soon we had things well in hand.

At 6:45 P.M. the ringing of the door bell announced the arrival of the guest of honor, Jackson, and Capt. Deming and Barber, who were ushered into a candle lit room. After a jolly greeting and a short chat, we returned to our kitchen duties to be interrupted later by the arrival of Jimmy Hare.†† Cooking utensils were scarce, so were the working tools,

††James H. "Jimmy" Hare (1856–1946). Born in England, Hare arrived in the United States with his wife and five children in 1889. Moving from freelance photography, he took up an adventuresome career in photojournalism. His assignments for the *Illustrated American, Collier's Weekly, The New York World,* and *Leslie's Weekly* took him into battle and behind the lines in the Spanish-American War, Russo-Japanese War, Mexican Revolution, and World War I in Belgium, France, Italy, and Greece. At home he pictured Presidents McKinley,

but with a single gas burner and a single electric grill we finally managed to get the eats lined up, but before partaking of them we enjoyed a toast with a round of old-fashions, which, with the couple Jimmy and I had before the guests arrived put us in good shape for work. A yell from the kitchen sent the boys to the table—their places being designated by names on little chicks—this dinner having an Easter touch to it. The mock Turtle soup was grand.

There was great conviviality and Jackson was very happy indeed, remarking, among other things, that it was "strange [for] you young fellows to be catering to us old fellows." Jim, of course, could be no one else but Jimmy Coit—smiling, laughing, talking—feeling on top of the world and remarking that it was the best day of the year for him, to which I could not help but concur. I hustled the empty soup plates to the bathroom sink, then smeared the butter on the toast prepared by Jim and spread the sauteed diced Spanish Onion and mushrooms upon it. This was a new dish, Jim having got the idea from a saleslady in the store in which we purchased the groceries. Then there were more stories and a toast to me with wine in appreciation of my help in the party. Again the dishes went to the sink—Jim, now in high spirits—or rather the spirits in him—laughed in his usual infectious manner to most of the questions I asked, especially my request for a spoon. He finally dug out a large one, broken-handled and green! A cleansing put it in shape for serving the Birdseye limas, smothered in butter—ditto for the mashed potatoes.

Meanwhile the steak had been put on the glowing charcoal embers and was then cut up and well greased with melted butter—Jim forever smiling and remarking that "things were coming along great." Great were the exclamations as we set the dishes before the boys who went at them heartily! "Fill the bowl" yelled Jimmy and kept pouring the wine as fast as the boys took any out of the glasses. Jimmy Hare was feeling mighty happy remarking that he had come a "sick man" but was "OK now." Then to the fresh pineapple, sliced and decorated with a few

(continued from previous page)
Theodore Roosevelt, W. H. Taft, and Woodrow Wilson. A friend of Orville Wright, he snapped the Wright Brothers' experiments at Kitty Hawk. Lewis L. Gould and Richard Greffe, *Photojournalist: The Career of Jimmy Hare* (Austin: University of Texas Press, 1977).

stemmed cherries—and eventually to coffee, cheese and crackers—with everyone stuffed full, and "leavings" on the plates. From the bouquets of roses and daffodils, garnished with a few pussy willows etc.—Jimmy selected a rose and pinned it on Jackson remarking "Now you look like a bride's maid"—and so we fixed the rest of the boys the same way. Then to the fireplace for stories! Great was the cheer in everyone's heart to be there that night

Jackson's birthday anniversary will be [tomorrow] April 4, 1936 (93 yrs) but taking:

Jackson at 93	Barber at 61
Jimmy Hare at 80	Coit at 51
Deming at 75	Bonney at 38

gave us a total age of 398 years for the six of us—an average of little over 66 years—Jackson remarked that "you youngsters pull the average down" and laughed at Jim and me. With cigars, cigarettes and pipes going strong—the stories also got going strong—would that I could remember them! . . .

Jackson was later taken with a coughing spell and Jim mixed whiskey and soda and when serving it said that he hadn't had so much fun since he left his mother. J. Hare told about his Kittyhawk experiences when the Wright Brothers first flew, J H having taken the first photograph of them in flight. Byron Newton, who was also at Kittyhawk, had a copy of the picture and in later years he told the story so often he believed he, himself, had taken it—and one day in his office in Washington when J. Hare was visiting him he actually told J H about taking the first picture—and Jimmy told him then and there that it was OK to tell other people that but he couldn't tell that to him (J. Hare) who took the picture. A few years ago J H had Newton as a guest of the Adventurers' Club and Newton, to some extent, atoned for the error by loudly and frequently praising Jimmy (JH) for his taking the first photograph of the Wright flight.

We enjoyed some candy—a special for Jackson—a rabbit pulling a cart of candy—and sang the Stein song a few times. Remarks were made that with the party for Jackson tonight, another the following night, the one at the Explorers Club Sunday, and at Demings Sunday

night, J. Hare wanted to know what Jackson would do next week. The boys being so happy they decided they could not wait another year for a party, it was decided that we would in a similar way celebrate Coit's birthday on May 14th—Jackson being the first to make note of it in his engagement book, after carefully scanning it with his pocket reading glass to make certain of the date. But all parties must end sometime— so we gathered in a circle before the fireplace and again sang the Stein Song, and eventually left Jimmy smiling on the door step as we piled into a taxicab.

April 4

Called at Jackson's room at about 4:45. Found him enjoying the flowers presented to him on his 93rd Birthday Anniversary today. Among the several bouquets and potted plant was a basket of various colored roses from the Oregon Trail Memorial Association through Dr. Driggs, its president. We did not count the number, but there appeared to be enough to make 93. Jackson saying that on his 91st anniversary the bouquet contained 91 roses! One of the most pleasant gifts was a group of 50 homemade greeting cards from the pupils of 6-A in one of the NY public schools before which Mr. Jackson and Dr. Driggs spoke sometime ago

After a short chat he commenced to dress for his big dinner at his son Clarence's home in Brooklyn, and, as he was changing his shirt, his new suit arrived so he was enabled to "doll up" properly. I assisted when I could After I had gotten a cute yellow rose bud on his lapel and dolled up his pocket with a nifty new handkerchief, the telephone rang to tell us that Mr. & Mrs. Deming, Barber and Coit were awaiting us in the lobby so we hurried down and were soon off to Brooklyn

It was a happy party—not only the event, but also the individuals, see the photo—and all were going strong at 11:30 P.M. when we decided it was time to start for home. Clarence showed to me many old photos, pamphlets, keepsakes, etc. among them being a poem entitled "My Father"—a very clever bit of words—and a perfect word picture of him (Mr. Jackson)—a copy of which I hope to acquire some day when Clarence is willing.

April 22

. . . Tonight I found him as chipper as ever, just getting off a letter to Mr. Albright. I looked over the newspaper and Jackson pecked away at his typewriter, but eventually decided to do over the letter, saying he became a little mixed up near the end and would finish it when we returned from dinner. However, I urged him to do it over—and he did, after hunting up some items to keep me interested. . . .

After completing the letter, we stretched and prepared to go out to dinner when Jackson said, "Will you have a little drink?" I looked at him a moment, then replied, "I never touch it—you know that" and he parried with a quizzical look and said, "Well, you're going to touch it now!" He headed for the bathroom to get some cold water and returning said he wanted to empty the bottle of Antedeluvian so that we could sample the contents of the bottle Mr. Fuchs gave to him at his 93rd birthday party. We killed a short one with the toast from Jackson "Mud" and I concurred "The same old mud"—so we put mud in our eyes, and went up to Childs After dinner we returned to his room for a short chat, and he showed to me another water color he is doing for the Govt depicting a pony express rider passing a gang erecting the telegraph line.

He also showed to me a small oil depicting the Scott's Bluff scene; being done in a warmer gray for the shadows with the higher points a brighter red from the sunset glow, and asked me how I liked it. It is better than his larger one, and I told him so to which he agreed saying he liked the tones better. I then gave him my print of the Mt. of the Holy Cross which I asked him to fix up by writing something in white ink across the darkly shadowed portion so that it would show—as framing it hid the comment he had put on the back,‡ He said he was glad that I had a good print of the negative, as the plate had been broken and he showed to me all the prints he had left—only 2—which had been made from another plate and were very poor, being quite contrasty and lacking very much of the character so evident in my print. He said my

‡Jackson wrote across the front of the picture (dating it from his original note on the reverse): "This photograph made by me Aug. 24, 1873, is the first picture ever made of the Mt. of the Holy Cross. Dec. 21, 1933. W. H. Jackson." Collection 1643:292, CHS.

print was one of the first exposures—stereoscopic at that—and he said it was the "first and his favorite" of the pictures he had taken. He then hunted up a clipping, being a recent photogravure section picture of the Holy Cross, depicting services being held on the mountain opposite the Holy Cross, and pointed out the better qualities of my print. These were quite evident. The newspaper picture had too much foreground, hence the valley did not show and it lacked perspective, also it was taken too late in the day—the sun is right for a good picture only at sunrise, at the other times the shadows being not good for a fine picture; also, there was too much snow in the crevices on all the peaks, giving the crevices a rather frazzled appearance. Jackson will fix up the print for me to be picked up later. I then showed him several enlargements Jimmy Walters had made from my 6mm motion picture film. They were approx 8 x 12 and showed Ingersoll and Jackson together, Deming lighting Ingersoll's pipe, Jackson & Steve Johnson shaking hands, and one of Deming toasting Jackson—all taken from my Jackson reel of pictures. Jackson was delighted—and I left the prints with him

During the visit I asked him about photographing along the DLW and his notes showed that he did the work in 1899 shortly after returning from his round the world trip for the "World's Transportation [Commission]"† but he had not pictures in his possession, all being in the possession of the party who acquired them from the Detroit Publishing Co. who recently died.†† Jackson intends to stop there (Detroit) on his way out west this summer and endeavor to acquire his Russian pictures to make slides for lecture purposes—he just can't rest until he gets sufficient slides to complete the needs for such a lecture! He said the execu-

†Jackson returned home to Denver in March 1896, technically not having been around the world.

††November 4, 1937, a Detroit newspaper reported, "Purchase of approximately 40,000 negatives of western pictures taken by William H. Jackson, pioneer photographer, for the Edison Institute museum at Dearborn, Mich., was announced Thursday by Henry Ford."

The entire collection of Jackson's original glass plate negatives numbered over 52,000, according to *The Colorado Magazine* for April 1949. That year the CHS acquired as a gift from the Ford Foundation and the Edison Institute in Dearborn, those negatives related to areas west of the Mississippi River, while those concerning subjects east of the Mississippi went to the Library of Congress.

tors had consulted him about prices they might ask for the many thousands of negatives in their possession, the collection to be broken up and disposed of to any interested at the highest prices. He said they used to get $5.00 for an 8 x 10 negative but he told them $1.00 or less was all they could expect now.

While discussing the Detroit Publishing Co. matter, he said that he closed up his Denver shop in 1898 and went to the Detroit Publishing Co. that year. At that time he said he considered his stock complete worth $30,000.00—loaded all of it in a special car and came to Detroit, turned over all of it to the Company and took the price in stock—not in cash. The Company paid dividends for a year or two, then those stopped. Eventually, when receivership was closed he said he got about $6000.00 in salary, etc., etc., and invested it in Kelvinator and Barum Aluminum—the former being around $100 a share and the latter, of which he had 400 shares, around $6.00. His broker sold out the latter to bolster his account on the former when Kelvinator dropped to around $6.00 and then Aluminum, which had been sold out, went up to $100.00 so Jackson was out about $25,000.00—and I believe that ended his stock market activities.

April 30, 1936

Dear Bonney:

Tuesday night the 28th was [a] "Ladies Night" out special program at the Explorers. A week before, unwittingly, I invited a Mr. & Mrs. Nichols of Colorado to be my guests that evening for the get-together. Dinner, as well as the entertainment—invitations I [don't] very well recall. However I have no intention of calling off our dinner which will include Mrs. Bache, as soon as we can arrange a date.

Mr. Albright has invited me to go to Morristown with him on Saturday. If I go I hope I can arrange for an afternoon trip so that on the return I can stop off in E. Orange. I wish to attend the Camera Club dinner. . . .

Cordially

W. H. Jackson

Bonney's marginal note: The reference to the 28th is to Jackson's

remarks several weeks ago that he wanted Dora and me to come over to have dinner with him as our wedding anniversary (2nd) April 28, 1936. However, both Jackson and I forgot the matter until too late—but he has no intention of calling off the arrangement, as will be noted—and wants to include Mrs. Bache at the dinner.

May 2

Just as I was leaving the house to go to the Orange Camera Club Jackson rang the bell and I found him at the front door, as chipper and happy as could be, dolled up like a million dollars—but minus his overnight bag. He said Albright had not showed up to go to Morristown to look over the Gov't laboratories and the work being done there, hence he sat around his room awaiting a call from me and when it did not come, he phoned to East Orange to me, but got no answer—which was because Mrs. B., Dora and I had taken a walk out into the Park to enjoy the beautiful day. In hurrying away from NY he forgot his bag, but both Jim and I promised him pajamas etc. and he stayed overnight with Jim Walters. We walked down to the Camera Club, enjoyed a chat, a good meal, a lecture by Gardner, a chat later and parted at midnight.

May 3

This morning Jackson and Jim called at house and we chatted for ¾ hour before we put Jackson on the train for NY. He wanted to get back as he had invited his son and family to dine with him—and later in the evening I presume he went to Demings to finish off the week-end at about midnight.

Jim and I both agree after Jackson departed that he certainly was a great chap—still alert and very much interested in everything, politically and otherwise. Jim says if he were asked to pick a representative American he would pick Jackson.

May 8

I found Jackson comfortably seated, reading a "Literary Digest" atlas. In a businesslike way I said, "Mr. Jackson I believe" to which he replied, "Yes sir—and what business have you to transact with me this evening?" to which I replied, "the business of filling my stomach with good food, and filling my mind with good, intelligent stuff" and, said he, "and hav-

ing a snorter with me." With the formalities over, we launched a conversation on pictures, and he showed me a photo made by the National Parks people of one of his small monotones depicting Bridger and a companion getting their first view of the Yellowstone geyser basin—a nice composition.

. . . After disposing of the "mud in your eye" we started for the elevator after I remarked that I wanted to telephone to a friend. He kept insisting that I use his phone and I just as determined not to use it because I saw no reason for his being charged 10¢ for a call thru the telephone board at the hotel, when a phone on the first floor served as well. He said his phone was for the convenience of his friends and "razzed" me all the way to the elevator about being "too finicky." Great boy!

After the usual at Childs restaurant on 5th Ave., we walked around to Bagoe's Drug Store And then to Demings, Madison Ave. on 31 St., where I found that he was expected to give a lecture to a lot of female teachers brought there by Dr. Hillegas (Columbia Univ. or some large high school)—although Jackson had misunderstood some time ago when the date was arranged. He hot-footed it back to his room, got his slides and went to it with a "punch." So once again my suggesting a stroll around to the Demings saved the day! He doesn't exactly forget—the trouble is people don't properly impress upon him a definitely set date, but rather casually arrange such dates and take things for granted that all will be OK.

At lunch he told me that Bagoe had introduced him to one of the Bonney girls (Miss Therese) and her mother,‡ who now have an apartment across the hall from Demings, and that he had recently spent several pleasant hours with her—the daughter, looking over old photographs of which she has a large collection—many being very choice items. Jackson got a big chuckle out of telling me that while looking over pictures of Parisian nudes he remarked to her that they were "professional models of course" to which she replied, "Oh, no, they're whores." Jackson said that he was non-plussed for a while—but finally gained his composure after realizing that she had lived for many years in Paris

‡The Bonney ladies have no apparent relationship to Elwood P. Bonney himself.

May 21

Called at Jackson's room with Blaine McCarthy before going up to Adventurers' Club Meeting. Jackson as chipper as ever. I showed to him an article taken from the NY Times 5/21/36 about "Uncle Sam" and Jackson said this party "Bryan" who wrote the letter, was wrong in some of his statements—and finally found a blue-printed 3 page article giving the early genealogy of the Wilson family. There wasn't much time to read and discuss it, but Jackson said one of his cousins, a Mr. [?] who is now with the Penna RR is much interested in the family history and has done a lot of work on the family genealogy. This 3 page blue printed article written by the granddaughter of "Uncle Sam" stated that Uncle Sam Wilson resembled Abraham Lincoln very much. This is contrary to what Jackson previously told me—that Uncle Sam Wilson was short, fat, and jolly—but Jackson didn't recall telling me that. Some day we intend to go over the article and 3 page item more carefully. And so to Adventurers' Club.

June 1

Jackson entertained Dora, Mrs. Bache and me at dinner this evening. The girls had been out in NY Bay to greet the Queen Mary on her first arrival and later we met at the Latham to enjoy Jackson's treat which he has wanted to give us for some time past. He was chipper as ever, and before going to dinner we looked over several of his oils and water colors and viewed some of his photographs taken in Africa on his "Round the World Trip." Then to Childs for a snorter and a good meal, after which the girls returned to East Orange, and Jackson and I continued our visit. We had a jolly time looking over the C. M. Russell prints of which Jackson has about 80 and I listed several that I eventually want to acquire from dealers. (Clarence later gave me, or I bought for a small sum, all of these).†

†Jackson had accumulated a file of Russell prints in 1933 when Jack E. Haynes wrote him, "I am sending you with this letter a total of 71 different colored Charles M. Russell prints. These comprise a collection which you, Dan Greenburg and I have which I believe is not elsewhere equalled for the number of subjects represented." Haynes to Jackson, September 16, 1933, Collection 1643:107, CHS.

Jackson was perturbed about one thing—that being the result of a letter he wrote to Russell [not to be confused with Charles M. Russell] of the Park Museum saying he was going out West this summer. Russell replied that he was sorry Jackson was leaving the organization, to which Jackson replied that he had no intention of leaving the Park Service work, but had for the past 10 or 12 years always taken a western trip and apologized for not having made the matter clear in his first letter or observing the amenities of the service and expressed the hope that he could continue the work when he returned. His only complaint (he wrote in the letter) was that they had not given him enough work to keep him busy. He feels that they might be wanting to let him out easily, thinking perhaps, that his work is not satisfactory. He said all the letters he got from the Park People said his work was fine, but he doesn't fall for that and thinks that is just the usual line, and would relish real criticism Jackson feels that the Park Service work should be historically accurate and this is what he strives for, but surely the mural work and other types pictured in newspapers and magazines is far from being historically accurate

June 10

It was my "night out"—so, I called Jackson on the phone and arranged to have dinner with him. As he had to attend a Membership Committee meeting at the Explorers Club, it was not until 6:10 P.M. that he walked into the lobby of the Hotel Latham, but he was as "chipper" as ever, and smilingly walked towards me for a warm handshake. He suggested going up to his room for a chat before dinner and then called my attention to his trousers which were the ones he had spilt a bottle of ink on, after which he immediately plunged them into a tub of cold water and left them overnight, with the result that there is not a slight indication of ink. This so enthused him that he decided to wash another pair of trousers and he showed to me a light colored woolen pair which he had washed in his tub and then hung over an ordinary suit hanger. There was no doubt but that it was a fine job, even the crease looked pretty good with ironing.

He suggested that we have a "snorter"—which we had—and then fell to discussing politics. He fears that the Republicans will have a hard

fight and rather doubts that they will beat Roosevelt—which many also fear, but he hopes for a change and a Republican President in the White House soon, even though he now is on the W.P.A. payroll with the Nat'l Park Service. He said he had not heard from Russell about his last letter and he thinks that maybe they are arranging to transfer him to the regular payroll of the Nat'l Park Service as they mentioned they had hopes of doing when they first took him on††

Upon returning to his room . . . we fell to discussing religion. Jackson, of course, is of Quaker descent although I never heard him profess any faith and I never heard of him going to church. He said he believes in living right, doing good by everyone and enjoying life and let the future take care of itself—with which I heartily agree.

He chuckled gleefully as he told me that his wife (he did not say which one) used to describe the difference between the Orthodox and Hiebrites [sic] Friends by saying that the only difference was that one sect believed that the devil had a tail and the other, that he did not have a tail.

We then discussed at length the article he is writing for the Nov. or Dec. Appalachia Magazine (Mt. Climbing) about his association with Thos. Moran, the artist, in the Yellowstone region in the early seventies. Jackson has a few pages completed—and numerous notes to proceed with the manuscript, but regrets he cannot recall any anecdotes or really personal stories or happenings. Unfortunately, Jackson did not keep a diary during the years 1871–1872 while in the Yellowstone region, although he kept diaries for several years to and including 1870, and in 1873 he commenced keeping diaries again, and said he did so more industriously than ever. He says that if he had a more inventive mind he

††National Park Service officials directed Jackson's work while he was paid via Works Progress Administration (WPA) funds. During the Roosevelt administration the WPA sponsored arts projects around the nation as well as programs for writers, musicians, and the performing arts, and it provided for construction of public buildings, bridges, and roads. Jackson's works on the four surveys were hung in halls of the new Department of the Interior building in 1938. His other paintings for the government were distributed to various national parks and museums. See correspondence between Jackson and government people Fryxell, Hall, Ewers, Burns, and Cammerer in box 29, F. M. Fryxell Collection, AHC; also Collection 1643:21, 27, 87–92, 104, CHS.

might work up some material, but of course, he will not do it, even if he could, because he would not tell anything but the truth He fears that he is putting in too much background in the way of details, daily doings, travels and other historical data already in print but he has condensed it and it serves well‡

Jackson asked me to come to the Orange Camera Club to see an exhibition of his photographs (early ones, of course) this Saturday but I explained about attending the Friends' picnic, whereupon Jackson jokingly remarked that he hoped it would rain. I told him I have one more evening with him before I left on the 19th for vacation and before he also went on his, and he commented about missing our usual Saturday afternoon visits at 1 P.M. and we jokingly agreed that wives and prospective babies certainly do interfere with our "doings." And so, after a warm handshake and a good luck, we parted.

[Jackson penned several postcards to Bonney during his western trip in 1936. Some are reproduced here to indicate Jackson's care to keep Bonney informed. They demonstrate Jackson's zest for life and pleasure taken in his yearly western trips. Reciprocal affection vis-a-vis Bonney is evident.]

[New York City]
7/3/36

Dear Bonney:
Sorry I shall not be here to welcome you back but it will not be long before September.
My round trip ticket made via U.P. Portland, Oregon, thence south to S. F. and Los Angeles returning by way of Dallas, Texas, St. Louis and Washington
Cordially,

W. H. Jackson

‡The article on Thomas Moran appeared in *Appalachia* for December 1936. Jackson, the master photographer, marks his lifelong friendship with Moran, the great artist, from 1871, when the two accompanied the Hayden Survey to Yellowstone.

Denver, Colorado
7/10/36

Just arrived. Had a fine visit in Detroit—a day at visiting about the Parks of Chicago and now here. Hot! of course, but air conditioned trains made traveling a pleasure. Temporary address, I may have told you. c/o D. A. Greenburg, Cheyenne, P.O. Box 498.†

Denver, Colorado
Aug. 4, 1936

Returned Saturday from trip including Taos, Santa Fe, Chaco Canyon and Mesa Verde. Friend Gilchrist driving Plymouth coupe made the 480 miles from Mesa Verde in one day.†† Fine weather except each day with showers. Start north the 6th—first to South Pass, then the Yellowstone. Drop me a line c/o J. E. Haynes, Mammoth, Y.N.P.
Jackson

Ogden, Utah
August 21

Dear Bonney:
At "Frisco" I got my ticket for returning East by way of Yuma and Dallas exchanged for Union Pacific by way of Omaha to St. Louis, Washington, D.C. just for the purpose of meeting the Appalachia and Colorado Mountain Clubs in camp during coming week at Jenny Lake Teton Nat'l Park.

As I was crossing on the ferry from Oakland to San Francisco who should sit down beside me but Mr. Cammerer, Director National Park Service. Put up at the same hotel and had fine visit together
Sincerely,

W. H. Jackson

†Dan Greenburg (1876–1940). A friend of Jackson's and companion on some of his Wyoming trips, Greenburg had been associated with the Wyoming Historical Landmark Commission and served as regional director for OTMA.

††George Gilchrist. Denver businessman and longtime friend and correspondent of Jackson; their letters were frequent from 1934 to 1942. Collection 341:1–22, CHS.

New York
9/3/36

Dear Bonney:
Here we are—back again in the old standall primed up for whatever comes our way. Instead of taking in Dallas on my return I came direct by the U.P. so as to take in Yellowstone which I had to pass by going west because of failure to keep itinerary from other parties not coming in time. However, all's well that ends well and I am expecting to have someone of about your size and appearance to be dropping in on me Saturday afternoon with a fine appreciation of snorters in general. WHJ

New York City
9/23/36

Dear Bonney:
Mighty glad to have your letter for it has been awfully lonesome to have a whole week, or more, go by without your cheerful presence, if only for a few hours, to break the monotony of daily existence. Sorry to hear you had a bad time recently but glad to know you came out of it all right. I have been too busy to think about myself and have wished so much that on my nightly pilgrimages to Childs that I had some one else to talk to besides the waitress and the smiling cashier lady. But I do take a dry martini, occasionally, all by myself, but thinking of you as being opposite at the table. I hope you get around this side of the river soon, and when you do try and bring Jimmy Walters with you—and if you can, I will try and get Jimmy Coit for a good old time foursome by ourselves—ala—Childs.

I have been bothered since my return about my file of Pony Express Couriers—Just before I left for the West someone wanted to look over them—and I allowed the whole set to be taken away—and now "for the life of me" I cannot remember who it was. Perhaps who ever it is, may have a conscience—and then eventually return them. . . .

My regards to your good wife, and I hope it will be a boy!
Sincerely,

W. H. Jackson

Bonney's marginal note: It was a girl.

September 26

... I found Jackson as "chipper" as ever, both in appearance, in actions, and in spirits. The reference in his letter of 9/23 about my poor health had to do with an upset stomach extending over a period of two weeks— and although I was not at all 100% we went to the Automat and enjoyed our usual "standee," Jackson taking a glass of milk and apple pie, while I had coffee and my old standby, cream cheese and marmalade on raisin bread. Later we walked down 5th Ave. to enjoy the sunlight, then over 23rd St. to the Tube station where we parted, reluctantly apparently, as I hesitated and suggested to Jackson that he remain on the east side of 6th Ave. but he came across and altho we shook hands about 15 feet from the stairway, he trailed me to the top of the stairway before finally departing.

During his visit at the Nat'l Parks office at Berkeley, Calif., they assigned a large amount of work to him and he has completed one picture—an oil painting about 20" x 24" depicting the first view of the Mt. of the Holy Cross as seen thru the rising clouds and mist as the Jackson party ascended the mountain. It is a striking picture, the peak being outlined against the blue sky, rising clouds and mist in the valleys, and 3 men ascending large bare rocks in the left hand corner. He has completed sketches for the next picture, a full view of the cross showing the photographing scene.

New York City
10/19/36

Dear Bonney:
When you didn't show up at the Adventurers' Thursday evening I knew something had, or was about to happen, so your card was only a confirmation of that hunch.

This is a belated acknowledgement of the arrival of Miss Elaine but I wish you all the joy in the world in her, now nearly a week old and trust that both, mother and babe, are coming on all right. Your troubles will come some [time?] later when you will have the care and responsibility for the future of this young lady on your hands. . . .
I remain sincerely,

W. H. Jackson

Revisiting the Tetons

Jackson returns to Grand Teton National Park
in 1933 during one of his annual western trips.

S0025496

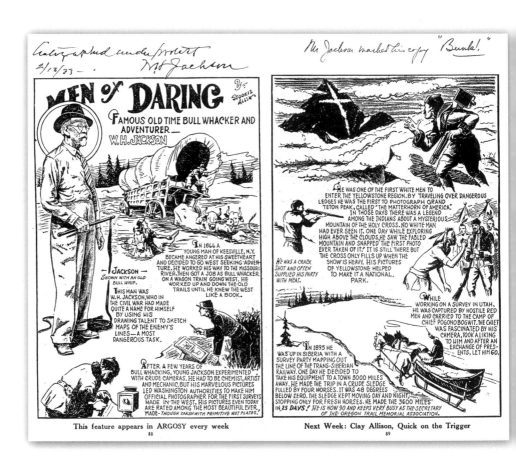

Autographed under protest

"Autographed under protest" is how Jackson inscribed Bonney's copy of this illustrated *Argosy* feature. Bonney added, "Mr. Jackson marked his copy '*Bunk!*'" *Argosy* 236:2 (February 11, 1933). See journal entry for February 13, 1933.

Right: The journal

Bonney's journal entry for February 13, 1933, describes Jackson's discovery of the canyon that Hayden named in his honor.

2/13/33

While visiting Jackson at the Army & Navy Club (N.City) tonight, he showed me a picture — a photograph — of a gathering of members of the Natrona County Historical Society taken in Sept 1927 at the dedication of "Jackson Canyon" — between Casper and Red Butte, Wyoming.

While on a sidetrip during the 1st Expedition to the Yellowstone in 1870, Jackson found this canyon, and Hayden named it in honor of Jackson — and the Historical Society made certain of the dedication by appropriate exercises in Jackson's presence in Sept 1927 ————

Elwood C. Bonney

W H Jackson.
April 1
1933

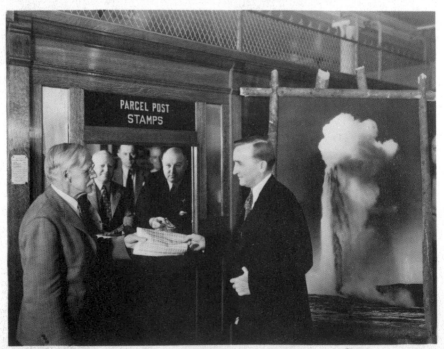

W H Jackson July 30, 1934

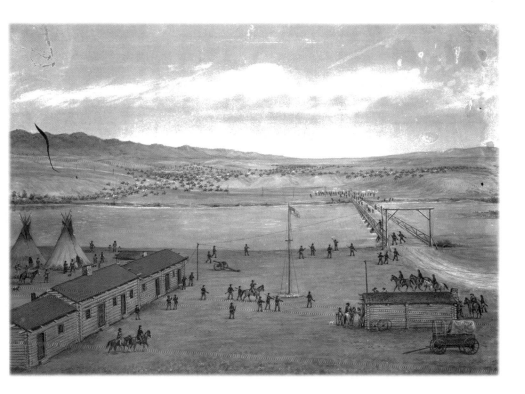

Above left:
Ninetieth birthday
Jackson celebrates his ninetieth with the
Explorers Club. Left to right: Frederick S.
Dellenbaugh, Ernest Ingersoll, Roy Chapman
Andrews, Jackson, Lovell H. Jerome, Edwin
W. Deming, H. R. Forbes. See journal entry
for April 5, 1933. S0025502

Above:
The Platte River Bridge fight
Jackson's painting depicts the noted battle
in remarkable detail. See journal entry for
May 11, 1935 (note regarding H. C. Bretney).
S0025424

Left:
The Yellowstone stamp
Postmaster General James Farley sells the first
block of Yellowstone National Park memorial
stamps to Jackson and Senator O'Mahoney.
See journal entry for September 7, 1934.
S0025319

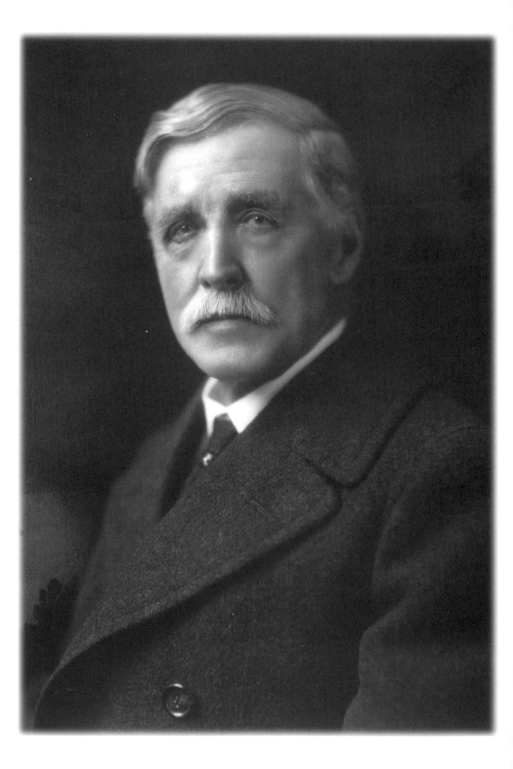

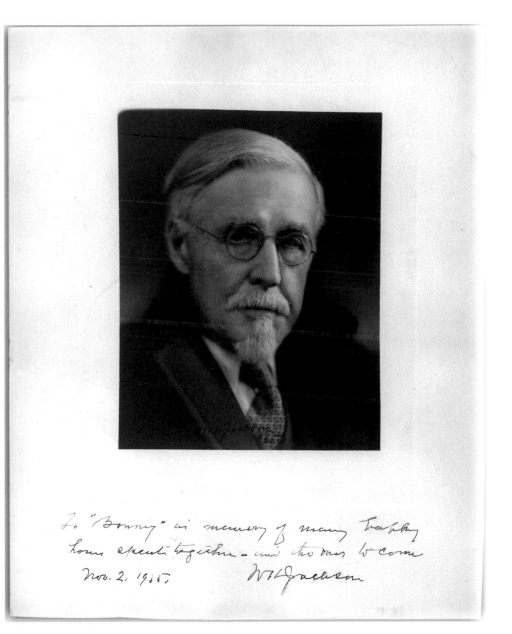

To "Bonney" in memory of many happy hours spent together — and the ones to come
Nov. 2, 1935. *W H Jackson*

Left: Jackson at ninety-two

"His Favorite Photograph," Bonney says.

S0025321

In memory of happy hours

Jackson inscribed this photograph "To 'Bonney' in memory of many happy hours spent together—and the ones to come." See Bonney's entry for November 2, 1935. S0025320

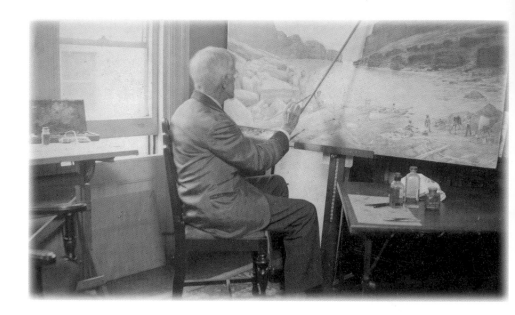

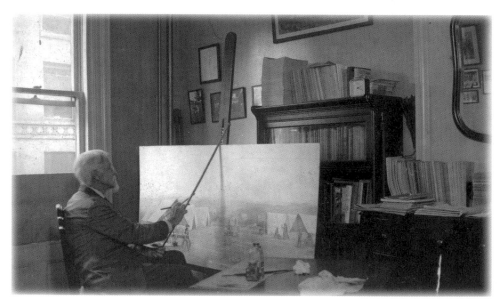

At the Latham

Bonney shot these images of Jackson in his
room at the Hotel Latham with his paintings
of the Powell survey (top) and the King survey.
"Jackson's hotel room gave him the vantage
of getting plenty of north light," Bonney notes.
See journal entry for November 2, 1935.
S0025473, S0025474

"Year of Jubilo"

In his 1866 diary Jackson wrote out this score for "Year of Jubilo" or "Kingdom Coming," no doubt picking out the notes on the flageolet (flute) he carried along. See journal entry for February 5, 1936. Collection 341:3A

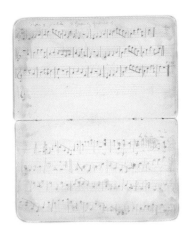

John White

Publicity photo of the "Lonesome Cowboy" in 1933. From John I. White, *Git Along, Little Dogies: Songs and Songmakers of the American West* (Urbana: University of Illinois Press, 1975), 13. See journal entry for February 5, 1936.

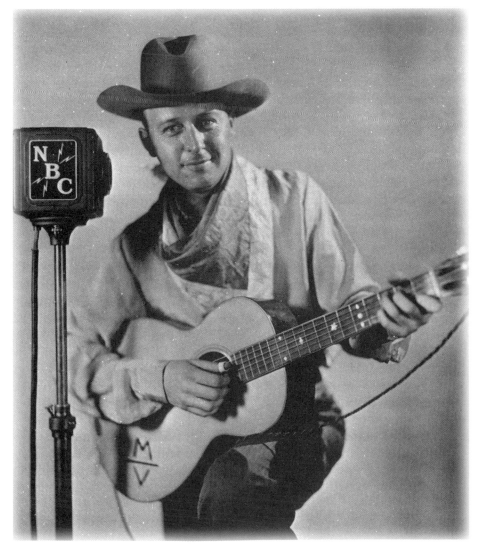

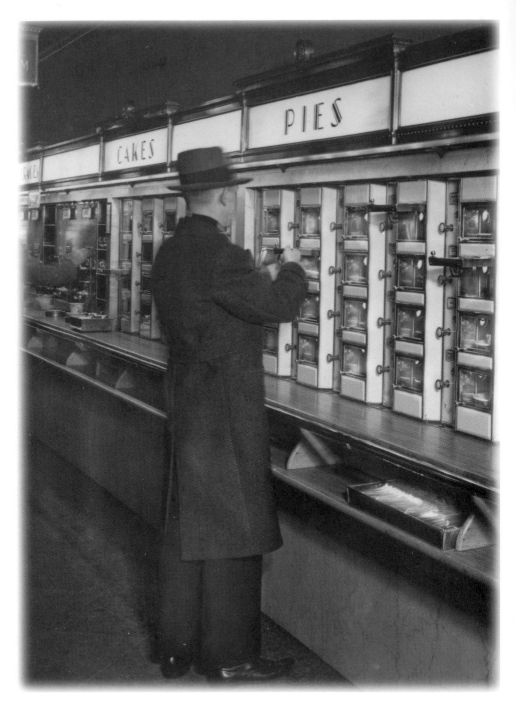

Automat

Berenice Abbott, *Automat* (detail), 977 Eighth
Avenue, February 10, 1936. Bonney and
Jackson met at an automat like this one
many times during their ten-year friendship.

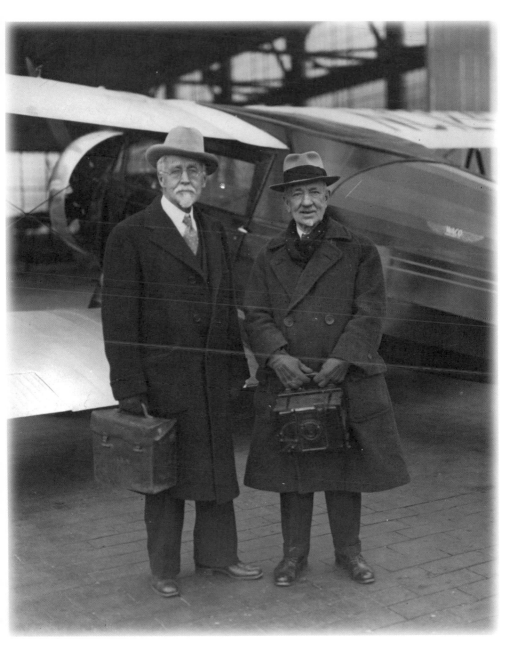

With Jimmy Hare

Jackson and Jimmy Hare, noted Russo-Japanese
war and *Collier's Weekly* photographer, in 1932.
See note on page 85. Photo by Rudy Arnold
Photo Syndicate, Floyd Bennett Airport, Brooklyn,
New York. S0025505

DISCOVERED AMERICA WEST OF THE HUDSON RIVER AND COMES HOME TO REPORT!

Cameraman Jackson, the youngest old pioneer that the Rockies ever knew, is our guest of honor tonight, preparatory to the real reception and dinner-dance being arranged for 2000 A.D.

"Backward, turn backward oh Time in your flight,
To those pre-Civil War days, if just for tonight!
Let me set up my tripod for Grant or for Lee,
And for old Sitting Bull as he squats in a tree!
Just shove back the clock to the Sixties again
When the wide open spaces were run by real men!"

On April 4th, 1843, in a modest little farmhouse that graced the main street of Keesville, N. Y., Dr. William Henry Jackson, our distinguished guest-of-honor tonight, peeked over the edge of his cradle and said to the little circle of admiring parents and neighbors gathered for the joyous occasion; "I'll bet you that in something less than 100 years from now, I will be the guest-of-honor at a bang-up dinner to be given by pals of mine at the "Adventurers' Club." They will try to tell me about *their* adventures, but where will *they* get off to talk adventure tales to me when they will have to admit that I was shooting Indians, with my camera of course, when they were nothing but a lot of merry twinkles in their respective fathers' eyes?"

From that time on, adventuring came natural to our guest-of-honor who adventured his way through little red schoolhouses, nice whitewashed chicken-coops and a street p a r a d e where he marched for John C. Fremont. He had never believed the talk he heard around Keesville, that there was really nothing much west of the left bank of the Hudson River, and the very persistance of such tales was a challenge to him: so he packed up his kit, which consisted mainly of a camera and tripod of a vintage now coveted by museums, and hiked toward the setting sun.

A detailed account of what ensued thereafter would be unfair to Dr. Jackson, whose recent volume *Time Exposure* tells the story of his very active and interesting life.

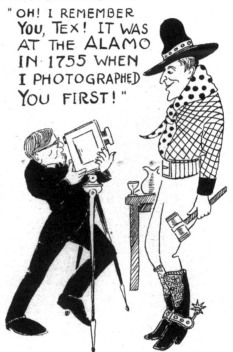

"OH! I REMEMBER YOU, TEX! IT WAS AT THE ALAMO IN 1755 WHEN I PHOTOGRAPHED YOU FIRST!"

(Radio news-photo by "Left")

We shall content ourselves with merely mentioning just a few of the highlights in the career of Photographer Jackson, leaving him free to scoop the world on some of the more momentous events of his life when his next bestseller comes out in about 1975. Be that as it may, our honor-guest succeeded, whether by the aid of side-door Pullmans or just plain hiking in reaching St. Joseph, Mo., and then Omaha, at which remote spots the Pony Express had its eastern and western terminals in that day.

So the world's greatest adventurer toting around a (Continued on page 5)

The Adventurer honors Jackson

The April 1941 Adventurers' Club bulletin features a tongue-in-cheek cartoon of Jackson and Tex O'Rourke on the occasion of Jackson's ninety-eighth birthday. The facing page shows Jackson in flying suit with pilot Lt. Col. George Witten. See journal entry for May 1, 1938.

(*Continued*)

box-like gadget known as a camera followed the sunset to become a bull-whacker, or cowboy, and horse trader. When he got good and bored, he enlisted as a private soldier (waiving any officer's commission w h i c h might have estranged him from his beloved camera) and took up cudgels against the "South" with Co. K, 12th Vermont Infantry. This military venture, however, took Dr. Jackson up to what was known as the "Oregon Trail," which had to be reached for the most part through the Bad Lands of Nebraska, with which our honor-guest became very sympathetic and later photographed; also made paintings of and revealed them as actual beauty-spots, if you know what we mean! We do not—having been there too!

After that came a natural and lawful end of Dr. Jackson's military service, with an honorable discharge and a return of enthusiasm for the camera, so he was ready for bigger and better conquests. Into the wilds of Wyoming then went the ace adventurer; but the Civil War was still going on, and federal scouts and foragers, coming upon the wanderer with the tripod and funny looking box, questioned, delayed, diverted and annoyed our honor-guest until, quite exasperated, Dr. Jackson wrote a letter to the War Department at Washington. He protested that the Civil War was really interferring with his business asking how the Government expected "Leslie's Weekly" or any other publication in New York to get the right dope on the virgin West, if such annoying monkey-business was continued! In due course the military leaders at Washington got word through that Dr. Jackson was not to be further molested—and he *was not,* as witness his presence here as our guest of honor tonight, hale and hearty, genial, and optimistic, asking no favors of anyone and——98 *YEARS OF AGE!*

The great art and research institutions of A m e r i c a, know and esteem Dr. Jackson. His historic handiwork is everywhere to be seen, and he says the job even at that is far from done. The press and public of America know and love Dr. Jackson for his many matchless qualities, and the record he has made as an artist and chronicler, a surveyor and recorder of useful facts, and above all — as a friend, companion, loyal citizen; a man, who in memory at least, will live on forever!

Yes, Dr. Jackson is the peer of all adventurers because he started adventuring first, will finish last and finally will have made contributions to the knowledge and art of the world that none of us can match!

So, Dr. Jackson — *YOU WIN!*

— *Elmore Leffingwell.*

plane and enjoyed himself hugely for several hours, looking down the chimneys of Manhattan Isle. Then he turned to George Witten and said: "Say, why can't I fly to the Pacific Coast?" He was assured that could be arranged.

"But you understand, Col. Witten," chirped our guest-of-honor, "I mean a *non-stop* flight! No hopskip-and-jump trip for me!"

Our flying Colonel stared and gasped, narrowly averting a tail-spin. "Dr. Jackson!" he shouted, "You're way ahead of your time! All passenger planes stop en route! Only racers make the non-stop trip!"

"That's me!" snapped Photographer Jackson!

When You Say You're Old - *You Are!*

Lt. Col. George Witten of this Club, who flies through the air with the greatest of ease, recently asked one of our members to take a spin in a plane with him. "Thank you," was the reply, "but I'm 40, and too old for that sort of thing!"

Dr. Jackson horned into the situation and the invitation from Col. Witten was transferred to him. He hopped into the

The Old Oregon Trail Calls Him Back!

Airplanes may be making the sky-trip from New York to Eugene, Oregon, in "*nothing flat*" when the year 1943 rolls around, but that will have no influence on our guest-of-honor because he is already booked to head a "trek" which the American Trail Association is planning. He will poke along the entire trail, just

(*Continued on page 6*)

Ninety-third birthday

A party for Jackson at his son Clarence's home, April 4, 1936. Bonney identifies the attendees as (left to right): "Jackson, Mrs. Pierce, Bonney, Mr. Pierce, stranger, Deming, Clarence's two children, Father-in-Law and Mother-in-Law of [Clarence] Jackson, Clarence and Wife, 2 friends of Jackson, Jimmy Coit, G. Y. Barber, Miss Pierce, Mr. Fuchs, Mrs. Deming." Photo by Jimmy Hare.
S0025316

Postcard from Yellowstone

Jackson stayed in touch with Bonney even during his annual western trips. He sent this card to Bonney from Yellowstone on August 27, 1936. S0025318

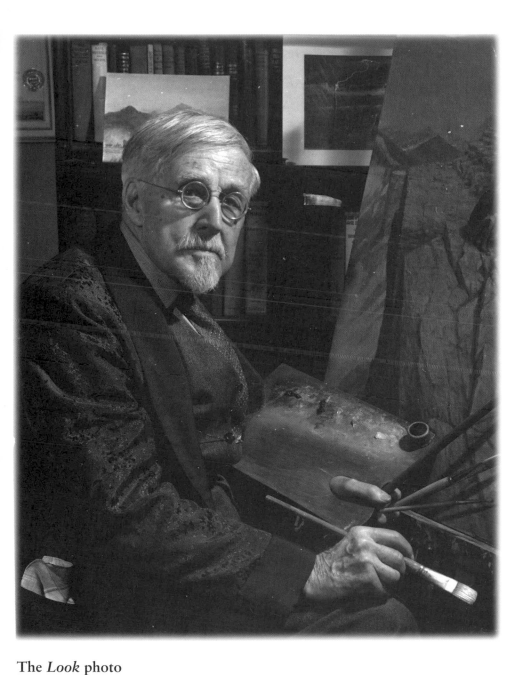

The *Look* photo

Frank Bauman photographed Jackson for
Look magazine, September 1939. See journal
entry for April 1, 1942. S0025214

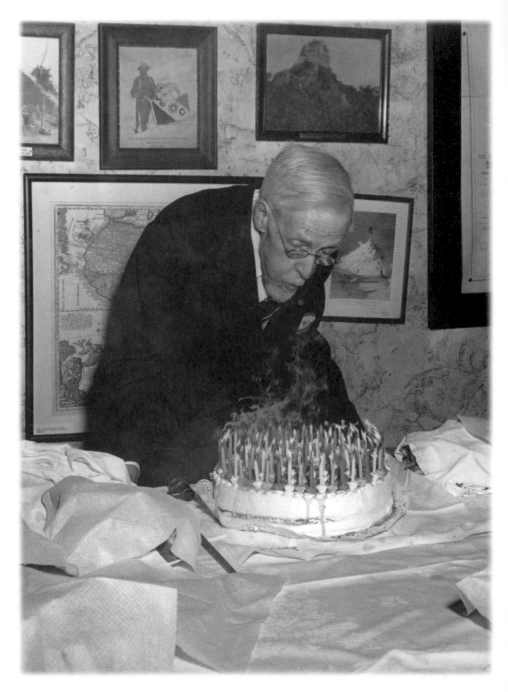

Ninety-ninth birthday

Jackson's son Clarence gave Bonney this shot of
Jackson celebrating his ninety-ninth birthday at
the Explorers Club. S0025504

1937

New York
June 2, 1937

Dear Bonney:

It has been about 2 weeks since your last letter. In that all three of you were more or less "under the weather" and hearing nothing further I have felt some concern as to how you are coming on. Much of the responsibility for not keeping in touch with you is my fault in not replying at once to your letters, the only excuse being that you were expected to come over here some afternoon. Your failure to do so in the meantime is what is worrying me. My fears are lessened, however, by the old adage that "no news is good news," so I trust you are alright in every way

I suppose the real reason we have not seen or heard from you is because of the time and attention given to the new house—probably at about this time in the condition that takes all your spare time—I am expecting [an] invitation to the "house warming" this Fall.

I sincerely hope that the wife, the baby, and yourself are over with your colds and now that more settled summer weather is coming on, that you will suffer no further inconveniences. Walters tells me the baby is growing wonderfully. Expect to see you before I leave for the West— may even visit to East Orange myself before then. My regards to Mrs. Bache when you see her.
Sincerely,

W. H. Jackson

June 7

Elaine's arrival on Oct. 15, 1936 certainly did put a "crimp" in the Jackson-Bonney "get-togethers!"

However, as soon as our homelife became a little settled, I found time to make a little visit at Jackson's headquarters and he subsequently came to East Orange to see Elaine at which time he presented her with

a sterling silver porringer with her name engraved upon it. I missed a few Adventurers' Club meetings but got around to the December meeting when Jackson, Jimmy Hare, Jimmy Coit and others helped celebrate with several rounds, mostly Martinis!

Jackson again visited us at East Orange on February 13, 1937 and I took some movies in color of Jackson holding Elaine—came out pretty nice, too.

Saw Jackson again at some subsequent Adventurers' Club meetings— but the big night was on April 2, 1937 when Coit and I gave Jackson the annual dinner on the eve of his 94th birthday anniversary. And what a grand time. Those present were Jackson, Deming, Hare, Barber, Clarence Jackson, Coit and Bonney.

After loading "to the gills," we sat around and enjoyed the fire place and wonderful yarns. Clarence told one on his dad—about the early days in Denver when Jackson wore the old fashioned, long nightgown and stood with his back to the fire to warm his rear, when suddenly it caught fire and he went jumping around the room attempting to put out the flames and keep from burning his "seat." Clarence demonstrated— and a glorious laugh was had by all—including Jackson, who seemed to enjoy the story very, very much. No pictures taken

June 9

This morning I had to go to NY City on business at the Acme Fast Freight Co. office, and on the way stopped at the Latham Hotel, but Jackson was not in. When returning at noon I found him "at home" and he was delighted to see me, and I was feeling the same about seeing him. He said he was soon to write me a letter saying he was sorry he would not be able to see me before starting west, as he had changed his plans and was leaving tomorrow night. He then showed to me a letter from the University of Colorado, at Denver [sic], to the effect that at commencement exercises on June 14th they would present to him a medal of distinction in recognition of his work and interest in the West and desired to make the presentation to him in person.‡ Jackson said Albright

‡At the University of Colorado commencement exercises in Boulder on June 14, Jackson in cap and gown received the honorary University Recognition Medal for Distinguished Service to Colorado and the West.

had been out there recently and was back of the action. Consequently, Jackson changed his usual plans of going west about July 1st and would go now, stopping in Detroit to see his daughter one day, then on to Denver

Jackson has been very busy recently, being wined and dined by many, in fact, last week-end he spent with a friend at Scarsdale and had too many fancy cocktails and Brazilian tea, upset his insides, and suffered from the "runs," and Monday night he was a guest at the Town Hall Club at a luncheon to Edwin Markham and said he went through the motions of eating, but actually only tasted a little of the many things put before him

He gave me a reprint from Appalachia magazine of his article "With Moran in the Yellowstone" as I never did receive the one he mailed to me. He also gave me a copy of the folder "A Reception in honor of Captain W. H. Jackson on his 94th Birthday, April 4, 1937—Explorers Club, NY"—He had placed a question mark in front of "Captain" and remarked about the use of Captain and Doctor in connection with his name. He said Robinson, Sec. of Explorers Club, always insists on using "Captain" but he did not know why and indicated that he was not altogether pleased about it—and he felt the same about Schindler and some of the other boys at the Adventurers' Club using "Doctor." Of course, he never was cursed with a "Captain" or "Doctor" appendage and is satisfied about it, and happier to be just plain "W. H. Jackson." . . .

I then told him the Mae West story—about Mae stopping off at the Rodeo in Wyoming. Greenberg had sent to Jackson an auto plate advertising the rodeo for the summer and that was the reason for the story telling. After I finished saying that Mae wanted to know whether the cowboys always carried their guns in their pockets, or whether they were just glad to see her, you should have heard him laugh and he followed up with many a chuckle. He agreed it was a great story—could be told in good company—and he was going to tell it to friends when he got out West

I asked Jackson why he did not fly out west. He said he could not arrange a stop over at Detroit to see his daughter—and besides he wanted to go to the Pacific Coast after leaving Denver, consequently ticket arrangements made it necessary to get the whole trip properly lined up to

save cash. He said that some day he wanted to make a non-stop air flight to the coast and if he could not afford it he jokingly remarked that maybe all the publicity he was getting recently might help in getting him a trip for the news value, etc. out of it. But best of all he would prefer to have me and Jimmy Walters make an auto trip with him the full three months of his vacation as he would enjoy himself more to always have some one with him he knew and felt content with during the entire trip.

Cheyenne, Wyo
July 13, 1937

Dear Bonney:
. . . I've forgotten how long it is since I got [your] letter for I had discarded the envelope and there is no interior evidence of the date. But I am mighty glad to know you are all so happy despite the hot weather and that the young lady thrives upon it. We have had some rather warm weather out here but you know how it is in these high altitudes for I don't mind it much. Sunday I was one of a small party pic-nic-ing up in the Laramie Hills between here and Laramie City. Showers all around in the mountains but did not hit us until supper was about over which necessitated a quick clean up to get under cover. These showers, however, which have been occurring sporadically along the foot hills, have moderated the temperature so much that I have seen some "softies" wearing overcoats.

For a little ancient history of my doings—The affair at Boulder, in which I appeared in "cap and gown" to receive a certain award went off in fine shape, but the medal has not come to hand yet—all in good time— Met my friend Gilchrist who drove me all through New Mexico last year. We intended going to the Mount of the Holy Cross by way of Loveland Pass—a new route, but this pass was still closed and have deferred the trip until late in the season. With other friends a long trip was made thru the Black Hills Country taking in the colossal figures in Mt. Rushmore and the great bowl from which Picard sought the stratosphere.† Had a big celebration and a hot time at old Fort

†The Stratosphere Bowl near Rapid City, South Dakota, is a natural formation favorable to the launching of balloons. From here in November 1935, Explorer II was launched, ascending to a then-record height of 72,395 feet.

Laramie†† *in commemoration of its dedication to the nation for all time.*

Friends here want me to wait until "Frontier's Day" about the last of this month, but I think I shall take in Yellowstone Park in the meantime and then go on to California, returning in time to join some members of the Oregon Trail Assn. in a meeting at Salt Lake City about Sept 1st. You will hear from me later about it all

Victor, Idaho
Aug. 5, 1937

Left Cheyenne two weeks ago on the UP Metroliner. Have had a glorious time, most of it in Yellowstone Park. Am now on my way back to join party of the Oregon Trail Assn. in a review of matters along the old route. Due Salt Lake City Sept 1

Jackson

TO MEMBERS OF THE ADVENTURERS' CLUB

Our beloved member Captain WILLIAM HENRY JACKSON met with an unfortunate accident in Cheyenne, Wyoming last August 14th, when a grating that he was standing on gave way. He fell through breaking several ribs. His condition is not serious but he'll be at the Memorial Hospital in Cheyenne for a few weeks.‡

I am sure that Captain Jackson will be glad to hear from some of his friends in the Adventurers' Club.

Raymond C. Schindler,
President

††Fort Laramie, a fur trading post since 1834, had been purchased by the U.S. government in 1849 from the American Fur Company. Thereafter a military reservation, it was abandoned in 1890. In 1937 the Wyoming Historical Landmark Commission acquired title to 214 acres of the old site with its ruins and held appropriate public ceremonies. The fort was taken over by the National Park Service in 1938 and is now a National Historic Site. Jackson first saw the frontier post during his bull-whacking days of 1866.

‡Jackson was hospitalized in Cheyenne for a month as a result of several fractured vertebrae. Jackson to Meacham, October 9, 1937, Meacham Papers, Special Collections, University of Oregon Library; Jackson, *Time Exposure*, 336.

Telephoned to Jackson. He said it would be fine to have lunch together and I left the office at once and headed for New York

He looked fine—and acted cheerful as ever. There was no sign of his recent accident in Cheyenne, except possibly a slightly stooped appearance, it seems his back is slightly more "humped" at the shoulders. We enjoyed a long chat—it was the first I had visited him in his rooms since a short visit a few days after his return east, and when he visited our home at 30 Potwin Ave. Madison, N.J. with Jimmy Walters a couple weeks ago

Jackson was painting another scene of a western fort of covered wagon days for use in the book of his pictures which Dr. Driggs is planning to publish—[it will be] a picture a page with descriptive reading material—the pictures being owned by the Oregon Trail Association.

He had on his dresser a pile of bronze, silver and gold medals awarded to him during past years since 1880 in Denver by photographic societies and during subsequent years at various other cities—and some foreign countries, such as India, where he was awarded a prize for some pictures he exhibited while traveling around the world. He said he had many more but they had been lost.

I then observed a picture—an oil painting of tents of Civil War days and two soldiers. Upon inquiring about it, he cheerfully—and quite gladly explained that a man named Landon of Vermont had seen the spread of pictures by and of Jackson in an issue of the Sunday Herald Tribune of NY City last summer and had wondered whether that Jackson was the man who painted the picture mentioned. Landon is the son of Capt. Landon of Co. K Vermont Volunteers (which was Jackson's company) and had gotten the picture from his father. He sent it to Jackson to identify the picture and the two soldiers in it. On the back of it Jackson had printed his name and the date 1863. He was quite pleased to see his picture after 74 years! It was in splendid condition. Jackson said he had had it photographed. He said one of the soldiers—the one cleaning his gun was Birdsall, but he was not quite certain who the other one was but mentioned the name of one tent comrade

He then went into the bathroom to take some medicine prescribed by Dr. DeForest (of Adventurers' Club) for his bladder trouble which he

said was clearing up nicely, and when coming out slyly asked whether I wouldn't like a little snorter of some Scotch before going out to lunch. I agreed it might be good for my health and accepted. He said he had not been taking any lately—and after urging me to take a "good one" he broke his rule and orders and took a "wee" small one—say 2 or 3 thimblefulls. After agreeing Scotch or any other was a good thing to have around in event a snake crawled out from under the bed or bathtub and bit one—we left for lunch—as usual at the Horn and Hardart Automat

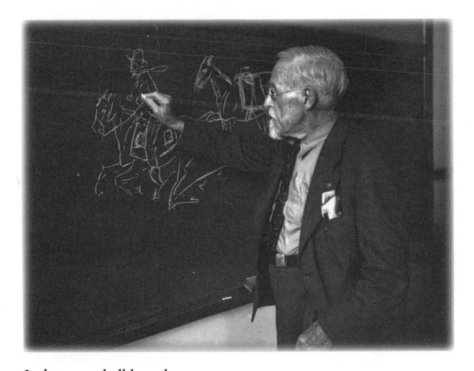

Jackson at chalkboard

Jackson lectures to a high school class in the Dearborn Village museum (Michigan) on September 23, 1937, shortly after recovering from his accident in Cheyenne, Wyoming.

S0025503

1938

January 20, 1938

Dear Mr. and Mrs. Bonney:

My enjoyable visit with Jimmy Walters and son Nash last Sunday, with dinner at Childs, reminiscent of many we have had there, and then to Demings afterwards, prepared me for your invitation the following Monday to come over to Madison for a week-end visit with "you all."
I have been looking forward with pleased anticipation for some time past when I could do that same thing and now that you have that extra room all ready for the entertainment of guests I am awfully sorry that I cannot, this week, enjoy its hospitable comforts as well as the companionship of Mr. Mrs. and Miss Bonney.

This is the why of it: I am just in the throes of editing an article by my friend Dr. Fryxell for the American Annual of Photography, which must be completed before the end of the month.†

I have had so much interruption during the week that I have not accomplished much and I have reserved Saturday and Sunday for that work. It has so happened lately that these two days have been my busiest, catching up on things overlooked or neglected during the week. But there is a wonderful attraction in an open fire, popcorn and apples— perhaps cider, that will bring me over, sooner or later, whether E. P. comes here first or not.

Tonight I am an invited guest for the Buckskin Dinner of the Camp Fire Club at the Hotel Pennsylvania so I will miss out on the Adventurers' night. This sort of thing with more frequent meetings at the Explorers, have kept me pretty busy, particularly as I am such a dawdler in writing or other work. But I thank you for thinking of me and with best wishes for all, including, Elaine of course, I remain, Sincerely

W. H. Jackson

†See the first note on page 60. Fryxell's article, "William H. Jackson: Photographer, Artist, Explorer," appeared in the 1939 American Annual of Photography.

April 13

I have been very lax the past few months in keeping my written records of visits to Jackson—but I have also been very lax in keeping in touch with him. I have seen him a few times since writing my last notes dated Nov. 16, 1937; either in NY City or when he called at Madison over the week-end visit with Jimmy Walters at East Orange. In fact, he kills a couple birds with one stone by visiting Jimmy Walters and then having Jimmy drive him out to Madison to see us. A few months ago when he called he particularly brought two photographs—one taken while lecturing in the Dearborn Village Museum on Sept. 23, 1937, the other taken Sept. 15, 1937 when he left the Memorial Hospital at Cheyenne, Wyoming

The usual birthday anniversary dinner . . . did not materialize this year. I made several efforts to get in touch with Jimmy Coit, but he did not answer my inquiries, and all I could learn was that Jackson would be out of the City, the information coming from Coit's brother. But grand old chap that Jackson is, he let me know without mentioning fact of the failure to hold the party, that he wondered what happened to me, by mailing to me a copy of "Science News Letter" of March 19, 1938, which arrived on April 8th. It contained an interesting article by Ronald L. Ives††

Yesterday the 12th, I telephoned to him and went over at noon time We exchanged greeting and inquiries into our health, happiness and activities. He spent his birthday anniversary at his daughter's, Mrs. Pattison at Chevy Chase, Md. and enjoyed a grand celebration. All his children and grandchildren were present, the first time in many years that all have been together. As usual he did not remain there long, having returned on April 7th as he had understood that some organizations were to give him parties, but none so far came to be except the Adventurers' Club dinner at Hotel Woodstock on April 11th.

Of course, Deming had a party for him at a recent Sunday night gathering in his "teepee."

††Ives' biographical article, occasioned by Jackson's paintings being hung at the Department of the Interior museum in Washington, D.C., lauds the artist's work, his pioneering in photography, and his exploration of the West.

[Jackson has] put the final touches on a small oil of the camp in the Mancos canyon, depicting the boys around the camp fire the night they first saw the first cliff dwelling—and framed it and hung it. It is a dandy—just the right effects of camp fire and evening glow and haze. He has been busy completing or touching up water colors for the Oregon Trail Association and says they are about ready to submit the pictures to the printer for the brochure. He reports that Driggs has had many of the pictures so long and probably made some loans of them, so that a few are missing. But he doesn't mind doing them again—some, he said, he has already done three or four times

Jackson called my attention to a bound book of greeting cards he had received, and we enjoyed a happy fifteen minutes looking over them. It was a homemade job from cover to cover—including the covers, by the students of 6B-3 class of a school in NY City. A year or so ago someone got him to address the class and the youngsters were so pleased afterwards that they sent him homemade greeting cards on his 94th anniversary which I believe I have heretofore mentioned. This year they went one better by making greeting cards, full page paintings, wrote long letters or poetry etc. and bound them. Many cards were quite ingenious and required skill and patience. Jackson was tremendously pleased and in return he personally inscribed to each one a print of his picture made from a cut of a photograph taken by Robinson of the Explorers Club

April 17

We had just finished our dessert and were chatting at the table at Eastburns when the doorbell rang—heralding the arrival of Jackson and Jimmy Walters. After introductions, where necessary, we sought comfortable chairs and chatted—Jackson being as spry and chipper as ever, despite a late evening hour and activities of the preceding day. During a conversation with Mrs. Bache, he said he expected to go to California again this summer and hoped to see his brother whom he has not seen for 50 years. Jackson said this brother was a "drifter like him" and was never at home in Santiago, Calif. whenever Jackson was out there—consequently they haven't met for a long while. Jackson also plans to see his grandchildren while out there. He also mentioned that he has another brother living whom he hasn't seen for a long while.

After a long and pleasant visit, it came time for him to leave to get back to NY City to be on hand at Demings' usual Sunday night party. I accompanied them to the car, and while we exchanged an enthusiastic hand shake he said, "Will I see you in NY some time soon for lunch or a visit to 'Sinful Maverick' Garrettson or will I have to come out to Madison to see you again before you come in?"—good old boy! . . .

April 22

After finishing my business at the Acme office, I phoned to Jackson who replied he would be glad to have lunch with me, so I invited Flynn [of the Acme Freight Company] and we met Jackson shortly later. After a short visit in his room we left for lunch

Of course, the conversation, as is usually the case whenever two people meet these days, turned to the New Deal activities and the [?] of Pres. Roosevelt and his crown prince James Roosevelt. Some good stories were told, LaGuardia (Mayor of NY City) was condemned, and a few others "panned." Historical subjects were mentioned and particularly distorted facts and the failure of many writers and speakers today to do sufficient research or use care. . . .

While in his room Jackson showed us a small oil on light canvas about 10 x 12 of himself on horseback with a camera and tripod over his shoulder, coming up over a sharp peak followed by his packer and 2 more horses, which he said he just found among his various items, having painted it he thinks about the time he left the Detroit Pub. Co. and came east. It has one abrasion streak across it which he plans to repaint, then clean and hang

> *Bonney's marginal note:* This is the picture used on the dust wrapper of the book Clarence published after WHJ's death. Clarence painted in his Father's initials and date "1873" (I argued against it.)

Jackson said Major Russell (of Adventurers' Club) had been to see him about telling a story on Bob Ripley's Believe it or Not Radio Hour . . . and said Major Russell was going to ask me what I thought would be the best story. I mentioned to Jackson that the story of finding the old revolver might be good; of course, a lot of Jackson's life could be worked in with it.

May 1

Jackson visited us over the week-end of April 30–May 1, 1938. He phoned to me at the office, after receiving my letter on April 29th saying he was not going to Albright's home for the week-end and would come out to see us. I suggested he come to office some time after 11 A.M. Saturday morning. He did not show up and at 11:50 I left office, wanting to be certain to meet him before the train left at 12:10 P.M. As I walked down the platform, I thought I recognized him coming up #2 platform which would necessitate him crossing the tracks, and particularly treacherous switch-points, which might open and close anytime and trap him. Sure enough it was he. He had taken the wrong platform. He said he was confused—could not understand how he could have left New York City at 10:30 A.M. and gotten to Hoboken at 10 A.M. He had forgotten that he left the City at 10:30 A.M. by Daylight Saving Time, while the R. R. Co. operates on Standard Time and its clocks are shown accordingly. Consequently, he sat down in the waiting room and read his paper for about an hour, and then headed for the office. It was fortunate we met, because had he been a minute later, or I earlier, we would have passed on different sides of the train, and that would have been unfortunate, indeed, with me running wild hunting him, and he confused by tracks and trains and probably risking his life—luck was with us!

As he had already purchased his ticket, we boarded the train, and arrived in Madison without further adventure. We walked the mile to home, as it was a splendid day, and he was glad to get the exercise. Dora had lunch prepared for us, and that disposed of, we chatted on the sun porch for a few hours until Elaine finished her nap. Jackson had with him a half dozen photographs furnished by the Parks Dept. at Washington—reproductions in 8 x 10 of his 20 x 24 photographs taken in 1875 in Colorado.‡ They were excellent, but Jackson said they were not the best taken by any means, as the best—the choice pickings had been broken years ago when a case containing the original glass plates was knocked over by an assistant during one of his exhibitions.

‡The giant camera, using 20 x 24 glass plates, was the largest Jackson used in the field. He also carried a 5 x 8 camera on this 1875 expedition to Colorado, Utah, and Arizona. Jackson, *Time Exposure,* 236–42.

He also had an 8 x 10 print of himself in a flying suit (4/21/38) standing beside an open cockpit plane, with Lt. Col. George Witten at the controls. Jackson later went up with Witten and flew around Long Island and enjoyed it. However, Jackson laughed about being dressed up in a heavy flying suit (Witten was not) and said it would have been unnecessary†

In the evening we chatted, Jackson read the phrenologist's report to Dora—and he laughed heartily at the first line reading "You have a noble head." The phrenologist "hit" one or two points about Jackson, but he does not put any "stock" in the report It does mention that Jackson should go into the army to "broaden" out and get a few "knocks"—but Jackson had the right idea in saying that "it is like most all other predictions—merely in general terms so that there is always sure to be a few 'hits'—and many 'misses.'"††

We finally turned in at about 11 P.M. but as that was a little too early for Jackson, he asked for a few volumes to look through, and I gave him some of my mountain climbing volumes containing many fine pictures—particularly "Navga Parbat"—which he enjoyed very much.

Sunday morning found Jackson "under the weather." He had a distressing night, having upset his stomach Saturday by eating a large amount of cashew nuts. He had not told us about it until Sunday morning explaining that such nuts usually act as a mild cathartic but had been a little more than that this time. Fortunately our meals yesterday had been fruit and vegetables only. He apologized by saying that he was "sorry that I had been a little indiscreet." Consequently we took things easy. He did not have much sleep all night and had been up at 6 A.M. and sat in the tub in a warm bath for a long time, and then taken a cold shower, in accordance with doctor's previous instruction which he said helped him considerably

At all times he carried on well, being chipper at the dinner table,

†The pilot for this flight was Lt. Col. George Witten, a member of the Adventurers' Club. Jackson climbed on board the open-cockpit two-seater after a forty-year-old club member declined a ride, saying he was too old for that sort of thing. *The Adventurer* (May 1938).

††Jackson had saved the skull-bump interpreter's report since 1861. Collection 341:23, CHS.

telling stories and commenting in general He also got great enjoyment out of spinning coins on the floor for Elaine's enjoyment—and he likewise got great pleasure out of holding her, observing her and taking interest in her offerings of her playthings.

As he expected to go to Demings that Sunday evening I took him to the depot to catch the 7:21 P.M. train. While we were sitting on the bench waiting for the train I heard #6 blow for the crossing at the west and I knew what to expect later. I told Jackson that a steam train was going to roar through the station in a few minutes. We watched it approach and as it came round the curve and blew for the station warning the passengers to get back I told Jackson to hold his hat and keep his eyes closed. Most of the passengers waiting for the electric train to follow, went inside the depot but Jackson and I "stuck it out" and suffered the dirt and dust as #6 rolled, roared and thundered by. He seemed to enjoy it much as any youngster would—and commented about what would happen if such a mass traveling at that speed should strike a stationary object.

A few minutes later the electric train arrived and we bid good-byes.

May 11

Last night I was Jackson's guest at the Explorers Club to hear Melzer talk and show pictures of his hike along the continental divide across Colorado‡—to be published later in the Saturday Evening Post

We dined at Childs Fifth Avenue at 30 St.—as usual starting with one of Grandmother's Bulldogs (gin & orange juice) and then he ordered roast pork! I took a vegetable plate. He topped it off with a chocolate nut sundae!

During the meal he again commented about Clarence's lack of interest in his (Jackson's) activities and again opened the subject (which hurts me now as he too frequently mentions the matter) of the disposition of his old diaries and other items of interest. I again stressed the point of him seeing that they are safely put in the hands of some organization

‡Carl Melzer, forty-five, with his eight-year-old son and a nineteen-year-old companion, had ascended all fifty-one of Colorado's 14,000-foot peaks during the summer of 1937, according to *The Colorado Magazine* 14:6 (November 1937), 236; also *Trail and Timberline*, April 1938, 43–4.

such as the Colorado Historical Society to which he has already given some items (Early Colorado Journals as I recall it) or to the New York Public Library.

July, 1938

Left New York July 22nd. A week in Detroit where I had a cordial interview with Henry Ford—good progress is being made with my old negatives. Arrived Denver Sunday morning at the Albany Hotel and expect to hang around here the next ten days. Love to Elaine's parents—Best Wishes

Jackson

> *Bonney's marginal note:* The reference [is] to Jackson's old negatives taken over from the defunct Detroit Pub. Co.

Victor, Idaho
Aug 28, 1938

All lovely out here, but I am near the end of the trail for this year & will soon be turning back for the old Latham. Love to all,

Jackson

New York
12/8/38

Dear Bonney: Tune in WEAF at nine o'clock on Tuesday the 13th for a "dramatized" story of my adventure among the "renegades" of the Blue Mts. in 1874.†
Love to Elaine

Jackson

†Jackson's early exploits were romanticized for public consumption during the 1930s. The adventure mentioned here must be the one described in Bonney's entry for April 5, 1933.

1939

January 7

I have been very lax in not keeping my diary up to date. I have seen Jackson several times since last summer both at visits to his room and while visiting us at Madison N.J. several times accompanied by Jimmy Walters whom Jackson would sometimes visit over Saturday and then the two of them would motor out to Madison.

All of us can see the gradual change coming over him as he ages. Of course the accident in Wyoming a few years ago took its toll but age has also gradually weakened his hearing and eye sight, he tires easier and sometimes suffers from slightly upset stomach as was the case when he visited us last fall but he still is a mighty remarkable man for his age! Mentally he seems to be as alert as ever, recollects easily early experiences and knows where to find anything he wants in books or in his files. Unfortunately, he realizes he can't live forever and has a greater tendency to open and discuss the question of the disposition of some of his personal effects It hurts me to hear him talk of that eventual day which will someday take him from us, but he mentions it without any qualms or sentimentality. He says he realizes he can't go on forever, that the day must come sometime, and seems to look upon that impending day as one on which he will merely be going away on one of those usual summer jaunts to the West.

. . . Jan. 2nd Jimmy Walters phoned saying he and Jackson were coming over to the house and shortly afterwards they arrived. Jackson said he had not gone to visit his daughters in Detroit or in Chevy Chase but had remained in New York City for the Christmas holidays, the first time in seven years, and spent Christmas with Clarence. As usual he went to Demings' New Year's Eve Party. Apparently he felt a bit lonely, for on Monday he came out to the Orange Camera Club to their annual reception but he hadn't told Jimmy he was coming, although he probably expected to meet him there. When they arrived at the house both were quite cheerful and admitted they were filled with "Tom and Jerrys"

etc. After visiting for a few hours they left but I made a date with Jackson for the evening of Jan. 6.

On Friday night Jan. 6 Dora and I met Jackson at his room He is still painting some nice pictures—and just finished one depicting a night in a storm as lightning struck a telephone pole alongside which the wagon train was stationed for the night. It is based on an original pen and ink sketch in his original book of sketches.††

He showed to us many items of interest, newspaper clippings, books, paintings, letters, etc and we chatted for about an hour or more before going out to dinner. Among his recent acquisitions is Stefansson's new book "Unsolved Mysteries of the Arctic" being #142 of the edition limited to 200 copies and sold at the Explorers Club. It is nicely inscribed to Jackson.‡ He took my breath away when he said he wanted me to have the volume and that as soon as he read it he will pass it along to me because he knew of my interest in the Polar Regions. He remarked that he was acquiring too many books and other items and had no place to keep them and wanted all his space for western items in which he is particularly interested. I tried to talk him out of the idea but he seemed determined to see that I got the book as soon as he could read it to familiarize himself with the contents.

We went to Childs, as usual. On the way he said he wasn't even doctoring his sore throat but would see a doctor Monday. He [was] to attend the Photographic Society Meeting the next day to which he had been invited to make a speech [and] the newspapers report his attendance and speech. The Herald-Tribune quotes the same thing that he said to Dora and me—that he did not see what new and startling change could be made in photography now except to improve present practices.

††Severe thunderstorms are often mentioned in the diaries of Oregon-California Trail emigrants. In his autobiographies and a painting, Jackson recorded the drama of a wild night for travelers beset by such a storm.

‡Vilhjalmur Stefansson (1879–1962). Arctic explorer, author, lecturer. Schooled at the University of North Dakota, University of Iowa, and Harvard University, he spent eleven years on expeditions among the Eskimos of the Arctic. After 1924 he engaged in writing and research on the northern regions while consulting for Pan American Airways and the U.S. government. He was president of the Explorers Club in 1937, of which Jackson was the beloved patriarch.

After the meal we walked around to visit with the Demings for a while—then around by a small shop to get some lemons for a hot punch, then back to his room for another chat. He gave us 6 nice apples We did not open the Scotch but urged him to take a hot punch and get into bed and with hearty good nights at the elevator we left him

February 18–19

Jackson visited us over the week-end, having met me at Hoboken at noon on the 18th. He looks better than I have seen him in the past few years—getting quite stout, nice plump cheeks and fatter around the waist. He said his trousers are so tight he can barely get them closed at the top and no longer need wear a belt to hold them up. When he put on his tuxedo for the Explorers Club annual dinner last month he found he had to squeeze into it and fears he will have to get a new one when the next occasion arises to "dress up." Still eats anything. Dora had prepared lunch for us and after he partook of a big bowl of thick homemade split pea soup and several crackers, peanut butter and jam, Dora asked him whether he would like ice cream on his pie. He replied that he would and was presented with a generous slice of freshly baked pie with a goodly portion of homemade ice cream on it. He leaned back, took a deep breath, threw out his chest and said "All this and heaven too." These words are the title of a recent book of fiction—a book which I have seen advertised only once His remark shows that he still is a keen observer or I'm slipping badly! At any rate all of us enjoyed a hearty laugh—and Jackson "put away" every bit of the pie.

While I assisted Dora with various details of housework, etc., Jackson enjoyed himself browsing around my book cases taking particular interest in Russell's "Good Medicine" and "Plowed Under."† He said he considers Russell the finest painter of the old west—and he enjoyed my copy of Russell's "Worship to the Morning Sun" which hangs in the breakfast nook opposite the seat we gave him.

In the evening we sat by the fire, chatted and listened to the radio— and some records of light orchestral and similar music.

†Charles M. Russell's *Trails Plowed Under: Stories of the Old West* (Garden City, N.Y.: Doubleday, Page, 1927) is a classic collection of yarns told in cowboy vernacular by the master western painter and humorist.

Shortly before 11 P.M. I actually fell asleep while listening to a record, but Jackson was wide awake, possibly as a result of a short nap he enjoyed in the afternoon when he awoke a little startled, thinking, he said, that he was in his room and heard the telephone ring—so it appears his rest is disturbed in the same manner as with us younger folks.

He wasn't ready to retire at 11 P.M. altho we were. Dora asked him whether he would enjoy a cup of Ovaltine—and then his secret of good health—or at least fatter nature was made known. He said that for the past year or two he had made it a practice—in fact a habit to take a cup of hot Ovaltine every night before retiring. He went to his bag and took out a bottle which contained his mixture of Ovaltine and malted milk. Ours was with regular milk, but he enjoyed his regular mixture. After fixing him up with good reading material to keep him awake until midnight or later we retired. In the morning when I arose at 8 A.M. he was still snoozing and later said he enjoyed a good night's rest.

While I busied myself with chores about the "estate" he again browsed about my books. He checked over many volumes to see that I had important ones but missed Stoddard's lectures volume which included the Grand Canyon trip which volume was almost entirely hidden behind some fancy work on the side of the book case so he did not do bad; I might have missed it if I hadn't known just where I kept it. As we were looking over the volume, we missed the word "except" in his handwriting stating that all the pictures illustrating the lecture were taken by him *except* those marked with an "X" he immediately commented that certain pictures were taken by him and he didn't understand why he had not marked them, and he marked several when the "strangeness" became so overpowering we checked back and found that those marked previously with an "X" were those not taken by him I mention this incident to show how alert mentally he still is

April 6

Jackson phoned to me yesterday at noon saying he wanted me to be present that evening (April 5th) as his guest at a little birthday anniversary dinner with some friends at the Hotel Latham. The usual cheery "come-come" answered my knock. I found him more cheery and chipper than ever, in fact I think he looks and acts better than he has in the

past several years. His face is more plump—his waist band expanded beyond what I heretofore took as its normal status. As usual our conversation turned to our past activities, and particularly his "doings" in the line of painting, writing, reading etc. He is still painting, having one unfinished water color (about 20 x 20) of some famous battle ground in the West (which he named but I have forgotten). As usual we "pawed" thru his circulars, pamphlets etc and discussed some books He insisted that I take home Stefansson's "Unsolved Mysteries of the Arctic." . . . He never understood why he purchased the volume, but I think it's quite probable that because of his poor hearing he did not fully understand whatever announcement was made at the Explorers Club at the time the sale was made and that he probably assented to some remark not realizing what he was doing—as this has happened in many instances of which I know and he has later corrected his statement or a nodded assent by the proper remark after his listener has questioned or otherwise shown some surprise at his first answer

April 30

We were pleasantly surprised early this afternoon by the tooting of an auto horn at our back door as Jackson and Jimmy Walters arrived for an unexpected visit. Both had attended the Annual Dinner of the Orange Camera Club last evening but apparently it was a little too much for Jim as he acted and appeared to be sleepy—and after a short but cheerful conversation with Dora, Mrs. Bache and me we finally persuaded him to take a nap which he agreed to do, having enjoyed the same privilege when calling here several months ago. While the girls prepared dinner, Jackson, whom I could not persuade to take a nap, and I strolled around my "estate." It was a delightful day but snappily cool and I put on a windbreaker and hat. Although Jackson kept aloof from sissiness and refused to put on his hat, saying his regular suit of vest and coat was sufficient. He looked fine and acted the part but I noticed him shrug his shoulders a few times when the chilling winds hit him. We were out probably a half hour, then we came in to browse among my books

Jim awoke after an hour's rest and all of us went on the lawn and indulged in taking color movies and colored and black and white stills! I got two nice black and white stills of Jackson and some colored mov-

ies. He joined in the fun whole heartedly as usual and even getting down on the grass with Dora and Elaine by the forsythia bush

May 25

Visited Jackson at his hotel tonight. He had returned 2 days before from a 10 day visit with Barber at his farm in the Adirondack Mountains. Jackson looked and acted fine. He was chipper and talkative and all was well with the world except that he expressed a bit of provocation about the article about him written by Karl Detzer and published in the Washington (D.C.) Post on May 7, 1937, which was condensed and published in the June, 1939, Readers Digest on pages 29–32 The Digest condensed it considerably and in some respects avoided repeating erroneous statements, corrected others and in a few respects created some by the condensation††

I have never before heard Jackson referred to as the "father of the picture post card," nor heard him make such claim, even when he has shown to me the dozen or so cards he drew while in Civil War Camps and later salvaged after he returned home

The [Washington] Post article mentioned that he [currently] had many cameras and particularly a "minicam." This is entirely incorrect. All he has owned during the past several years that I have known him have been the average run-of-the-mill Eastman and a small German make camera. All of these ran between approximately 2½ x 3½ to about 3 x 4½ pictures

> *Bonney's marginal note:* 6/1/39 Jimmy Walters . . . said he had lunch with Jackson today—they went to Abe Cohen's Camera Exchange . . . and Jackson bought his first camera for color film—an Eastman Bantam 4.5 [with] 47mm lens—and Jackson bought his first color film (Kodachrome) and [?]. Jim says Jackson is good enough to get first class pictures without a light meter.

††Bonney passionately corrected errors in Jacksonian mythology. The following passage illustrates his point-by-point style of refuting inexactitudes. By implication, one may deduce the corresponding erroneous statements put forth in the article.

Jackson was not "first in the Yellowstone" and never claimed to be

Jackson very modesty refuses credit for being the discoverer of the Mesa Verde Cliff ruins He always credits early prospectors and trappers with these discoveries Jackson's official report and Ingersoll's letter to the N.Y. Tribune were the first notices of the ruins

His early works during the Civil War and across the Plains in 1866 and return in 1867 consisted of sketches but after that it is safe to say his work was by photography. I have never heard him say he did any sketching after 1870—I have never seen any such work by him and I doubt that he did sketch unless on rare occasions‡

[In 1866–7] he did not join a wagon train of 300 Mormons and he did not "sketch Indians all the way," [and] Indians did not bother them on any part of the trip.

Jackson said tonight he never claimed to have made the first photographs of the [Pawnees, Omahas, Poncas, and Winnebagoes in Nebraska]—in fact he said other photographers—many of them—had visited and photographed these tribes long before he did.

Jackson never named it "Mt. of the Holy Cross" and never claimed the honor, altho he was the first photographer of the peak

Jackson laughed about his pleading for 31 years with Congress to establish the Mesa Verde park. He did no such pleading but naturally praised the wonders of the place whenever asked about them

After an hour's chat we decided to go out to dinner As we were finishing our soup we were surprised to have appear at our table Mr. Ellison of Tulsa Oklahoma, President of the Stanolind Pipe Line Co.† He was in the City on business and had been out at the World's Fair and upon returning late decided Jackson had probably already eaten, hence he ate and called for a visit. He joined in our chat.

A few days ago Jackson received a letter from the Selznick Movie people saying they were planning to photograph "Gone With the Wind"

‡Jackson indeed sketched after 1870. Some of his drawings of the Hayden survey and the world tour of 1894–6 are reproduced in *Time Exposure*. Many sketches also were part of his work as an illustrator in the 1920s and 1930s.

†See note regarding Ellison on page 26.

and proposed working into the picture something about Civil War photography and understanding that he had had such experience, were asking him if he desired to "participate." The letter did not state the nature of the participation, but Jackson assumes they wished him to serve in a consulting capacity. He said he had written them telling them that he did not photograph any Civil War scenes and that there was no one now living who had such experience as Brady and his men and several others were now all dead. However, Jackson did set forth his qualifications covering photographic experience before and after the war.††

During our conversation reference was made to a recent article by a doctor who stated that every drink of alcoholic liquor a man took shortened his life by 25 minutes, Jackson had a great laugh about it, and it was decided that if the doctor was right Jackson was cheating the undertaker!

As we left the elevator on our way back to Jackson's room two women enthusiastically greeted Jackson and after we reached his room he said to me, "Do you know who they were?" I replied that I had not recognized them, and he said they were the ladies who lived opposite his room I playfully pushed him and Ellison aside saying "Let me at them" and started towards the elevator, but Jackson quickly replied "They're gone, gone with the wind," which ought to be proof that he is mentally alert and up to date in his use of slang and viewpoint of life

††Filming for *Gone With the Wind* began January 26, 1939, and finished July 1, 1939. Thus, the letter, if sincere, seems rather late in the day for any working relationship to be established. The movie premiered in Atlanta on December 15, 1939. Judy Cameron and Paul J. Christman, *The Art of "Gone With the Wind"* (New York: Prentice Hall Press, 1989).

1940

New York, N.Y.
February 5, 1940

Dear Bonney:

I've been owing you a letter for a long time, as yours, dated Friday, reminds me, but there were others before that have not been acknowledged, so I must get busy with my typewriter as long as you can't leave those babies for a few hours to come over to Manhattan, and I am too set in my ways to make the reverse journey over into New Jersey to settle old scores with a talk-fest. It would only be fair, however, for you to come here first for that Snorter and a Childs banquet before I take advantage of some fine day to get better acquainted with the new additions to your family. The little photo you sent represents a handsome pair of Queens of which you may well be proud.

I don't remember how long it is since our last letters crossed, but long enough to make you and yours quite like strangers; even your home address takes on a new name—Potwin Avenue being no more. When the leaves begin budding again I will go over to see about it.

For myself I am still making the same rounds—Explorers Smokers, Adventurers' Thrillers, Deming's Socials and various other affairs that keep one's calendar pretty well filled up. January 14th, you may have heard, Explorers gave me a special reception in connection with the presentation of my portrait by Dr. Wightman that he had made of me recently. Although a rainy afternoon there was a full house, attracted, perhaps, by the generous buffet lunch that was served. On the 31st a similar reception and presentation of a portrait was given Ernest Ingersoll at the Town Hall Club. About 50 present but everyone had to pay $1.50 for his eats and to listen to the talks.

At Deming's last Sunday, Haverly of the Explorers gave a talk with pictures on Lapland and Finland. The "Chief" was there with several other members, also Jimmy Hare, the first time for quite a while. By the way, have you heard from Jimmy Walters or when he expects to return? I last heard from him in Porto Rico [sic].

I am planning to go to Washington for the next week-end, princi-
pally to attend one of the meetings of Washington Branch of the Explor-
ers, something I have wished to do ever since it was organized about a
year ago. Of course there will be visits with my daughter's family and
numerous friends of the N.P.S. and Geological Survey. I must be back
by the 15th to attend a "Sons of Veterans" dinner at the Brevoort, which
will knock out Washburn's [sic] lecture at the Explorers on the same
evening. Sorry to miss it.

I am still worrying along with my collaborator in getting out TIME
EXPOSURE, and it is some headache, believe me. I am wondering in
what paper, or periodical you saw a notice of its publication. I thought
nothing of the kind had appeared except in the Spring Catalog of new
books by Putnam's.

Give my best wishes and regards to the Missus and the two bonnie
young ladies.
Sincerely,

Jackson

May 10

Visited Jackson—did not answer phone—operator said go up—some
times he does not hear (when I was in room later phone rang but he did
not hear it)—went up—room unlocked but not in—wrote note—as I
handed to clerk he said here comes Jackson now—he came in with
Albright—did not see me as I approached—I tapped him on back—sur-
prised and glad to see me—Albright left, merely came to hotel to see
Jackson home and cash check—had been up to see 20 mule Borax team
come in at 59th St.—Wallace Beery picture "Death Valley"—several
photos taken of Jackson with Beery—movies also—

Jackson asked that I lunch with him in Hotel restaurant—did so—he
asked me to sit close so he could hear me—said he couldn't hear so well
lately—went to room and chatted—said all the publicity he was receiv-
ing lately was keeping him busy—smiled about so many people writing
to him wanting to trace their ancestry and see if related—asking histori-
cal questions etc—had pile of unanswered letters

Said having terrible time with book of his life—publication date
changed to later date—he had manuscript in his room—changing it con-

siderably—sorry he ever went into the matter—doesn't like words, phrases etc. of party writing it—He laughingly told me that one great trouble was what the writer wanted to put in story, what publisher says public wants and what he (Jackson) wants to put in and said that when I read it and find unusual statements etc. and say to myself "that doesn't sound like Jackson," I'll understand the why and how of it—getting lots of publicity about book—showed me "4 Square"—a publication trade leaflet folded 3 or 4 times devoted to forthcoming books carrying a large (4 pages) spread about book and many errors taken from Washington Star article about "Poor old Bill couldn't make it." (the parade) etc.— also stated that Jackson did not smoke because he did not like taste of tobacco but he did drink because he liked taste of liquor and that at a recent dinner he had 3 Martinis before even starting—Jackson said he wondered what some of his Presbyterian friends would think of that and raised his eyebrows and laughed heartily (he is of Quaker descent).

Still doing sketching and painting in water colors—now making many sketches for chapter headings and end pieces. Had dust wrapper of proposed new book carrying his picture in oval (one taken by Robinson of Explorers) with 4 small scenes of incidents in his life

May 25–26

Jackson visited us at Madison over the week-end. It was originally intended to attend the dog show on Mrs. Dodge's estate but the rainy weather kept us at home. Corbett, Halley Patterson, and even Mrs. Dodge were disappointed as they had desired to meet Jackson again and Mrs. Dodge had desired to introduce Jackson to some of her friends. Corbett told me that he had planned with Patterson to get Jackson in the private club house, then introduce him to the many notables from the balcony.‡ Fortunately, the weather spared Jackson just one more of such affairs as we sat at home reading and chatting during the afternoon.

‡This scenario makes of Jackson a pathetic figure—a ninety-seven-year-old man put on public display so the host may bask in his fame. Indeed, one gains the impression from Jackson's incoming letters that various people solicited his ceremonial presence only to adorn their events with a celebrity. Collection 1643, *passim*, CHS.

Jackson met me at Hoboken Station. He was late and I suspected that he had gotten lost in the Saturday crowds. When just about to phone his hotel to inquire about him he appeared, just a wee bit flustered he said he had decided to postpone the visit and tried to telephone to me but was unable to find my telephone number in the book so he had no choice but to come on over to Hoboken and keep his date to meet me.

I considered he looked pretty well—and acted so—but when we arrived at home and Dora told him he looked well he replied "unfortunately"—He is not feeling so well as he might appear and he was frank in so stating. He said he really wanted to rest—to sit down and read and chat and get away from things for awhile. . . .

At about 5:30 P.M. we (Jackson, Dora and I) went out to Corbett's as prearranged and had dinner and met some friends. Jackson soon appeared his old self, was quite chipper and joined in all the fun. During one conversation about who remembered vice-presidents (it was quite surprising how few of us remembered more than one or two) Jackson took high marks in naming several from Lincoln's days on down. His memory was still quite keen and he mentioned numerous political incidents, the parties involved, what the details were and the outcomes. He partook of the supper with great relish and enjoyed the cocktails too. I mentioned to him his past troubles with cocktails and he replied that he had gotten over them and cocktails no longer bothered him. For perhaps an hour and a half we played a game called Ship Captain and Crew throwing five dice and using chips—and it was delightful to see his activities and cheery spirits. He gradually lost but in the end, in throwing for the entire batch of chips as the kitty, he won.

On Sunday we spent a quiet day at home delving into books, looking up historical matters, discussing notes, newspaper articles etc.—a purely enjoyable affair with a mind so keen as Jackson's and so deeply interested in all that was good—or sometimes otherwise—in the days of the old West

I had remarked to Jackson that I had seen his name mentioned in the papers as one of the veterans who would march in the Memorial Day parade in NY City and his age stated as 94. Jackson laughed and jokingly replied that he was peeved at them for giving his age as only 94

instead of 97 and said that he believed that he was to be the oldest of any that actually were to march on foot.

> *Bonney's marginal note:* A picture in Daily News of May 31 showed Jackson marching, with a boy scout holding him by the arm (entirely unnecessary)

Jackson a couple of times remarked that this summer he would like to get away for a complete rest—to go up north to some out of the way place instead of going west but still he expects to go west to attend the annual Oregon Trail Assoc. Meeting late in August and presumes he will start west sometime late in July this year. He said one of his friends wants him to come up to Maine again as he has not been there for several years but he is uncertain about going. I suggested that he go up to Barber's camp in the Adirondacks if he really wants to get away from things—there he will be at least 5 miles from the nearest habitation without any connection with the outside world except a radio. He seems to be getting fed up with long trips, almost continuous travelling, introductions, fuss, etc. etc. but still he knows his friends all insist upon him coming here and going there—and he seems to be sport enough to favor them

While speaking of Haynes—the Yellowstone National Park photographer—Jackson said he received from Haynes a telegram reading— "Congratulations on Your first 97th birthday"—and Jackson laughed very heartily.

While showing Jackson a photogravure clipping of Leigh's "Custer's Fight" and speaking of Deming and his poor work recently in both oil and water colors, Jackson commented about how stiff Deming's men and animals appear in Deming's "Custer's Fight"† and, in fact, in all

†Edwin Deming painted at least three versions of Custer's fight. One hangs in the Buffalo Bill Museum on Lookout Mountain, Golden, Colorado. Deming had been working on the theme as early as 1926 when Elizabeth Custer, the general's wife, wrote to Mrs. Deming declining the artist's invitation to look at his work. For her, it was a stressful time, approaching the fiftieth anniversary of the Little Big Horn battle. Nevertheless, she is said to have visited Deming's studio prior to her death in 1933. Elizabeth B. Custer to Mrs. Deming, May 30, 1926, Edwin Deming Papers, Special Collections, University of Oregon Library; Maurice Frink, "Edwin W. Deming," *American Scene* 12:3 (1971).

Demings work the past several years, except a very few oils I have seen which were probably done 10 years ago. Jackson commented how Deming's work had failed during past years—and we looked over Deming's brochure to compare his earlier works with his latter ones

I do not recollect what brought up the subject during the morning, but Jackson asked:—"What is this blood pressure?—What does it mean, what are its indications, what are the dangers?" I was astounded—but the high pressure bugaboo never worries him. I observed at dinner that he sifted salt on the potatoes etc just as though it were snow. He said that during the past years that Dr. DeForest (of Adventurers' Club) has been looking after his health, he has never taken his blood pressure or mentioned that feature to him.

He frolicked with the children—lifting Elaine off the floor several times and swinging her around by her arms—and held Diane several times. It was a glorious sight to see her reach for and inspect his beard, to hear him laugh and observe the 96 years difference in their hands.

Jackson brought with him for me to read the manuscript chapter "Mt. of Holy Cross" of his autobiography. After reading it—and checking it with the same chapter in his "Pioneer Photographer" by Driggs, I much prefer the latter as it reads much more like Jackson.

He said the new book is the greatest "trial" of his life! He is thoroughly "fed up" with it and "sorry" he ever went into the deal—in fact he was inveigled into it as the publisher—Putnam—picked Jackson as a likely subject [and] chose a man—Karl Brown—to write the story and then more or less put pressure on him (Jackson) and he fell for it. Of course, it is to be regretted that a more intelligent, appreciative man could not have been found—such as Fryxell, for instance, but he could not do it as he is in Hawaii or some other place in the Pacific for a year or two. A Mr. Dawson is Putnam's editor and he checks and criticizes Brown's manuscript and makes notes to check the historical facts. Brown has hired some woman to check up these matters in the Public Library etc. and wants to give her credit in the Preface.†† Jackson doesn't want

††By agreement, Karl Brown, the ghost writer of *Time Exposure,* had only three and a half months to write the manuscript. In the preface, Jackson does indeed thank a Theodora Hill, whom Bonney, in his copy of the book, identifies as Brown's wife. Jackson to Brown, October 25, 1939, Collection 1643:177, CHS.

a lot of such things, and I agreed with him—as it seems utterly ridiculous that his facts should be checked and any such mention makes it appear Jackson doesn't know what he is talking about.

Jackson is disgusted with the enthusiasm of Brown who makes so much fuss about little items in Jackson's life which Jackson considers as almost commonplace—the same as anyone with knowledge or understanding of the times and history would. Brown uses too many high sounding phrases, adverbs, adjectives etc. to suit Jackson Jackson has revised all such statements. For instance, in one place covering a mountain climbing story Brown wrote that Jackson "followed his feet," which is a statement utterly unlike Jackson. In another place in speaking of the commotion and upheaval a pack train caused in a small town Brown wrote "Never has a pack train caused so much confusion" which is a pretty far fetched claim and Jackson would never say it. Far be it from Jackson to even claim to know about the confusion any other pack train might have caused.‡

While speaking of the Holy Cross photographs, Jackson told me the number of stereo and 8 x 10 exposures he made the day he first photographed the mountain—and I put a notation in my copy of Pioneer Photographer. Jackson does not now have a print of the first exposures (either the first stereo which was actually the first exposure, or of the first 8 x 10). He said Albright had a print of the first 8 x 10 exposure. Jackson said that some time he might want to borrow my print which was made from the first stereo exposure and authenticated by him as the first photograph.

As an interesting little sidelight on Jackson—he still loves his cold shower in the morning and *got it* despite adverse circumstances on May 26. Because of the lime content of the water, the shower head clogs within a short time and sticks so tightly I have already damaged it in attempting to open it for cleaning. Consequently I unscrew it after each

‡Jackson also expressed his dissatisfaction with the book to his friend Fritiof Fryxell: ". . . I am having about the most brain-racking job I ever tackled in checking over the first draft of Ms. You can imagine how hard it is to keep within bounds the ideas and fancies of a writer who has no background of experience or knowledge of his subject." Jackson to Fryxell, May 1, 1940, box 29, Fryxell Collection, AHC.

use to drain the head, and did so Saturday morning, but had in mind putting it in order for possible use by Jackson before retiring Saturday. However as Dora and I were getting breakfast, and he was in the bathroom, we heard the water falling and making a very unusual sound, and immediately I realized that he had turned on the water but did not know how to screw in the sprinkler head, consequently, it was merely falling in an irregular stream instead of sprinklering. When he came out I asked him about it and he said he couldn't make the overhead one work, so he used the rubber tube and sprinkler head which we have attached for Elaine! . . .

June 13

Visited Jackson in his room tonight. He was not feeling 100%, but his trouble was muscular—not organic. He has been writing and typing so much lately on his book and personal correspondence that he has permitted himself to slouch somewhat in his chair This has strained his back, and reacted on his system generally. He went to Dr. DeForest (of Adventurers' Club) who is now his regular doctor and according to Jackson seems to be of the opinion that feet and legs cause a lot of our troubles. He told Jackson that one leg was 1½ inches shorter than the other—in other words, he had gotten his hips out of adjustment because one side was lower than the other as a result of slipping off one side of [his] special pillow. He stretched Jackson's leg—and he has been improving since, but still not up to par

I arranged to stay at the Latham overnight and so Jackson and I chatted until about 11:15 P.M. He said the manuscript was now in Putnam's hand being set up in type and that Brown had last night taken a group of photographs to look over for use in the book. He also has what is left of his original 1866–67 sketches and Civil War sketches put in neat order in loose leaf photo album for use if Putnam desires. We spent almost an hour looking over photographs of his paintings and sketches and chatting about incidences they portrayed. Jackson was chewing gum most of the time. He was chewing heartily when I came in the room at 10 P.M. and had the box open and Chicklets spread out on his table He was in stocking feet and feeling and looking quite comfortable. We discussed shoes. He wears the Douglas now and his

last pair had stood up very well—over a year of almost daily use and not yet worn thru and not even scuffed on tips. However, somehow the tip had gotten pushed in, but we easily pushed it out again and no damage even showed. He has to have the store order them specially for him because he has a short, wide foot and a very thick fleshy ankle. Some time ago some one gave him a nice pair of bed room slippers but he can't wear them. I tried them, but they were too small—so he is still trying to give them away

Yellowstone Park
August 26, 1940

Have been resting up here at Mammoth Hot Springs for a few days before "hiking" back home again. All well and have had a fine time. Book received enthusiastically out here.

WHJ

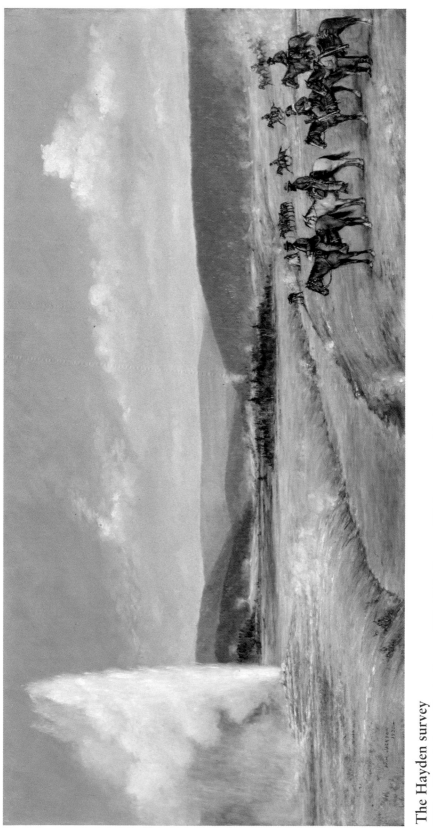

The Hayden survey
William Henry Jackson, *Hayden Survey: 1871*, 1935. Courtesy U.S. Department of the Interior Museum, Washington, D.C.

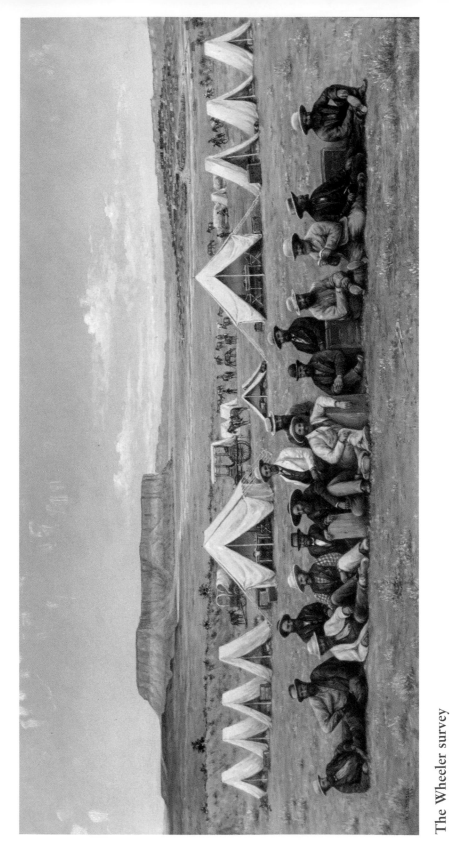

The Wheeler survey

William Henry Jackson, *Wheeler Survey: 1873–75*, 1936. Courtesy U.S. Department of the Interior Museum, Washington, D.C.

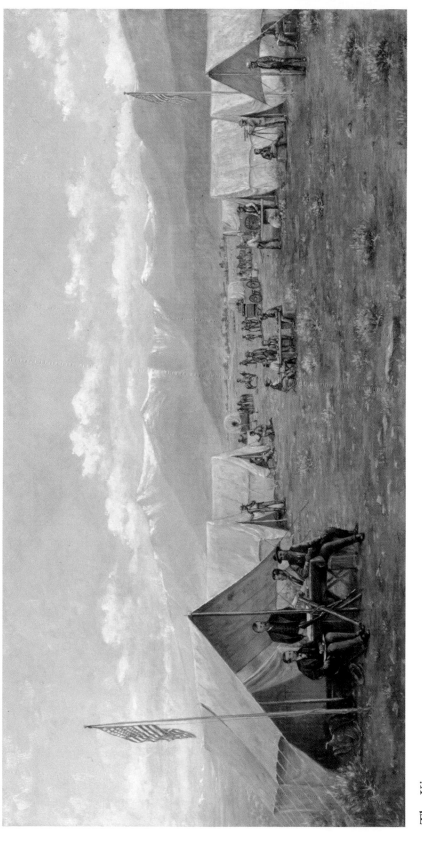

The King survey

William Henry Jackson, *King Survey: 1867–69*, 1935. Courtesy U.S. Department of the Interior Museum, Washington, D.C.

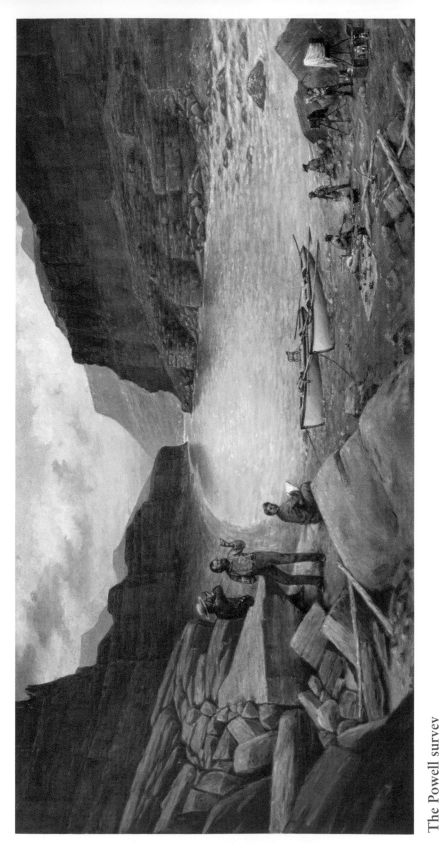

The Powell survey

William Henry Jackson, *Powell Survey: 1869–72*, 1936. Courtesy U.S. Department of the Interior Museum, Washington, D.C.

1941

January 3

Having been unable to visit Jackson during the past few months because I have been out of City on business and then staying close at home to be on hand for the impending birth of Barbara (3 weeks later), I made a special effort today while in NY City to see him.

I found him as chipper as ever. He had received a crate of apples from Barber, and a crate of oranges from Bretney, and was peeling an orange for lunch when I arrived—and boy, oh boy, how he loaded down the orange with good plain granulated sugar and then set it aside "to sweeten" as he put it.

He looked fine—cheeks full and rosy—mentally alert and smiling. I commented about his fine appearance and he replied "that's my trouble. I look too good" and "my appearance fools people." He said he felt his age creeping up on him; that he was "weak in his knees," "forgetful," has to be careful of his diet to a certain extent, receives letters from many people who have read his books and ask questions wanting to know more about him or events in his life etc., that he files the letters, then forgets where he filed them and who wrote them. All told smilingly and jokingly, with no outward indication of that fatal day such indications portend.

In connection with his reference to being "weak in the knees," he said that recently when crossing Fifth Avenue during his return from a dinner at Childs, the lights changed while he was in the middle of the street and he hurried to the sidewalk, catching his heel on the curb and falling sprawlingly upon the sidewalk. The fall temporarily stunned him—the shock was so much he lost all power to arise, and although he succeeded in getting up partly, he fell back again. As he lay there he noticed several people pass him and look down at him, and pass by without offering any assistance whatever, presumably, as he put it, he was just another drunk! Eventually he was able to get up on his knees, and then a passerby assisted him to his feet. He told me the story with a smile,

and followed it with quite a chuckle—and never an indication of any bitterness because many people took him for just another drunk!

He says he finds it increasingly difficult to climb steps, and for this reason avoids subways as much as possible. He commented how difficult it is for him to also climb ramps which are frequently so deceiving, and he particularly mentioned the ramp in the Grand Central Station. Although he has been doing a little lecturing and visiting friends, such activities have been reduced greatly lately and he said that this past 1940 Christmas was the first one in years on which he failed to visit his daughter in Detroit. Instead, he remained quietly in NY City. During past years he always made it a practice to return from Detroit to NY City on the day before New Years to be present at Demings' famous New Years Eve Party, but he said this year he missed the party, and remained quietly in his room. He looked for a taxicab and not seeing any he lost no time in deciding to return to his room.

He hasn't done any painting for over two months and is very desirous of getting back to it but wants to "clean up his 1940 correspondence" (said with a smile) but found his "hunt and peck" system of typewriting letters rather slow, especially when he stopped to grope for words and recast sentences.

I mentioned the favorable comments about the reproductions of his pictures in the "U.S. Camera—1941." He said it was a poor selection. Some of the pictures were taken from his book, others obtained from Washington. He was not consulted at all! He said several of them were not representative of his work during several periods†

He said he had been up at Rochester in December on the day when it was discovered that the sewer line valve had been inadvertently opened into the city water lines, and he had partaken of drinking water that day. Shortly after he returned to NY City he received a letter from the Rochester City Health Authorities saying his name had been found on a hotel register as having been a guest in the city that day and requesting that he immediately visit a doctor and be inoculated against typhoid fever. I

†The publication referred to is "William Henry Jackson: Frontier Lensman" (photography by Jackson, text by Hartley Howe), which appeared in *U.S. Camera*, 1941, vol. 1, *America*.

asked him whether he followed instructions, and with a big chuckle and the characteristic wave of the hand he replied "No."

The Explorers Club is planning another volume of "Told at the Explorers Club" and want a story from him. He plans to write one about his "flash powder" experience on the way to Mexico many years ago. At that time there was no commercial flash powder product on the market, and sometime before leaving for Mexico he arranged with a chemist to make up a batch of flash powder for him. As he remembers it, it contained magnesium, picric acid, some chlorate etc. This he had with his baggage in the Baggage Car. During the night the train stopped at Albuquerque where a transfer of passengers and baggage was made for California. Presumably there must have been some pretty rough handling of baggage for an explosion demolished the car and scattered things generally. Jackson was asleep in the Pullman car at the time, but next morning when he heard about it he immediately hurried to the station, and the first person he met was the Supt. of the division, who had been a drummer boy in Jackson's Civil War regiment, and who told him that it was a good thing he was asleep in the car as he would now have been a prisoner in the Albuquerque jail. The police had found the baggage tag and went looking for the owner, but the Pullman conductor refused to permit the police to disturb his sleeping passengers

January 10

While in NY City today I stopped at Jackson's Hotel and found him in his room. At my knock he called out the cheery "come" and with a smile greeted me with a "hello, how are you?" His next comment was to say that he was taking me to lunch, and we didn't tarry long in his room. It was then a few minutes after twelve, and he said he had an engagement at 1:00 P.M. with some woman who was going to call at his room "to meet such a wonderful [man]" and "who had done so many wonderful things" etc. etc. which he followed with his characteristic smile and wave of his hand—the right one, starting near his right ear and down and across his chest toward his left knee. We went to Childs, found a table in the crowd, and the first thing was to ask with a sly look in his eye whether I would have a Martini with him. We had one (and griddle cakes and bacon, ice cream & coffee) and as I commented that

someday people would say that his long life was due to the fact that he never touched liquor, he laughed heartily.

This reminded him that Mr. Brown who collaborated in his "Time Exposure" always wanted to play up the rough and ready side of his life and work in the story various incidences of drunkenness and rowdiness in camp and in town. He said that some time soon he plans to write an article, probably merely to hold in records, to put down in writing his feelings about his book "Time Exposure," which he still feels should have been classed as a biography by Brown and not his autobiography. He feels that Brown was "too taken" with many of the more important events of his life and desired, and actually did, "play them up" too much, using his (Brown's) words and ideas, instead of Jackson's.

Bonney's marginal note: Jackson said that for a brief and reliable story of his life, he always liked to refer to Fryxell's article.††

Jackson said he had observed that people who have written to him about his books, have, for the majority, made reference to the statements which were Brown's words and reactions, rather than Jackson's. Here's hoping Jackson can record his impressions as he desires. He again mentioned that several people have written to him in an endeavor to determine, if possible, how they might fit in some place in the Jackson family, or about incidences, pictures etc. . . .

He also mentioned that he was reading the book about Thomas Hart Benton, the artist, which some friend sent to him, and he let out a hearty laugh when he told me that Benton mentions some whores in the southwest who were so big it took two men to hold them down on the mattress! He said Benton took particular delight in shocking his friends and relatives by telling all the worst things he could about them or events in which they were involved. While he doesn't "go in" for rude reading, certainly he isn't squeamish about it, and takes the bad with the good and treats it all with the same respect. He said Ernest Ingersoll had written for the Explorers Journal a review of "Time Exposure" and had written to him that he regretted that Jackson had permitted any mention at all of his "bumming" his way from NY City to St. Joe, Missouri.

††See note on Fryxell on page 108.

Ingersoll doesn't like this sort of thing at all, which is evident from his own writings and regretted that it got into Jackson's book. Jackson also mentioned that he was planning disposal of his effects and said that his autographed books and his collection of prints of Chas. M. Russell's pictures he wanted me to have, as well as other things I might desire. He mentioned his plans to sort over his clippings and save the good ones and destroy the rest, but I warned him not to do any such thing. I told him nothing was to be discarded, I would take care of anything he did not want, and I again urged him to turn over to libraries, mentioning the NY Public Library, anything he did not want—and I told him of similar advice given to me by Dellenbaugh, and how I planned to follow that disposition of all my Dellenbaugh and Jackson material. I urged him to follow that course.

After we returned to his room we discussed a photo of the Holy Cross Mt. some photographer had sent to him The "angel" in this photo was poor, very poor, and Jackson commented that he frequently touched up [his] negatives to obliterate undesirable black spots in the snow where rocks showed through—a fact I had not known before—and he thought it should have been in this particular photograph.

The "U.S. Camera–1941" people sent him 4 copies of the publication which he thought was "queer" of them inasmuch as they did not consult him before the publication. . . .

March 3

While on the way to the offices of the Acme Fast Freight, Inc. this morning I stopped in to see Jackson I entered and found him sitting in a chair "resting," so he said. He rose slowly, helping himself by gripping both arms of the chair. After a handshake and a happy smile and a few pleasantries between us, he said he was feeling fine except for almost a continual weakness in his legs. During the past several months he said he found himself more and more unable to be on his feet very long. He particularly avoids ramps and stairways and remains in his room more than formerly, frequently avoiding engagements and meetings he heretofore almost rushed to with glee. The doctor has told him that the leg weakness is the result of his spinal injury a few years ago. He said his back hurts him if he leans against it while resting in hard back chairs,

but otherwise he does not notice any pain—but he admits he knows he hurt himself that time. Except for his back he feels fine physically. . . .

Starting on the week-end of the 23rd (Feb) he had four days in a row of dinners, lectures etc, each of which kept him long hours and late at night—and he has felt the strain, and says he must refuse some such invitations. On March 2nd he was in South Orange visiting a cousin, and being tired that evening he did not attend the usual party at Demings that night. While we were talking, a knock on the door announced the arrival of Deming himself who said that he had come up to see what had happened to Jackson in as much as he had not come down Sunday night. Jackson was pleased with progress he had made clearing up his room, throwing away a "lot of junk" so he said. I don't know what he threw away but I did notice that some items were missing giving him more room to move about and space to pile incoming items. He is still painting, and just now finishing up the last painting for Dr. Driggs proposed brochure on the Oregon Trail

April 27

Jackson, Deming and Jimmy Hare here today for dinner to help celebrate our 7th Wedding anniversary (of April 28). Jimmy Walters had persuaded the "boys" to come out to East Orange to attend the Annual Dinner of the Orange Camera Club on the 26th. They stayed with Walters Saturday night; and next day he drove them around . . . to Madison. Walters brought 3 steaks along which we grilled on the lawn, but as it was too cold to eat outdoors, we put the "feed bag" on in the house. Jackson seemed to have difficulty disposing of his food and did not eat much except the steak, with respect to which he said he was determined to eat all of it. He undoubtedly was very tired as result of late hours the night before and long auto trip. He moved about very stiffly, apparently with discomfort. We spent half an hour sitting in the sun on back steps and when he eventually arose to come in it was with much effort that he finally got up the steps. He commented that he had been sitting there so long he was stiff. He doesn't look so well—rather yellow or sallow skinned. I was particularly struck by his swollen ankles—they are becoming quite large—so much so that he can scarcely tie his laces. Jimmy Hare commented about him not being in too good shape and added that the fall out in Cheyenne a few years ago "didn't do him any good." . . .

After dinner we drove out to Corbett's for dessert as they insisted that I bring the "boys" out When we returned to our house, Jackson got out his kit and remained in the bath room for a long while—apparently having much difficulty. Undoubtedly he is going down hill very fast. We and our friends observed it—he had very little to say, could not face any windows because the light hurt his eyes, and rarely moved about. Still, he was the same old gallant Jackson when occasion demanded—but I fear he had made his last visit to Madison, unless there is much demand that he come and we bring him all the way by auto.

September 24

Visited Jackson. He again mentioned to me that he desired me to act as co-executor of his estate, a matter which he has heretofore mentioned to me during various visits which I have failed to record. My visit tonight was at Jackson's specific request to discuss the matter

Jackson said his purpose in asking me to serve as a co-executor was "to keep Clarence in bounds—to keep him under control." He seems to feel that Clarence will undoubtedly dispose of for cash everything he can get hold of without regard of his father's wishes, particularly as to preservation of certain items by their disposition to proper Public Libraries, Historical Societies etc where they will be properly protected and of the value they will be in the future to students of history. He said his family never took any interest in his work from the historical viewpoint—or if there was any such interest it was very little.

Jackson planned to consult his bank officials to see what arrangements he should make about his personal account (which he said was not large, yet still sufficient to keep him for awhile along with his other income) to protect his estate

He said he had spoken to Clarence about asking me to serve as an executor I told Jackson that I thought he should now dispose of all his most valued possessions such as diaries etc by depositing them in such libraries or societies he felt proper I also urged him to save all letters written to him‡

‡Some 1,950 of Jackson's incoming letters are preserved in the Bonney Collection (1643), CHS. For final disposition of the diaries, see notes on pages 156 and 157.

1942

2/15/42

Dear Bonney:

Drat this old pen! dropping ink unexpectedly—But all the same, I was mighty glad to get your letter although chiefly a record of the Bonney family's passing of their minor afflictions around from one to another impartially. Don't despair, however, Spring and Summer will also be around, when you will forget this dreary winter.

I received a letter also from Jim and Connie [Mr. and Mrs. Jimmy Walters] the other day. They seem to be very happy down there in Indiana in making their new home and sticking pretty closely to the job. All good wishes go with them.

I have plenty of work laid out for the next week—Explorers Club dinner, Tuesday; Adventurers', Thursday; and Washington dinner at Francis [sic] Tavern (GAR) Saturday evening. By the way—it is not the Explorers Tuesday evening, but "Sons of Veterans," another GAR affair at the Hotel Brevort—aside from all this I am kept pretty busy at desk and easel.

But I am paining for some diversion and I am hoping this will soon come from you—the contents of the big square bottle have not been lowered materially—it will furnish a good healthy "snorter" as a prelude to a sociable dinner in a quiet corner of the Latham—come soon.

Wish Jimmy and Connie could be with us. Am just about due at Demings for their usual version of a supper, Chop Suey. Regards to all the family with many good wishes. Sincerely,

Wm. H. Jackson
Hope you can make sense from this awful scrawl.

February 27

Colds which I have suffered from, and which have afflicted the rest of the family, have kept me from visiting Jackson for some time, but tonight we got together for another chat

His legs are gradually failing him, which makes it difficult for him to get around quickly or conveniently, and with gradual failing eyesight he can't avoid bumping into a few things and people—and he knocked the tomato juice cocktail glass from the table to the floor, which gave him reason to comment about his eyes going bad lately

He said that several parties were now endeavoring to book him up for celebration of his 99th birthday anniversary on April 4th, but he was trying to soft pedal the "doings" and save up for the next one—"if I make it" he said with the characteristic twinkle in his eyes. Certainly he is going to try hard to "make it."

. . . [We] discussed Driggs' "Westward America" illustrated by 40 of Jackson's paintings and recently published.† Henry Steele Commager in the NY Herald Tribune Book [Section] on 2/15/42 and R. L. Duffus in the NY Times Book Review 2/22/42 gave the book an excellent review—and the same applies to Jackson's pictures

Jackson has purchased a new electric torch with magnifying glass attached for reading. He paid $6.50 for it—and finds it far more suitable than a small pencil type one he previously used. The new one uses larger batteries, and the magnifying glass is about 3 to 4 inches across, and does not distort a bit, not even on the edges. It is a splendid asset to his activities and he is quite pleased with it. This raised the question of reading—and disposition of his books. Some time ago he gave away to the U.S.O., or some such outfit asking for books for the boys in war service, all his National Geographics, Alpine Journals, Trail and Timberline etc. etc. Included in these gifts was at least one book—maybe several—that he did not intend to give away to such recipients. The one book was a first edition of Bandelier's "Delight Makers" which he had wanted me to have and thought he had given it to me. He has frequently thrown out papers, new items, pamphlets, etc which I would have been glad to have—and in his forgetful way he thinks he has given them to me or others who might be interested whereas he has become confused and disposed of them with his waste paper

†Actually, thirty-one plates, dated from 1930 to 1941, illustrate the book. *The Old West Speaks* and *The Pony Express Goes Through*, also by Driggs, contain thirty-seven Jackson paintings and eight paintings with numerous black and white drawings, respectively.

Tonight [when] he opened up the subject of books, he gave me Hafen and Ghent's "Broken Hand;" Arrettson's "American Bison," Rollinson's "Pony Trails in Wyoming," Lant's "Overland Trail" and Nelson's "Rhythm for Rain." He has also earmarked for me Ghent's "Oregon Trail," Chapman's "Pony Express," "Conestoga Bell Wagons," and many others

March 6

Visited Jackson tonight. When I entered he was busy at the typewriter. . . . He asked to be excused a moment as he completed his letter, making corrections in ink on the typed letter—and it was only a moment—after which he suggested an early trip to the Latham Tea Room for dinner, to get a good seat and avoid the crowd. He got up spryly and suggested a "snorter" before going down stairs, and headed for the bath room and his little bookcase and a moment later he called out "come and get it." After approving of [the] size "snorter" I poured for myself, we "clinked" glasses and he said with the proverbial "mud in your eye," we put away that one. As we entered the Tea Room he turned to me and said, "I see a nice quiet corner all reserved for us," seemingly as chipper as ever. Although he thought a filet mignon would go good, he finally decided on the flounder—and while I refused my salad of cabbage and other stuff, he heartily devoured his promptly. It seems that any and all foods are delicious to him, and still treat him kindly!

We mentioned the proposed war time styles for men—no cuffs on trousers and no lapels or collars on coats—He doesn't approve—and sid they would soon have us down to shorts—and chuckled gleefully. He said they couldn't cut down on women's clothes, as they already wore a minimum! . . .

[Jackson] told me he struck a piece of luck very recently when a Mrs. Derr and her husband called on a visit—looked over several of his water color sketches, and asked him prices, insisted the prices were too low, and departed with $100.00 worth after insisting he raise prices to what they wanted to pay!

Jackson told me Mr. Albright was after some information for the Rockefeller interest about Jackson Hole, and asked me to look it up in "Broken Hand" which he gave me last week. I looked up the data in

that volume and in Alter's "Jim Bridger" and wrote Jackson a 7 page letter on March 7th

March 13

When I knocked on his door tonight, he did not answer. I knocked again—and still did not hear his cheery "come!" I thought perhaps he had forgotten our date, and gone out. Knowing that he never locks the door despite the valuable paintings he has in his room, including ones by Moran, and many books, etc.—I quietly opened it to find him slumped down in his chair with a pamphlet by Heber J. Grant†† . . . in one hand and his reading glass in the other. He smiled—and said he had been reading the pamphlet and "dozed off" as one some times does near dusk . . . and after a few yawns and grunts accompanied by a feeble stretch, he suggested that we go to dinner and avoid the crowd—after whetting our appetite . . .

We had to wait for the elevator—I pushed the button three times—and Jackson expressed his impatience—the first time I have ever heard such that I recall.

He said he was a bit tired as he sat for his portrait in oil this afternoon. Some of the boys at the Explorers Club engineered the deal Of course, Jackson will not have to pay for the painting and while he would have preferred not to go thru the ordeal of the several sittings, he obliged the boys by consenting. He isn't certain but thinks maybe it is the intention of presenting it to the Club

While we were eating, Jackson said he had to cut down on the food, and then he laughingly stated that he did not know which items to cut out as he enjoyed all of them. He certainly appears to enjoy most anything, and rarely comments about poor quality, but he did jokingly comment about being down through the potatoes in the clam chowder, but had not yet found a clam.

Our conversation ranged from the war and world conditions today to the kids at home and my lot at Basking Ridge—he is still interested in life.

††Heber J. Grant (1856–1945) was the seventh president of the Church of Jesus Christ of Latter-day Saints, serving from 1918 to 1944.

Back in his room our conversation turned mostly to events in his life and matters pertaining thereto. He had not yet obtained for me a copy of "Westward America" because of a misunderstanding with the publisher; as it was Dr. Driggs desire that instead of Jackson ordering directly from the publishers, the order should go thru the Memorial Trails Assn. [sic] which would thereby get a bigger "cut." However, it is promised for next week.

I had with me my copy of "Time Exposure" in which I noted in pencil about 25 corrections in accordance with notations by Jackson in his personal copy. His copy also has about 100 checks and question marks indicating statements, phrases and single words which are either misleading, inaccurate, or not characteristically his, and he desires many changes made if he is given the opportunity. When in the mood, and he has time, he makes corrections and notations, and plans completing the volume someday when he promised to let me correct my copy

As indicative of his sincerity, and distaste of sham and self glory, he commented about several people saying to him what a wonderful book his "Time Exposure" was—all of which he thinks is the "bunk" and that such statements are made to him to humor him, that people think they must say these things to him merely because he is an old man and [has] written his autobiography

We spent considerable time going thru his clippings in search of some [thing] about his flight over Gettysburg a few years ago on Memorial Day. One of my clippings indicated a flight over Arlington only.‡ We could not find the desired item—he was certain he had it recently. He said sometimes when he has referred to his clippings he carelessly files them improperly, and sometimes some one borrows items—and they are not returned. This latter is apparently true with respect to his 1866 notebook drawing of himself and pals in their room in Salt Lake City—also one self portrait he made in Salt Lake showing him in his ragged clothes. I have always been very fond of the last picture—and he can't find it any place. He agrees—he probably loaned it to some one—now

‡Jackson, at Arlington for the 1938 Memorial Day events, later flew to Gettysburg for the seventy-fifth anniversary ceremonies marking the Battle of Gettysburg. There, he flew over the battlefield with other veterans from North and South, scattering roses over the cemetery. Jackson, *Time Exposure*, 336–7.

he has forgotten to whom, and it will probably never come back as most other such loanings never again reach his files

Bonney's marginal note: 11/28/42 Clarence found a negative of it, original is still lost.

Jackson said a representative of the N.Y. Public Library recently called on him again to discuss turning over his items to the Library. It was specifically requested that Jackson not attempt to arrange or file the papers, as the Library would do that according to their method. They specifically requested that no books be included in the gift, as they had all Jackson had. A sign that he is looking forward to the 100th anniversary and beyond is indicated by his statement that he doesn't want to turn over to the Library his items he will need for reference, and his voluntary statement that this summer he is coming out to Madison some week end and enjoy the woods and a sunning on the lawn

March 23

Phoned Jackson—his voice was quite husky—it worried me and I made a date for tonight. I found him as chipper as ever—just the usual huskiness, which had sounded worse than usual over the phone

He said it is difficult for him to rise out of his chair—his weakness being in the legs just above the knees. It is so difficult for him to lift his feet more than six to eight inches that he never attempts to travel by bus—using taxies [by] stepping off the curb. As we sat in the chairs we endeavored to lift our feet up and place them in the seat of another chair. Jackson found that after the 3rd attempt he succeeded in swinging his right foot into the seat of a low chair, but not without helping the leg up with both hands lifting. His walk is fast becoming a shuffle. For the most part we sat quietly and chatted, discussing world events, personal matters, western history, looking at pictures etc.

April 1

. . . I found Jackson resting comfortably in his chair with his legs stretched out. His first words were, "well, here you find me taking my little siesta, as usual."

After the usual greeting with handshake Jackson pulled over a chair close to him and beckoned me to sit down, and we chatted briefly about

the weather and our health etc. both of us seemingly satisfied with life. He had completed the water color painting of the camp fire at Mitchell Pass, Scotts Bluff, [and wrote] on the inside cover of my copy of Driggs, "Westward America" . . . "Inscribed to—Elwood P. Bonney. Who, although less than half my years is yet my most companionable comrade— sociably and interest in Western Americana. So here's to all the Bonneys particularly, the three little queens with all the good wishes in the world. April 4, 1942."

What could I say, but squeeze his hand and say it was a grand inscription. And then he confessed that he did want to say "the three little queens waiting for two Jacks" and he said it with the characteristic twinkle in his eye—but said he couldn't write it. I told him I wished he had, and we laughed off the joke about a "full house."

It will be noted that he dated it ahead to April 4, 1942, his 99th birthday anniversary. And still with a cheerful outlook on life and quite capable of originating and enjoying one of life's little jokes!!

When Dora, her mother and Elaine were in NY City on March 28, and visiting the Little Church Around the Corner (where we were married) on 29th Street, they stopped around to see Jackson on a short visit, and he told them how much he appreciated my visits to his rooms and added that he didn't know what I "saw in an old man like him." The only explanation I can give is that I for one am not going to wait until he goes into the hills forever, and then regret that I had not visited and known him more intimately; and that I always treat him as though we were of the same age, and that age about 25 years! But I do secretly idolize him to an extreme degree, although I never indicate so in his presence—and it is this latter condition that makes the friendship "click" as far as I can determine.

Allen Will Harris in the Philadelphia Evening Bulletin for June 13, 1938, said of Jackson, "Once you've met Jackson, you understand why he remains so brisk, fresh and young despite his years. He has the frontiersman's dislike of sham, self-praise and glory." And in those few words you have the whole story! Jackson wants to be treated as one of the boys, and in no other way. Many were the times he insisted on holding my overcoat, but few were the times I "got away" with helping him put on his coat!

I have always endeavored to treat him as though we were of the same age, and on the same "level," and he has reciprocated in the same manner, except possibly he felt he was younger than I!—and except when he was in a reminiscent mood and "forgot himself" and talked to me about campaigning for Blaine, and carrying torches in the old time political parades, etc.—and then suddenly remembered those things were before my birth!

I have found that the trouble with so many of the people who meet Jackson, and those who have known him for a long time, is that they want to pay homage to him, and display too much deference and reverential regard to him in his presence. Jackson wants none of that!

And so we have gotten along well together for the past eleven or twelve years—sometimes like two little boys—although my first personal notes about him are dated November 21, 1932—I regret that I did not commence making notes earlier—or more completely. Much has been lost, never to be recovered, as I was incapable of recording the many interesting incidences and his experiences related to me. He has frequently commented how sketchy his diaries are, and even tho he rewrote his 1866 and 1867 diaries (after returning to Omaha in 1867) when the experiences were still fresh in his mind, and enlarged the many interesting incidences, still he confesses the revised edition is far from complete

Jackson then suggested the usual early dinner [He] joined with me in my favorite dish—baked ham a la Hawaiian—nothing more than a little grilled baked ham with a slice of pineapple and one prune—and he followed his usual practice (characteristic of some friends of mine) of saving some part of the roll to eat while waiting the dessert—and reminded the waitress to leave it, as she started to carry it away

Before returning to his room I told him that I had looked thru all his writings that I had record of, but was unable to find that he had mentioned in any printed article or books his experiences at Mitchell Pass, Scotts Bluff, when he nearly was squeezed, perhaps it might have been fatally, between his wagon and the side of the gully,† or his experience

†One version of the story is found in Jackson, *Time Exposure*, 124–25.

about lack of water when they made camp, and the boys had to go back 3 miles to the river for water, and then stumbling back to camp in the darkness over the rough ground had spilled all but about a pint each in their pails. Jackson said he must have written up the story somewhere, as it was a favorite of his, but neither could he locate any printed item on it, or suggest where it might be—hence, we decided that he must have mentioned it to me several times during conversation, and that was why I recollected so much about it.

He then got his rewritten and enlarged journals of 1866–67, and because of the difficulty of him finding it quickly reading thru his reading glass, he handed the journal to me—but first without much difficulty turning to the proper page—and asked me to read it as I could "read it easier" than he could. I read over several pages, and we laughed about the experiences, and when I suggested that I copy it in long hand to have a copy in Westward America to accompany the picture, he would have none of it—said it would take me too long to copy it tonight and not leave time for conversation—and even tho I wanted to do so, he was insistent that he type it for me—it would be "no trouble" to him, and he could run it off quickly during the day.

He told me that "they are going to make a circus out of the reception" for him at the Explorers Club on Sunday afternoon, April 5, 1942—and then enlarged upon it by saying that they not only wanted to display a water color (of Independence Rock) he was just finishing, but also planned to display several photographs of him, . . . Jackson felt embarrassed about the whole matter, but I think I encouraged him to take the whole matter lightly and laugh it off The 1935 Underwood & Underwood (Bacherach) is undoubtedly the best studio photo of him during the past several years, with Robinson's photo next (Jackson wearing a slouch hat). The Look Magazine photo of Sept 1939 (with bookcase in the rear and cliff photo at Three Tetons—see page 131 of Pioneer Photographer) rates high with Jackson. He regrets that the small painting back of his head was not removed.

April 5

Dora and I went to the Explorers Club this afternoon to attend the reception the Club gave to Jackson in honor of his 99th birthday anniver-

sary. The crowd was slow in arriving and much time was spent just "sitting"—except for short conversations with Jimmy Hare, Ernest Ingersoll, Dr. Driggs and Clarence Jackson. Jackson and his daughter, Mrs. McLeod, and a few friends were kept out of sight and round in the Board Room until about 5 P.M. when Joseph Robinson eventually opened the activities by calling certain individuals forward to the speakers table.†† Some of these were Deming, Hare, Ingersoll, Miss Moran, Mrs. McLeod, Stefansson, Albright, Wightman, Clarence Jackson, Dr. Driggs—Mrs. Gastter and a very few others. There seemed to be much confusion and bungling of arrangements in seating people at the table and although it was announced that the audience was to sing "Happy Birthday" to Jackson when he came in, some one did some more bungling, and he walked in during the confusion of seating arrangements—and had to be ushered out again. After about 5 more minutes of confusion, he was permitted to come in—and although the audience sang and clapped hands, the "punch" was not there. He looked small and shriveled compared to all about him, and his face was expressionless—in fact, he appeared to be ill at ease, and undoubtedly he felt worse than he looked. I had never seen him appear so crestfallen and dejected before.

Then the speechmaking began—much of the usual "blah-blah" that is generally expected at such parties. First Robinson called attention to Jackson's many photographs, prints and water colors on display, and the cabinet containing his diaries, sketches, photos and other mementos on display for this special occasion—being personal property, and not that of the Club; and introduced the Club member who arranged the display. Then Wetmore, V.P. of the Club was introduced, but not before the Club member who arranged the display made a speech, and Wetmore made a

††Joseph V. Robinson (1889–1972). Engineer, inventor, industrialist. On the back of an April 4, 1939, Robinson letter to Jackson, Bonney notes, "Robinson was a member of the Explorers Club and a very, very, good friend of Jackson. I do not know if what I am to write is truly true, but E.P.B. had seen him many times at the club and has 'understood' that he paid all the big bills generated by Jackson, especially in his—Jackson's—late years, as Robinson was very wealthy." Collection 1643:181, CHS.

At least one other good friend, Horace Albright, seemingly contributed to Jackson's support from time to time, channeling his donations through Robinson. Marian Albright Schenck, personal interview, March 1, 1997.

speech, and introduced Albright as toastmaster who made a speech, and then called upon each one at the table for a speech, mixing the speeches with anecdotes of his own, or introducing people in the audience—until finally speech making was ended by introducing Jackson.

However—he had twice previously gotten on his feet, and uttered some remarks which were not discernible because of his raspy, weak voice. He could not hear much of the speech making and became confused when he heard his name mentioned. There was much said about not honoring him because of his old age, but because of his youth, and there were some sincere tributes especially by Stefansson. There were also the usual incorrect statements about Jackson and some of his work— one in particular which I recollect is that he did not attempt any water color work until he was 84 years of age! Such a statement is very obviously incorrect. Jackson still has in his possession, and uses it daily, the original tin water color case he purchased in 1866 in Chicago and carried with him since then across the plains and elsewhere—and he has several times commented to me about this watercolor case—of course the colors being renewed from time to time.

Jackson made a short speech and while I did not clearly hear every word he ended with a statement that he had not done anything to attain the increment of old age and didn't deserve the honor that went with it. A special request was then made to make handshaking brief and not to ask Jackson to rise. Then followed a long period of commotion centered about Jackson, until he was ushered out to the Board Room for a rest, and shortly later ushered back in to cut the cake. I say ushered, but to me it was a heartbreaking scene for instead of permitting Jackson to walk alone, as he always prefers, and unimpeded by some one holding his arm, Robinson got behind him and placed his arms under Jackson's arms and literally carried him out—and in again—a pitiful and pitiable sight. Jackson's small, shriveled body supported by Robinson, a man twice Jackson's size. Jackson's coat lapels and shoulders forced high and out of line—it all seemed so much like a policeman escorting a helpless drunk, instead of the real Jackson briskly and independently moving about as one expected. Robinson plainly displayed lack of poise, control and a state of nervousness—and it was reported that Jackson was none too well, that his hand grew cold and that he was weak—and still

he was forced on to do things for the "show"—the "circus" Jackson told me it was to be—instead of being permitted to wander among the guests and converse with whom he pleased and for as long as he pleased, he was then hustled around again, out to the Board Room for a cup of coffee, and then in again and seated in a chair on a platform about a foot above the floor, and guests were again invited to greet him. Once comfortably settled, he rested and got back much of his spirit and better appearance, and at last showed signs of beginning to enjoy the reception. During the entire affair he was posed with many different people and in all there must have been more than 50 flash light photos taken of him conversing with guests and members.

Clarence remarked to me twice—and I agreed with him—that this ought to be the last time any such activities were permitted—and he indicated he, too, was worried about his father's condition—and doubted that he would be able to go to Detroit for a celebration at Henry Ford's Dearborn Museum—at the same time I overheard Clarence say to another party that he preferred they postpone any more celebrations for his father

April 7

. . . I stopped at Jackson's Hotel and inquired of the telephone operator how he felt. She said he was fine and I went to his room—Jackson answering my knocking with his usual cheery "come." At first he did not recognize me—apparently he had been "snoozing"—a thing he does more frequently daily—but after shading his eyes, he recognized me, smiled and shook hands and we inquired about the condition of each other's health. He said he was "weathering the storm" and still had a few parties left to attend. We briefly discussed the Explorers Club party and he said there was over 300 there—many of them not invited guests He recollected that he had asked me to come early to the party, and expressed his displeasure of having been confined to the Board Room so long waiting for the party to begin, instead of being permitted to freely associate with members and guests about the club quarters. He did not comment about the "doings" for him, but did say he was very glad to meet some people he had not seen for a long time or had not met before

Jackson had a fistful of telegrams congratulating him on reaching

the 99th anniversary—and he insisted on going over them with me show-
ing almost everyone of them to me individually—many of them being
from prominent people—including one from Henry Ford—and one from
Keeseville, his birthplace, signed by about 40 people. One from Fred
Black of the Ford Co. mentioned that they were expecting to see Jack-
son in Detroit on April 17th to be present at a party Ford was giving for
Jackson.‡ He said he doubted he would go out because it was almost
impossible for him to negotiate the train steps now that he could not lift
his feet high enough; and then he added if he could fly out he might go,
but he would not go any other way than by airplane both going and
returning

Jackson had one book wrapped ready for mailing—the book having
been sent to him by some one for his autograph—and commented that it
was hard work for him—especially when people did not send sufficient
paper or cardboard, twine or addressed labels and stamps—and there
have been several such cases—quite an imposition—but he agreed that
such was the penalty he paid for writing books and painting pictures,
and being famous, but he did not use this latter word The
autographed edition of [*Westward America*] issued by the Trails Assoc
was handled by having Jackson and Driggs each autograph 1,500 sheets
which were inserted at the time of binding. One of the worst imposi-
tions on Jackson in connection with this autograph matter was a letter
from a party in NY City enclosing a check for $5.00 and asking Jackson
to buy the book, autograph it, and mail it to this party, requiring Jack-
son to furnish the wrapping and the postage!

He seemed proud of his new suit, and asked me whether I had no-
ticed it Sunday and then went to his clothes closet and got it out. He
likes it, but showed me that the trousers were entirely too high at the
waist—about 6 inches too high—but he did not say why he did not have
it cut down at the time of purchase, or why he bought it that way—
apparently satisfied that it too, is a penalty for growing old and shrivel-
ing up. His voice seemed worse instead of better, and frequently was
nothing more than a whisper—and I observed that it is apparently diffi-
cult for him to breathe—his chest heaved considerably—and [he] seems
to have to force out the words.

‡Fred Black, official of the Edison Institute at the Ford Museum in the 1930s.

As I departed he asked to be excused [from] going out to the elevator with me, and as he sat in his chair he patted his legs just above the knees—the spots he had previously told me were his weak spots. This is the first during all the years I have known Jackson, and particularly during his residence at the Latham, that he has not gone out with me to the elevator, and the first time he has ever asked to be excused from such activity! Undoubtedly he is not well—appears very tired—and the request from him clearly indicates that he is weakening slowly but surely. So we parted, with an admonishing from me that he take a nap, and I turned out his lights as I went out.

April 10

Upon . . . the first information I had about Jackson going to the Mid Town Hospital . . . I called the hospital to inquire about Jackson's condition. I was told he was fine and that I could speak to him if I wished, and he was given the phone. His first words were "Hello Bonney—they've got me up here for a rest"—and then his voice broke to a whisper, but temporarily cleared and he continued by saying, "say Bonney, I'm sorry we can't have our little meeting at the Latham" and he laughed. I knew from that that he wasn't feeling so bad when he still thought of our dinner engagement and chat planned for tonight. He said he was OK—just up there for a little rest—where friends had insisted he go to recuperate from the intensive activities he had been going through with recently in connection with his birthday parties. He asked me to come up and see him in the afternoon, but as I could not get away from the office, I told him I would come up in the evening provided his callers during this afternoon did not overtax his strength—and I promised to call him at 5 P.M.

Good old Jackson!—despite the fact that he was "all in" . . . apologizing for his condition and inability to keep our engagement for tonight at the Latham! I phoned Jackson at 5 P.M.—he was eating at the time and although the nurse wanted to give him the phone, I told her it was not necessary when she assured me that he was fine and would be disappointed if I did not come up to see him—and I assured her that I would be up within an hour. When I arrived I found Jackson taking a nap sitting up in bed—and I quietly returned to the floor office where the head nurse told me not to depart, that Jackson would be disappointed if

he did not see me, and she went to his room. I followed some distance behind, and then heard her cheerfully speak to Jackson, and he greeted me with a smile and a handshake.

He joked about his being in bed and having to be taken there by his friends to get him away from his activities. He said he kept his dinner date on April 8th . . . with Mr. Pfeiffer and Major Procter, that they ate at the Latham and a half hour later they had Jackson on the way to the Hospital and that Pfeiffer was the one who insisted Jackson go there for a rest. Jackson said it would do him good and keep him off his feet and rest his eyes. However, he was a bit perturbed about a large stack of mail he left untouched—and he asked Clarence to look it over and bring up to him that which required immediate attention so he could take care of it! . . .†

MRS. DEMING TO BONNEY, JUNE 27, 1942, NYC, 12:00 P.M.

Dear Bonney:
Jimmy Hare just called me up. Jackson fell in his bathroom and broke two bones in his hip and several ribs. He was taken to the hospital yesterday—the same hospital—the Midtown—Ed didn't hear until to-night if he couldn't go up and see him. Ed was up to see him last week and Jackson would have fallen from a dizzy spell if Ed hadn't caught him and put him in his easy chair. I am writing in pencil as this is urgent and I can't find Ed's pen. . . .

I'm writing so you will know as soon as possible. They are not leaving him lying in bed all the time for fear of pneumonia and they dare not operate on account of his age. You had better see him as soon as possible. Ed will go up tomorrow. He fell at 6 in the morning and they did not find him until 9 o'clock. Imagine his being alone all that time! He should have had some one with him. Clarence should have seen to that.
Love to you all,
Affectionately,

Mother Deming

†This hospitalization, apparently for exhaustion, lasted twelve days. Howard Driggs was on hand April 20 to conduct the patient back to his hotel room. In just a few weeks Jackson would return to Midtown Hospital, there to "cross over the range." Driggs to Bonney, April 21, 1942, Collection 1643:264, CHS.

June 29

I was at home, enjoying the last day of one week's vacation when the attached letter of June 27 (Saturday) was received at noon from Mrs. Deming. I telephoned to her and she said that she had rec'd word of Jackson's accident and his present condition from Jimmy Hare; that Jackson was in critical condition and an operation was contemplated; and that no visitors, except members of the family were permitted to see him. Consequently, nothing would be gained by me telephoning to the hospital and I agreed to telephone to her in the morning to get the latest report of his condition

June 30

About 10:00 A.M. Mrs. Clarence Jackson telephoned to me at the office and informed me that Jackson had died about 2:45 A.M. that day. I told her that the day before I had received a letter from Mrs. Deming informing me of his accident and condition and had planned to telephone to her soon to ascertain his condition as I understood it was critical and that no one was permitted to see him except the immediate family. Mrs. Jackson told me that he had broken his hip at 3 places and because of his critical and hopeless condition they did not operate as contemplated but put both legs in casts so that he was held rigid which prevented movement and pain. She said Joe Robinson was in the room with her, Clarence and Mr. Jackson until about midnight; that Jackson rested peacefully and when he asked for a drink he was given a glassful of milk and drank the greater part of it—and later opened his eyes again and said to Robinson, "Where have you been and what have you been up to," then smiled sweetly, closed his eyes, rested quietly, said nothing more, and passed from this life at 2:45 A.M.

The telephone operator at the Hotel Latham called me this afternoon and said Clarence Jackson wished to speak to me but at the moment he was busy on another wire Clarence then came on the wire and said he couldn't find any will and asked me whether I knew anything about a will. I told him I did not have any knowledge of a will, that I had never asked his father about whether he made one or where it might be, and that I merely talked to him about what I thought was the proper disposition of his personal items. I reminded Clarence of his father's statements to me about wanting us to be his executors, the last

mention being at the 99th Birthday anniversary party at the Explorers Club when Mr. Jackson apparently reminded Clarence, as Clarence had commented to me that his father wanted to get us together about the matter, but that I had never had the heart to push the matter and Clarence said that he hadn't either—and we agreed that with his father apparently so happy and evidently improving in some respects that he appeared to be gaining sufficient health to carry him along for quite a while, neither of us had the heart to mention a will, or disposition of his personal items.

Clarence said he found a codicil form, but it had not been filled in, hence of no effect, but it indicated that a will existed, but the bank, hotel or other parties had no knowledge of the matter of a will or a safe deposit box. Clarence said he had consulted Major Procter and the banks and was endeavoring to get the bank account released. Clarence said he found some of his father's notes stating what disposition he desired made

I told Clarence that the Ford Museum was interested and that his father considered depositing some items there, but was uncertain which ones—that he felt that his material should be available for use and thought the Library was the proper place. Also the original 1866 journals (2 volumes) were given to Colorado Historical Society and that Jackson had gotten them back for reference and they are in his room. Clarence said he found them.†† I told him that his father had also recently told me that he had loaned some things—but I did not know to whom. Clarence said he thought best to move everything to his home and put in cellar to get catalogued

July 1

Dora and I attended services for Mr. Jackson at the Cook Funeral Home on 72nd St. Among those present were several members of the Explorers Club, some of whom I knew, others joined after I resigned—Lowell Thomas, Jimmy Hare, Capt. Deming, H. M. Albright, Joe Robinson, Joe Boland, also several Adventurers' Club members, several ladies, most

††The diaries in question, presented to the CHS at an earlier date, had been returned to Jackson by September 1938. The two volumes again came to the society archives subsequent to 1942. Jackson to Hafen, September 12, 1938, Collection 341:22, CHS.

of whom were strangers to me, some of Clarence's close friends . . .
Alden and Kathryn Deming, and Connie (Mrs. J. N. Walters)—Jimmy is
at home in Indiana and because of the short notice of funeral could not
get East. The services were not very satisfying. There was no music, the
room was crowded and muggy H. M. Albright spoke and at once
apologized for his inability to serve as a speaker He ended with the
remark that Jackson was "kind, gentle, even sweet"—which was the
only pleasing thing about the entire service—and after Dr. Lynch recited
a very brief poem, and a prayer was said, the services were concluded.
The guests departed quickly. We lingered to visit with Deming and Hare.
I did not have the opportunity of extending my condolences to Mrs.
McLeod and Mrs. Pattison (Jackson's 2 daughters) but I did speak briefly
with Clarence, who said a will had been found at Detroit in possession
of a brother-in-law‡—no further explanation and I did not question—
but that "they would probably want us to serve as executors" altho he
did not explain this statement. I told Clarence I would be very glad to
give him any assistance—and again he commented about moving every-
thing to his home to catalogue it—to which I did not make any further
comment. And we departed, and accompanied the Demings to their
home . . . and reminisced about Jackson.

‡The will, dated August 6, 1940, appointed as executor Jackson's son-in-law
Myron A. Pattison of Chevy Chase, Maryland. He resigned the position a few
weeks after Jackson's death in favor of daughters Harriett J. Pattison and Louise
J. McLeod. They promptly passed the responsibility to son Clarence, whose be-
quest was all personal property in his father's room at the Hotel Latham. The
balance of the estate was given to McLeod. On November 5, 1942, Clarence
declared his father's assets at time of death to be $670.65 and liabilities $228.26.
Collection 1643:303, CHS.
 Clarence delivered twenty diaries, originals or copies, of William Henry Jack-
son to the New York Public Library on August 17, 1942. List by C. S. Jackson,
box 29, F. M. Fryxell Collection, AHC.

Index